THE NOISE OF ICE
ANTARCTICA

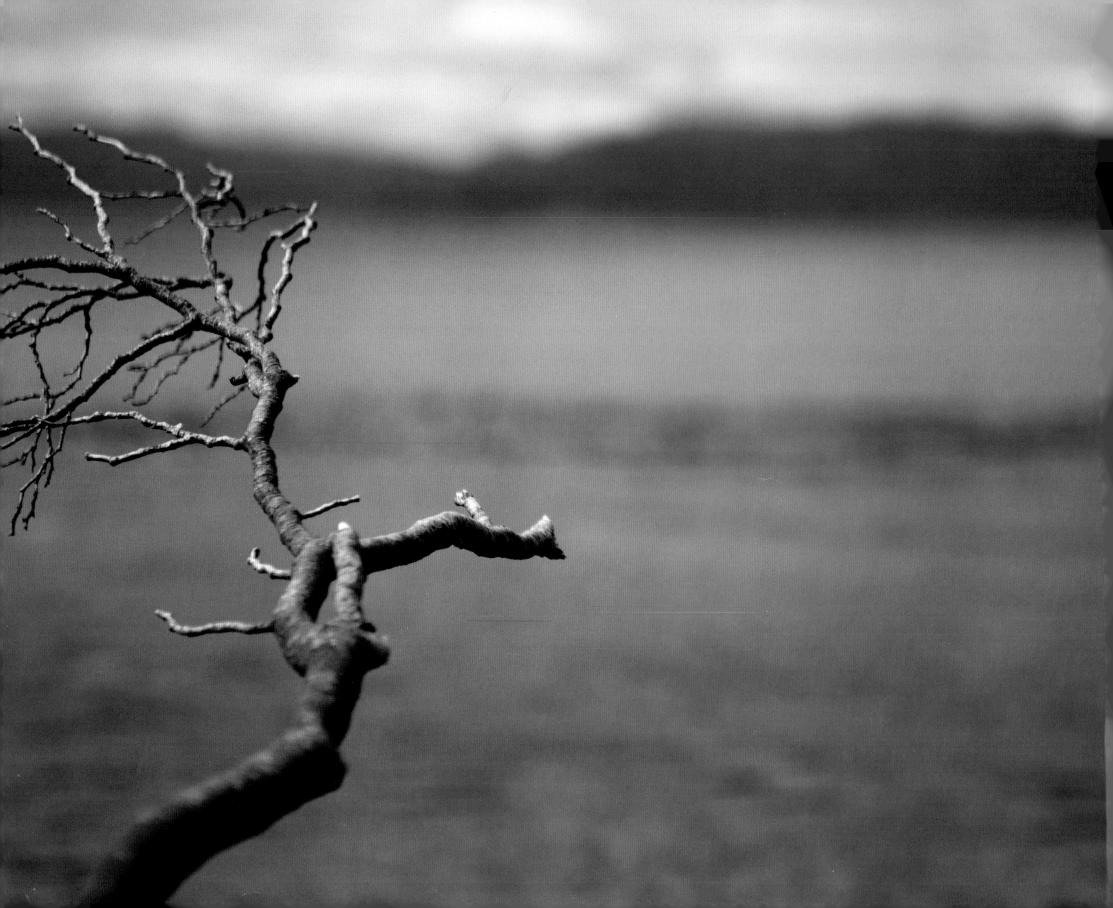

Foreword by SIR RANULPH FIENNES

THE NOISE OF ICE
ANTARCTICA

ENZO BARRACCO

MERRELL
LONDON · NEW YORK

CONTENTS

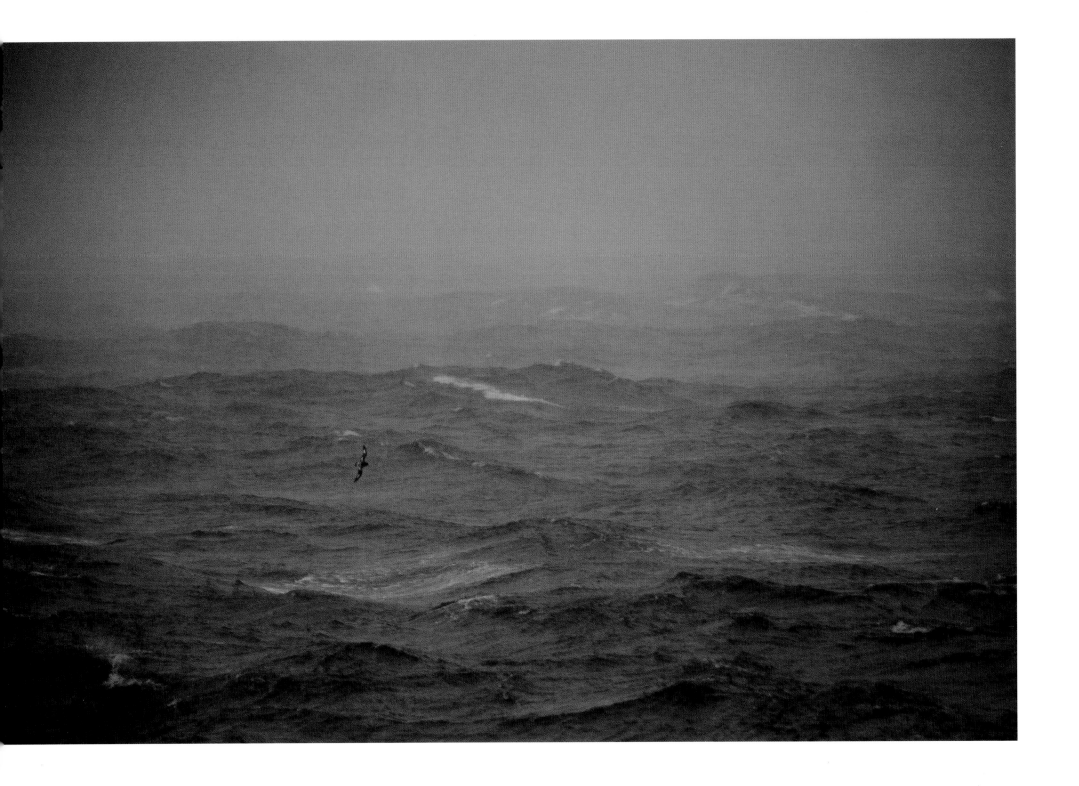

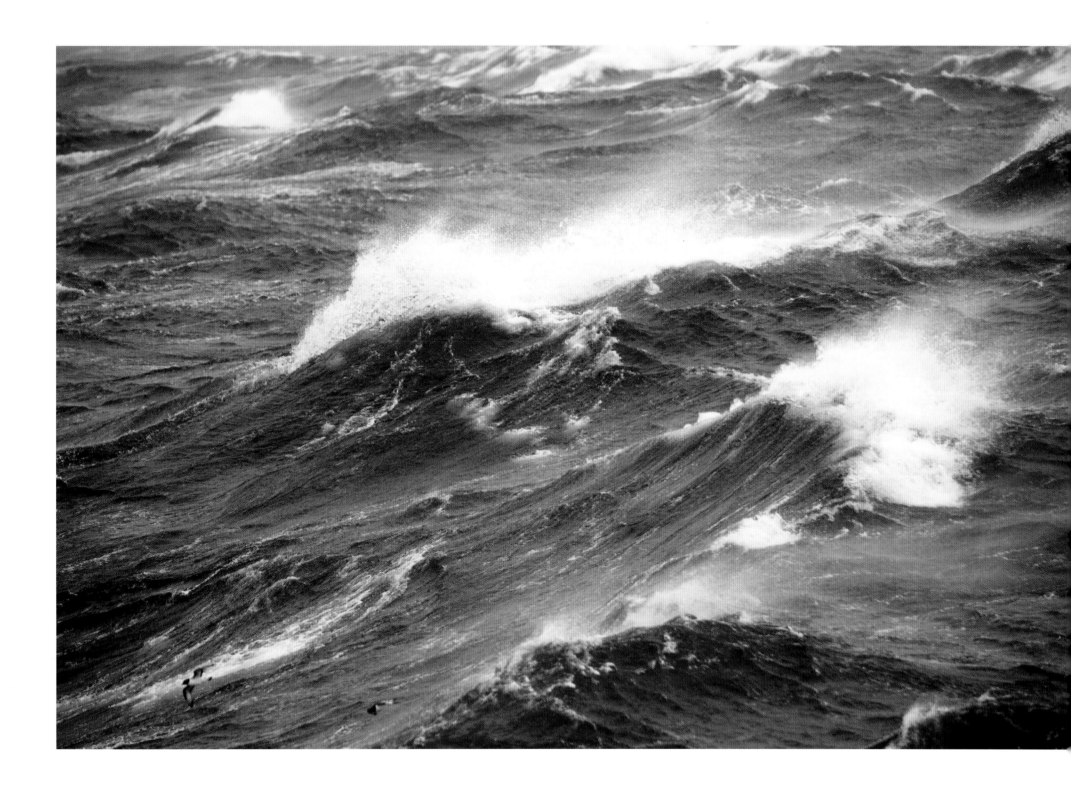

FOREWORD BY SIR RANULPH FIENNES

The Antarctic is a freezing desert twice the size of Australia. It's one of the coldest, windiest and driest places on the planet. It has very few inhabitants and is largely made up of ice, water and rock. But it is also one of the most intriguing places on our Earth – it is unforgiving, brutal and powerful. Yet behind this world of blasting wind and harsh, black stone, there is an ecosystem that is delicately balanced; there is light and dark, tranquillity and bluster. Above all, there is undoubted beauty. Endless, expansive beauty.

My love affair with the Antarctic began many years ago, but I was fascinated to hear how Enzo Barracco, a fashion photographer, interpreted the Antarctic. I know the passion, dedication and hard work it takes to plan any journey there, as well as the mental and physical toll of spending time in an environment where humans are aliens. This book explores what drove Enzo to embark on his journey, how he explored Antarctica with his camera and the lasting impact his project has had on him.

This book is about photography, but it is also about conservation. Antarctica is an area of the Earth that, at first glimpse, is largely untouched by humankind, but it is our actions elsewhere on the planet that ultimately threaten it. Over-fishing, global warming and rising sea levels all put this entire continent at risk. The stunning landscapes captured by Enzo are undoubtedly beautiful, but they should act as a reminder of the precarious position in which humankind has placed this part of the world.

I believe Enzo's work is a great way for key conservation messages to be relayed. Everyone has a role to play in conservation and in protecting areas of the world that are at risk. Art, such as Enzo's work, is a hugely effective way to communicate this message. It plays a crucial educational role, but it is also accessible and appealing. Photography allows people to dwell on a thought or an image, for minutes, rather than seconds. It is a finely crafted platform on which important messages can be placed.

Any expedition to Antarctica presents numerous challenges. The continent is one of the most difficult of places to get to, and, once there, is one of the most inhospitable places in which to live, so it is a place very few of us will ever experience with our own eyes. This is probably the first time a photographer has visited the area purely with the aim of studying it from an artistic point of view. I know first hand what an inspiring place it can be, and Enzo's work captures the magic wonderfully.

The photographs in this book are a perfect glimpse into a part of the world where extremes sit side by side: ethereal skies change to freezing storms in a moment, and glorious red sunsets leak on to perfect white ice. Enjoy Enzo's story and his glorious pictures – perhaps they will inspire some to try a different style of photography or to see the world in a different way, while some may be motivated to travel after reading about Enzo's journey. But crucially, I hope everyone who reads this book becomes more appreciative of the importance of Antarctica – a unique place that plays such an important part in the ongoing state of our planet. Witnessed by only a few, Antarctica should be enjoyed by many and protected by all.

Sir Ranulph Fiennes

INSPIRATION

I choose life over death for myself and my friends ... I believe it is in our nature to explore, to reach out into the unknown ... The only true failure would be not to explore at all.

Ernest Shackleton

His head wrapped in a thick woollen balaclava, and standing high in a niche on the west wall of the Royal Geographical Society in Kensington, London, the bronze statue of Sir Ernest Shackleton says everything about the man he was. There is a look of granite-hard determination in his rugged face; he is sombre, composed and driven. As I prepared for my trip to Antarctica, I would pass this statue every day, and each time I would look up at it and promise myself and Shackleton that I would see what he had seen and stand in his tracks in the ice.

Now, many, many months after my return, Shackleton's statue still inspires me, still makes me work harder. I feel honoured to have seen some of the things he saw. Looking into those fixed eyes, I see someone who is now more familiar, a person for whom I now have a much greater understanding and a much deeper respect.

It was, of course, Ernest Shackleton who sent me on this journey in the first place. It was his legacy, his desire never to give up and his immense courage that inspired me. My motivation for going to Antarctica was a love of nature and a respect for Shackleton's legendary expedition. I did not go as a test of my skill and my body, I went out of love.

My regular work revolves around fashion and portrait photography, and as such I have been lucky enough to travel to beautiful places around the world. In all the work I do, one of my main aims is simply to observe. In doing so, I'm able to see things much more clearly and communicate my view in a better way. Observing nature is no different. It allows me to communicate the pure power and beauty of nature in the hope that it will engender greater respect for her.

Nature has always been an inspiration of mine. My first exhibition, when I was starting out in photography, was about nature; she was my first muse, and, despite following a career in fashion, I have never lost my enthusiasm for the natural world as a subject.

Of course, there are obvious differences in the two photographic disciplines. In the fashion world, I can change the lighting in the studio in a few seconds. Somewhere like Antarctica, to change the lighting I must wait days and days in the cold wind to find the perfect time. In many ways Antarctica is like a model: it is beautiful, impossible to tame and totally unpredictable, and it can surprise and delight in an instant.

MEN WANTED for hazardous journey, small wages, bitter cold, long months of complete darkness, constant danger, safe return doubtful, honour and recognition in case of success.

Ernest Shackleton, expedition advertisement, 1900

One day, in a bookshop in London, I stumbled across a book about Shackleton. I was struck by his character, and his spirit of endeavour leapt out at me from the pages. After reading just a few words, the idea sank in. I knew what I wanted to do, and the thought was daunting and exhilarating in equal measure. Shackleton's courage and endeavour inspired me to discover the true end of the world – the wildest and most fragile part of our planet. I wanted to go to the furthest reaches of Earth to discover the limit of man. Everyone has their own Antarctica, but few know what it is. In many ways we are all explorers – each day we encounter new parts of the world, new people and new challenges.

We wonder: what is Antarctica? – that huge, icy, impenetrable expanse about which we know almost nothing. It is always there, motionless, silent. It is an extreme, violent and unexplored land, a land where there are no people and no society, where mystery reigns supreme, a land that will always captivate researchers and explorers.

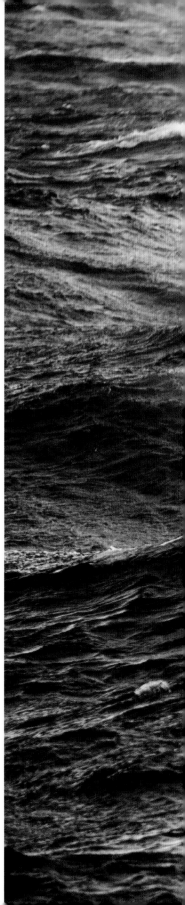

WAVE

Crossing the Drake Passage on the way to Antarctica, I got a strong sensation of being under the control of a powerful, immense energy. I felt as though I were riding on the back of a lion, knowing all the time that anything could happen, and that if it did, there was little I could do about it. All I could do was respect this awesome energy. The wind would whip up the waves, making them explode when the two came into contact. I was witness to the shape of energy.

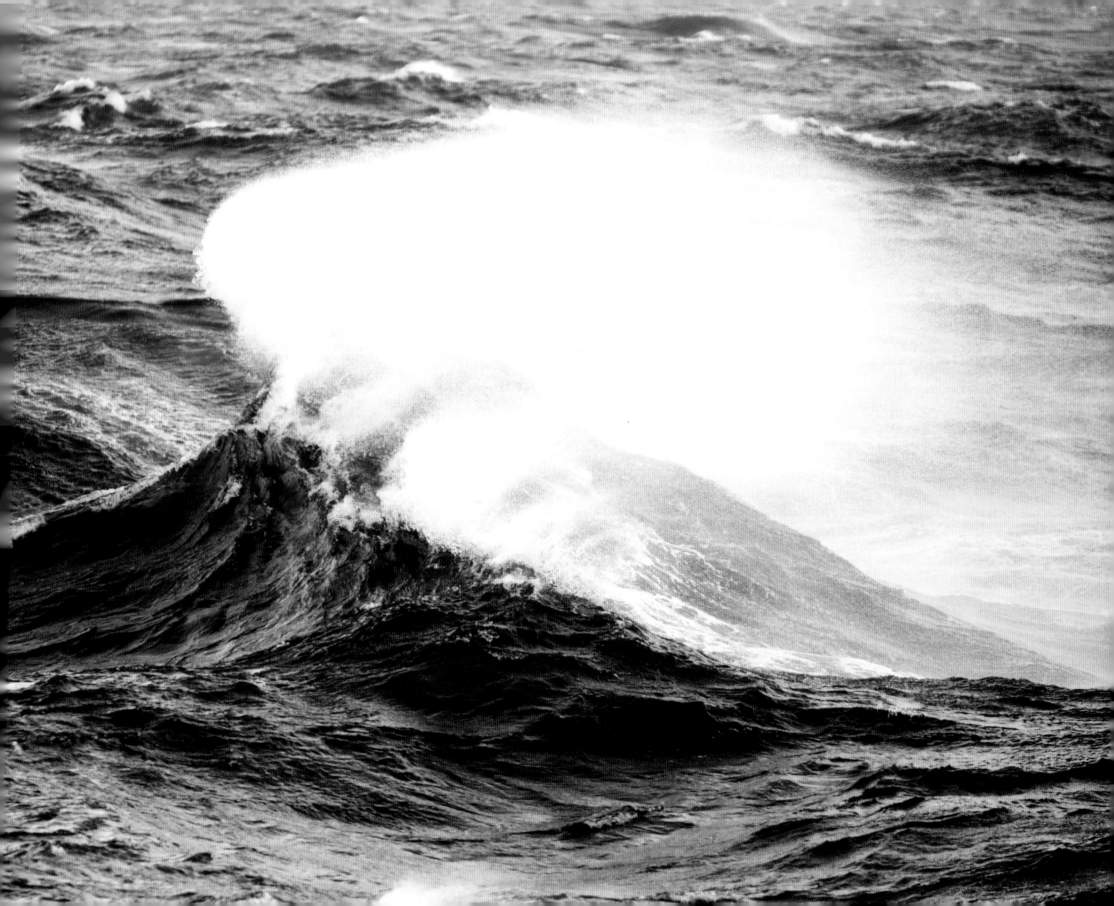

BLUE REGION

During the night, as we made our way to Antarctica, the staff of the boat would shine a powerful beam into the distance to spot icebergs ahead. Radar can sometimes confuse icebergs for waves, so the light was essential if we were to avoid hitting anything. Even small icebergs there are the size of a bus. One night I came outside to take a photograph, but the bitter cold affected the lens of my camera, making it difficult to focus. With one hand I held my camera, and with the other I gripped a rail tightly to prevent myself from falling. This photo – despite being taken in the deep of night, with danger, chaos, energy and mystery all around – has a quality of calm that belies its true context. To me it demonstrates the simplicity of nature.

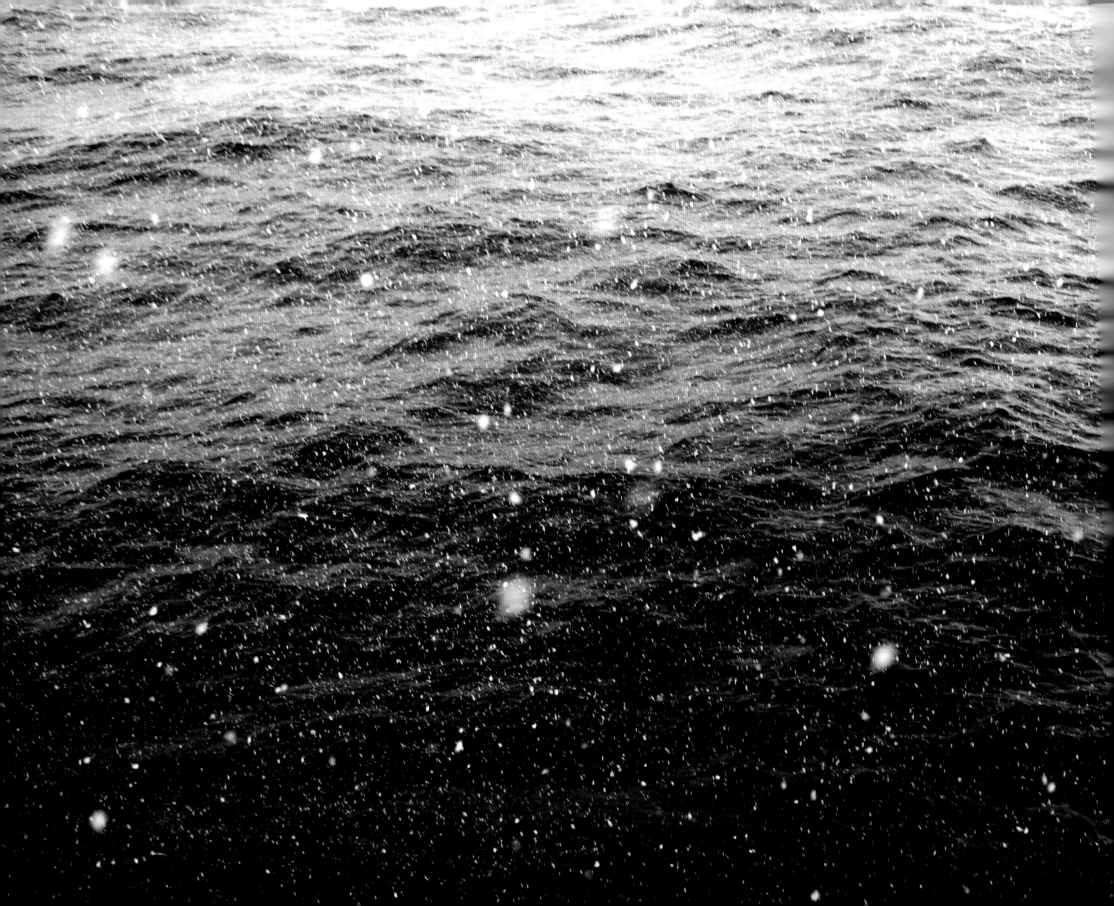

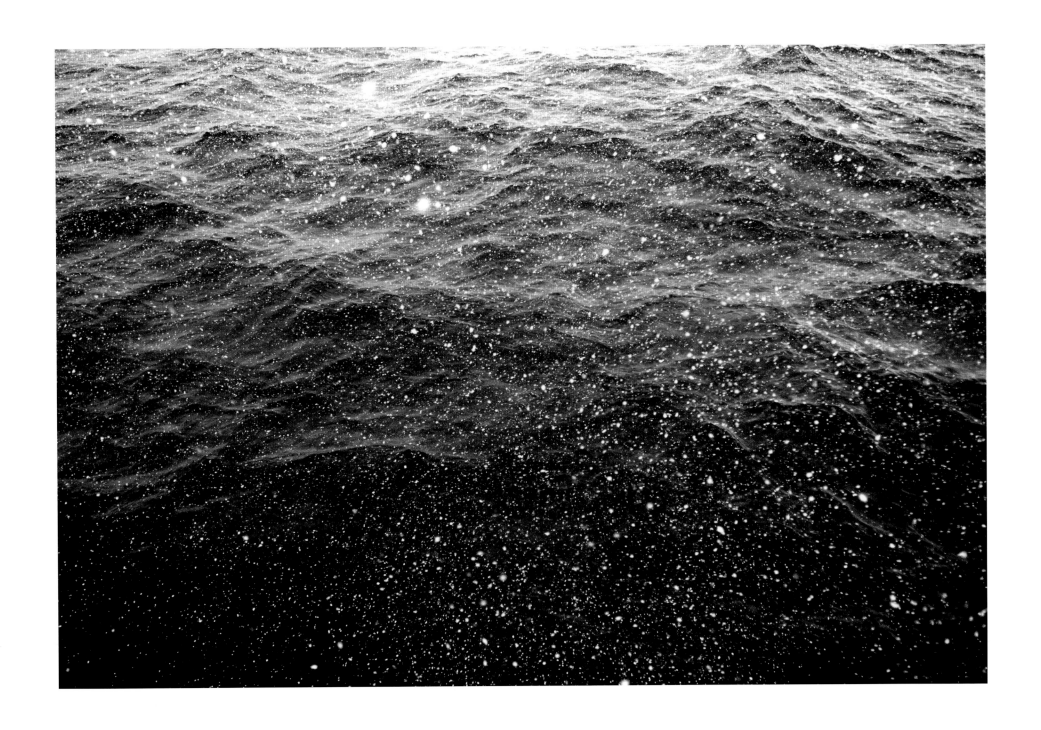

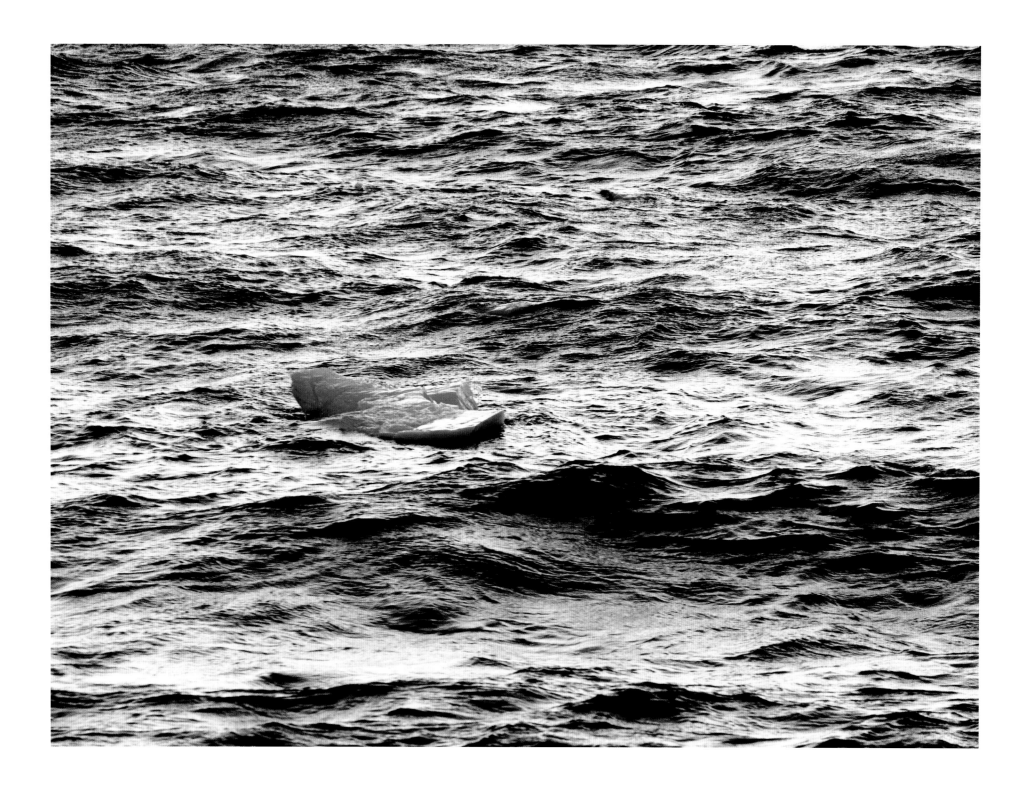

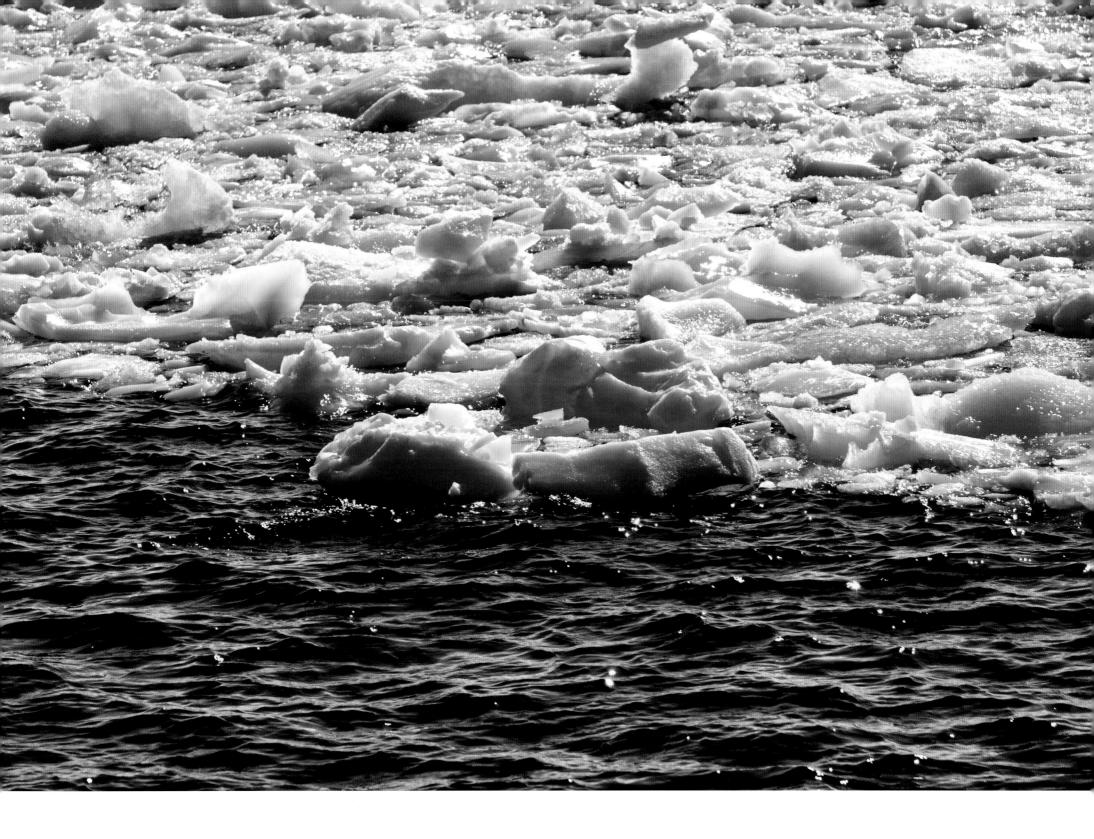

MY FIRST ANTARCTICA

After days of storms as we crossed the Drake Passage, the ocean suddenly became calm, and reflected the sky. It was a strange sensation, seeing the sea apparently swelling from the inside. The temperature dropped drastically. We sailed on for a few hours, through fog and then a sunrise, and then Antarctica appeared in front of us. After many days on the ocean, being battered by storms, it was thrilling to see her finally. Although we had reached our destination, this was just the beginning of our journey. It was far too cold and windy for me to focus the camera properly, but I decided to shoot anyway. I love this picture because it is the very first contact between me and Antarctica.

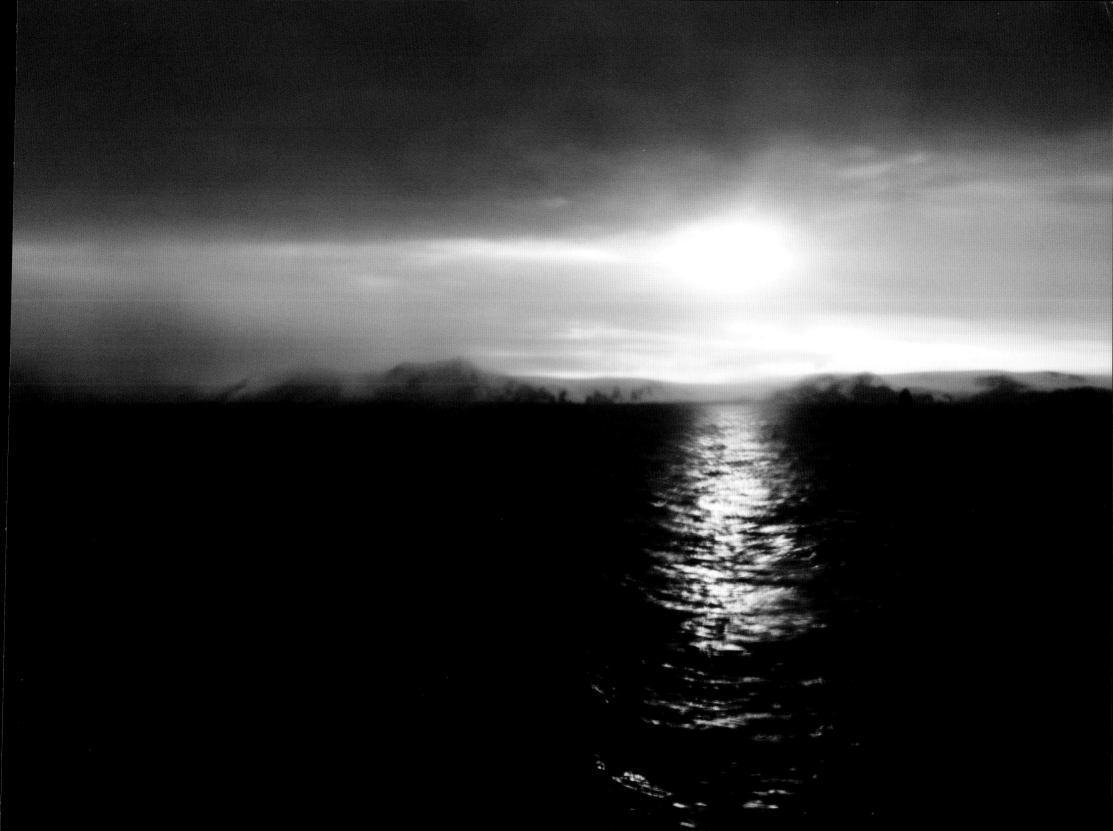

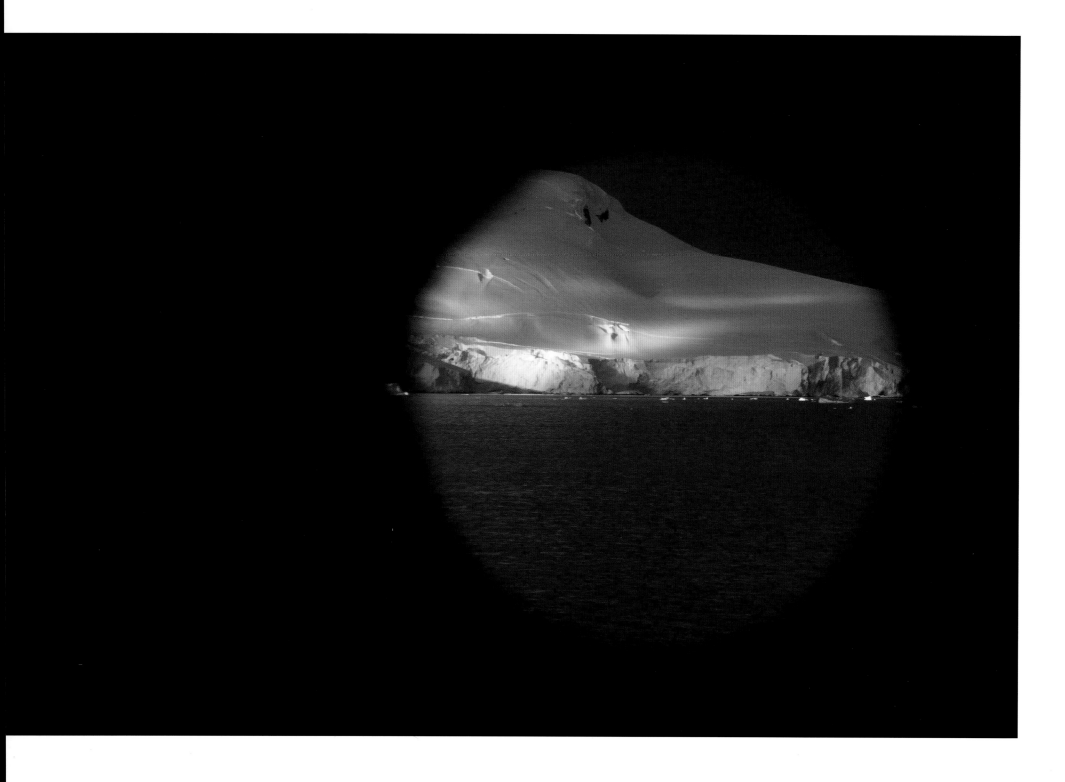

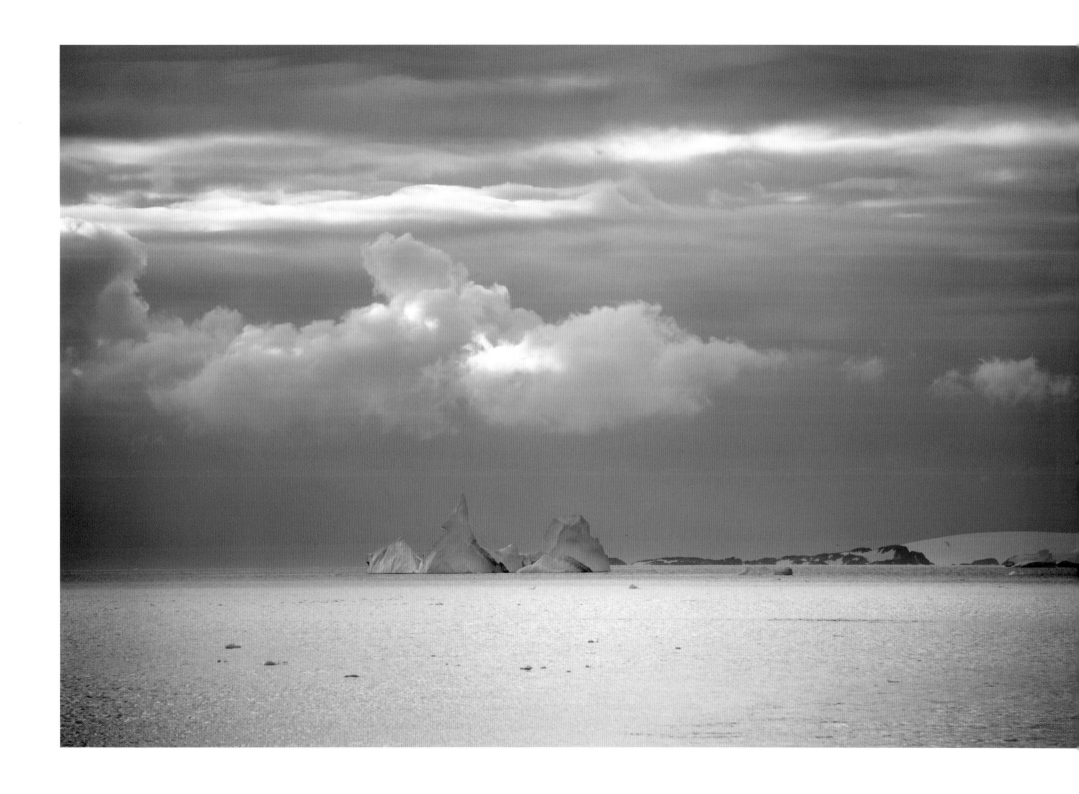

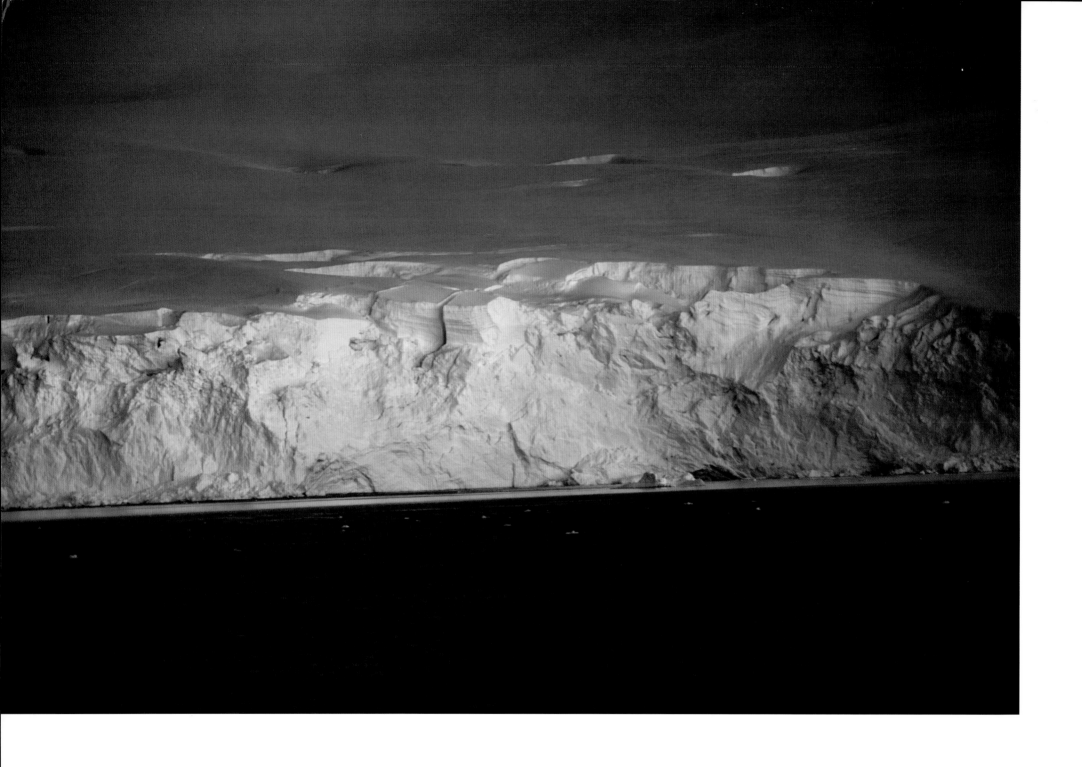

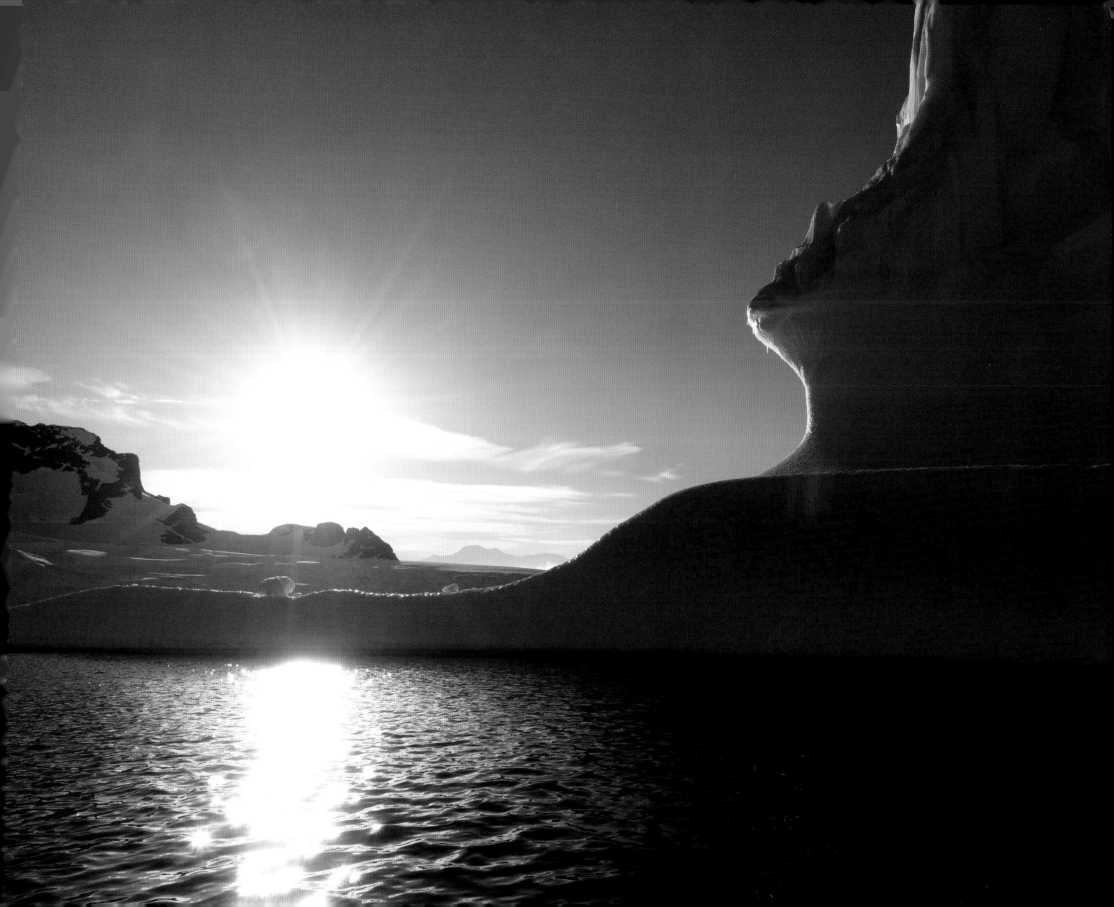

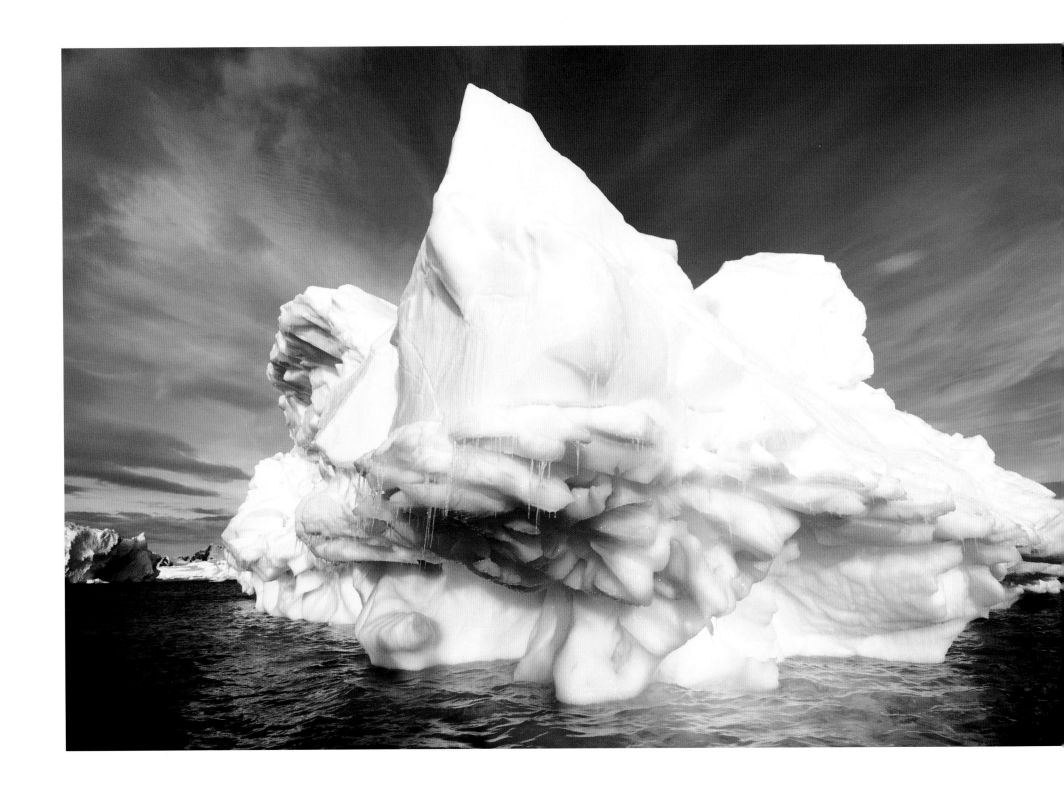

EXPLOSION

We spent a wonderful sunny day in a bay, slaloming among icebergs, while above us albatrosses fished. On one occasion we spotted a whale hunting, and tried our best to follow it. We lost the whale, but when I looked up I saw this, an astonishing shape that looked like an explosion of ice. Days before, the iceberg would have been the other way up, with the part that is now above the water submerged. As it melted, its centre of gravity shifted and it turned upside down. This wonderful shape would remain for only a few days before the wind reshaped it once more.

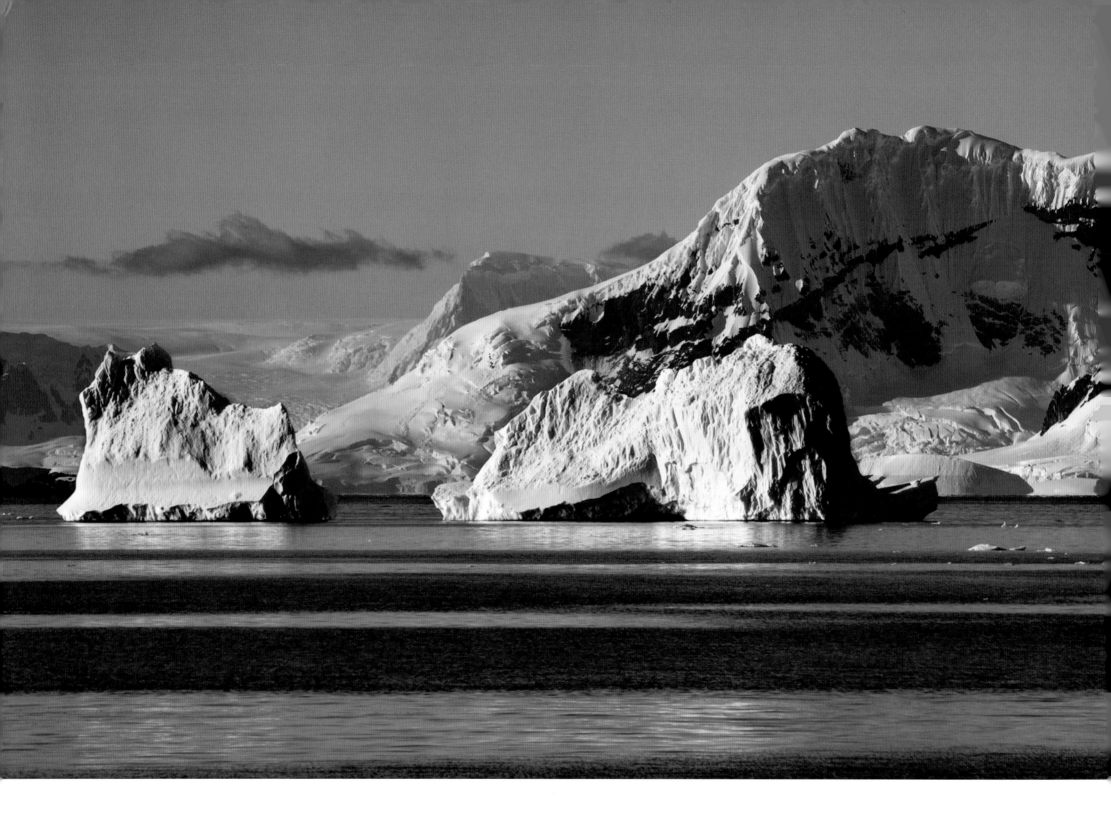

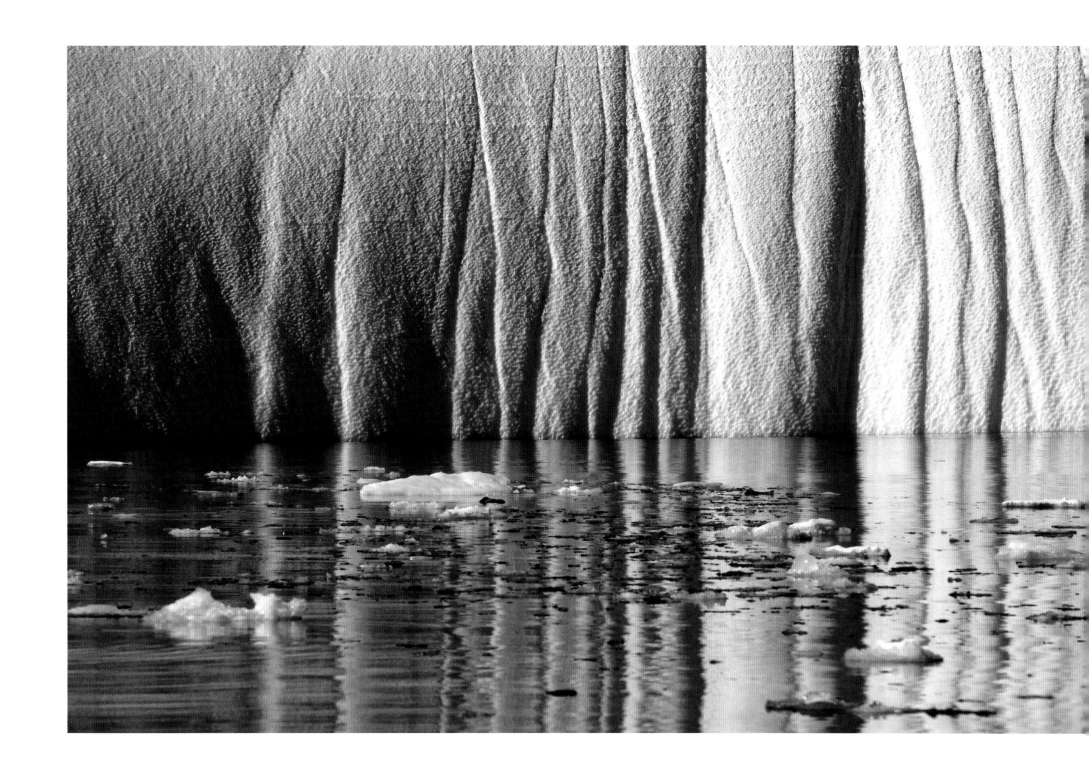

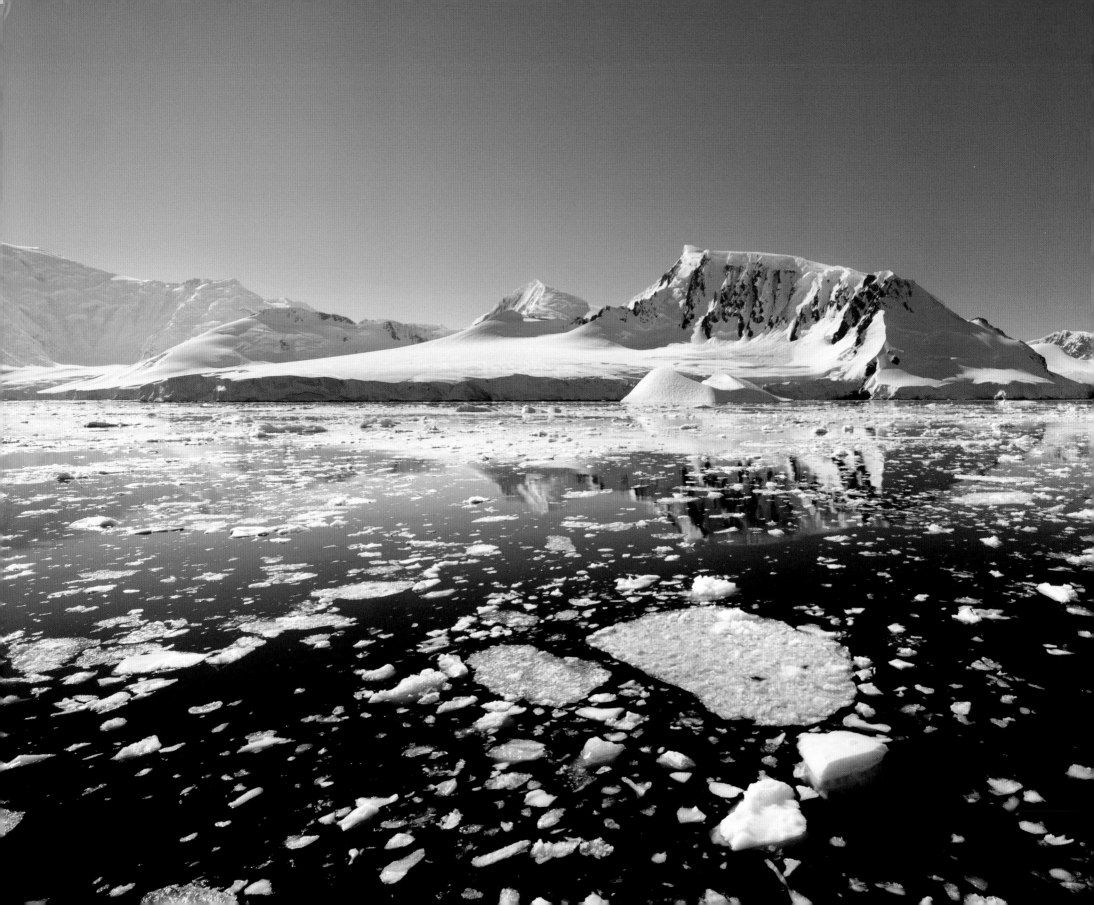

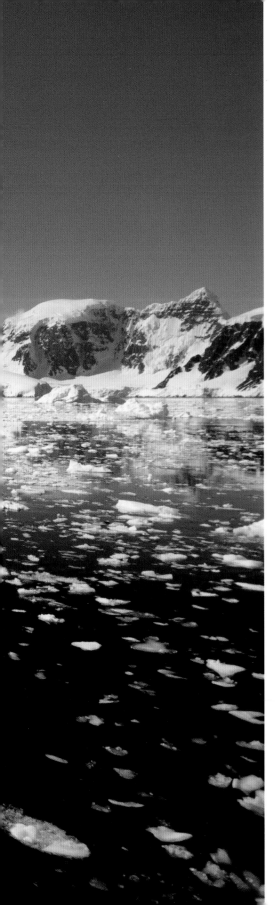

Out of respect for nature,
I never touched the ice.

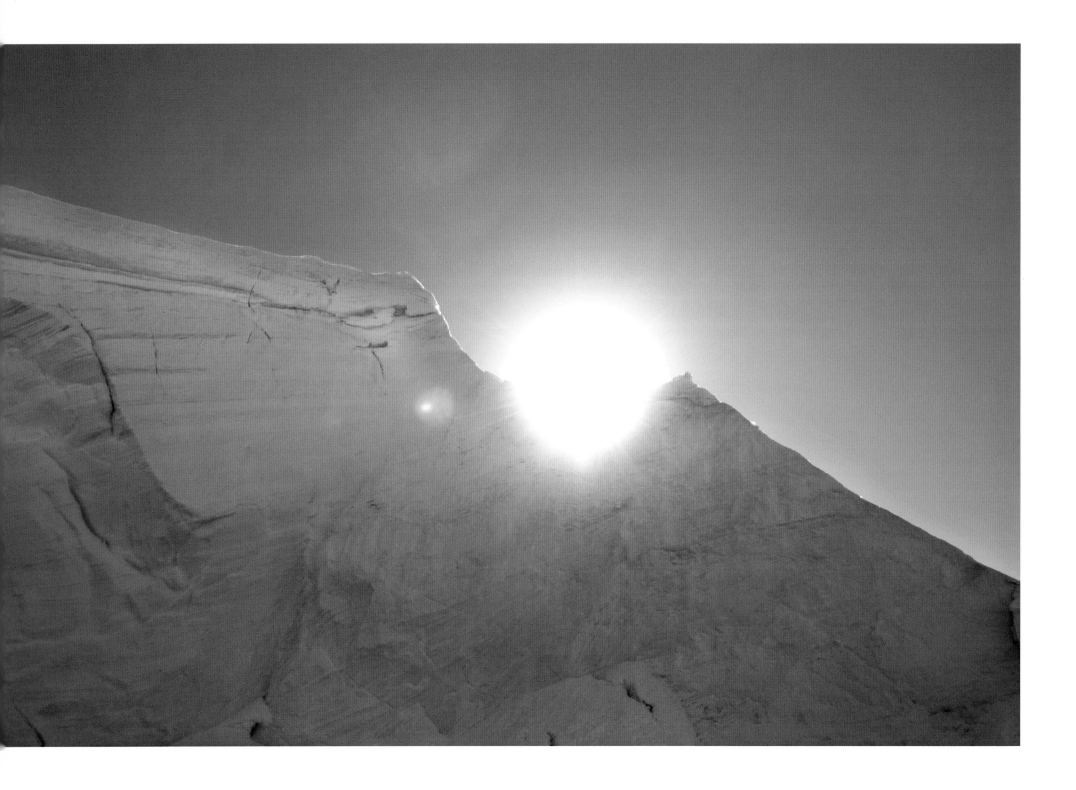

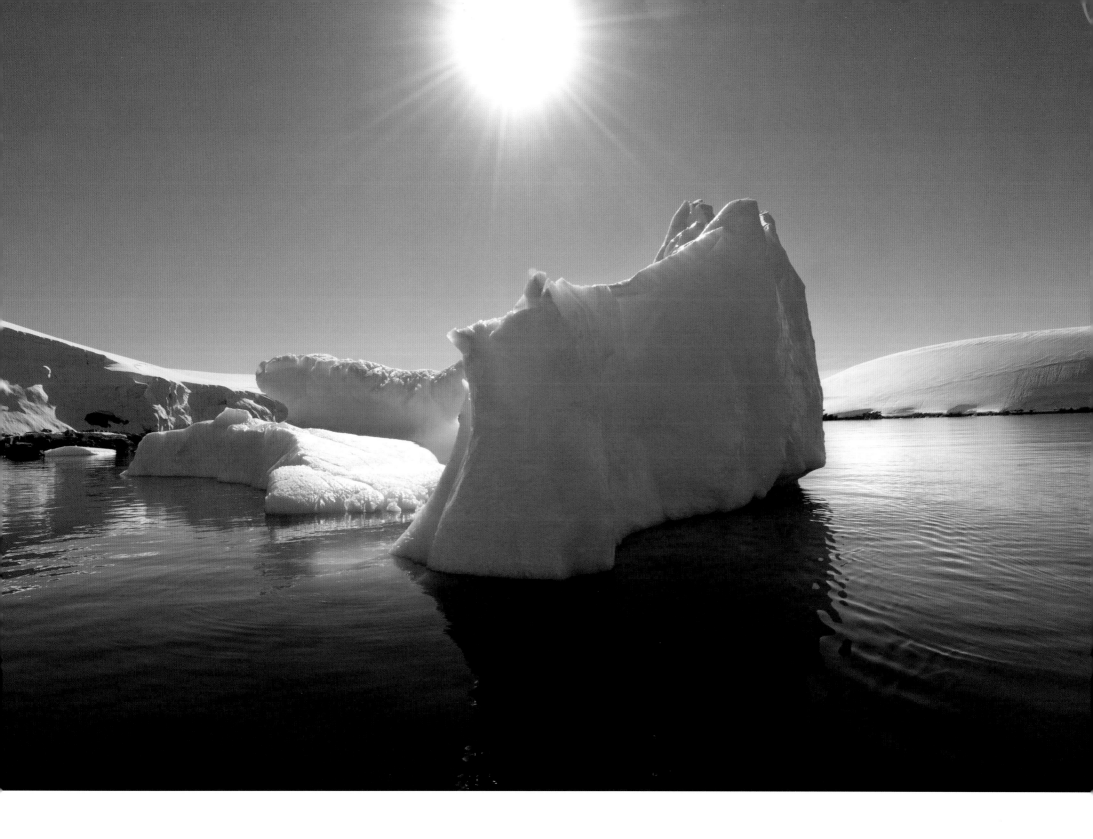

RIVER

This spectacular and unusual surface pattern is caused by wind and waves during storms. Watching carefully, I spotted an inner river within the ice, with water flowing through it directly into the ocean.

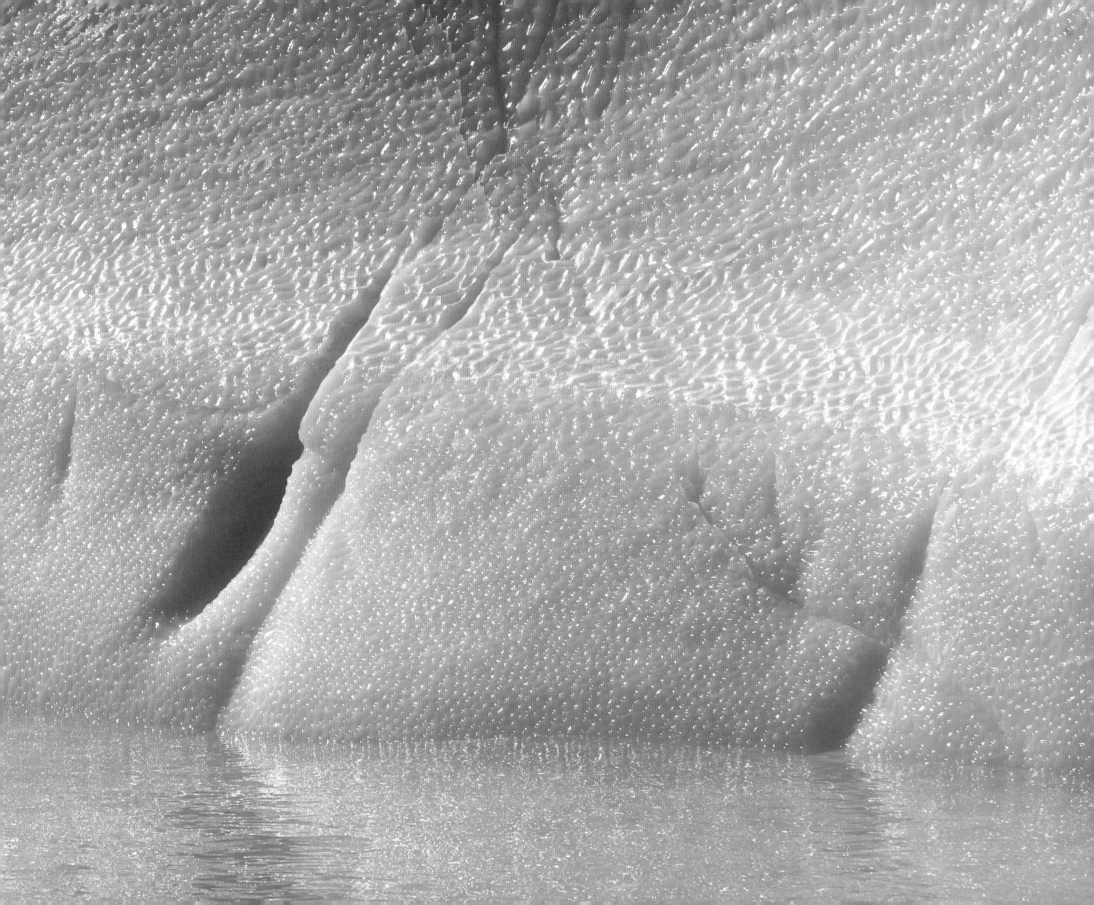

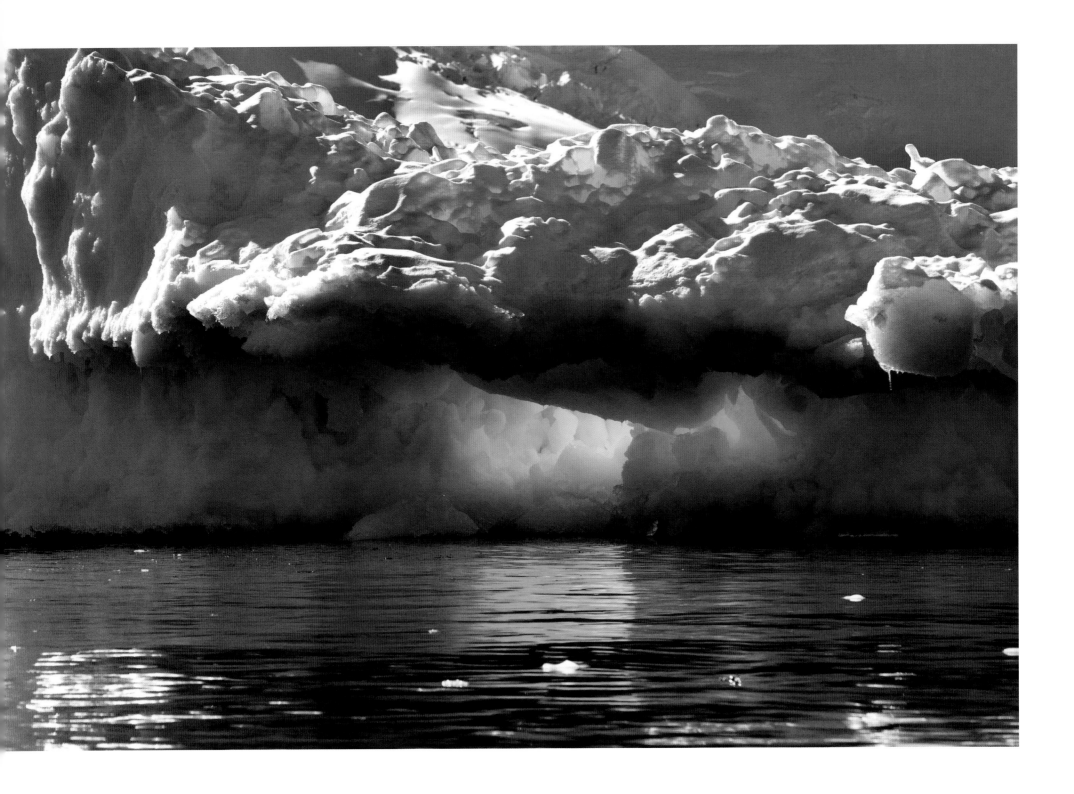

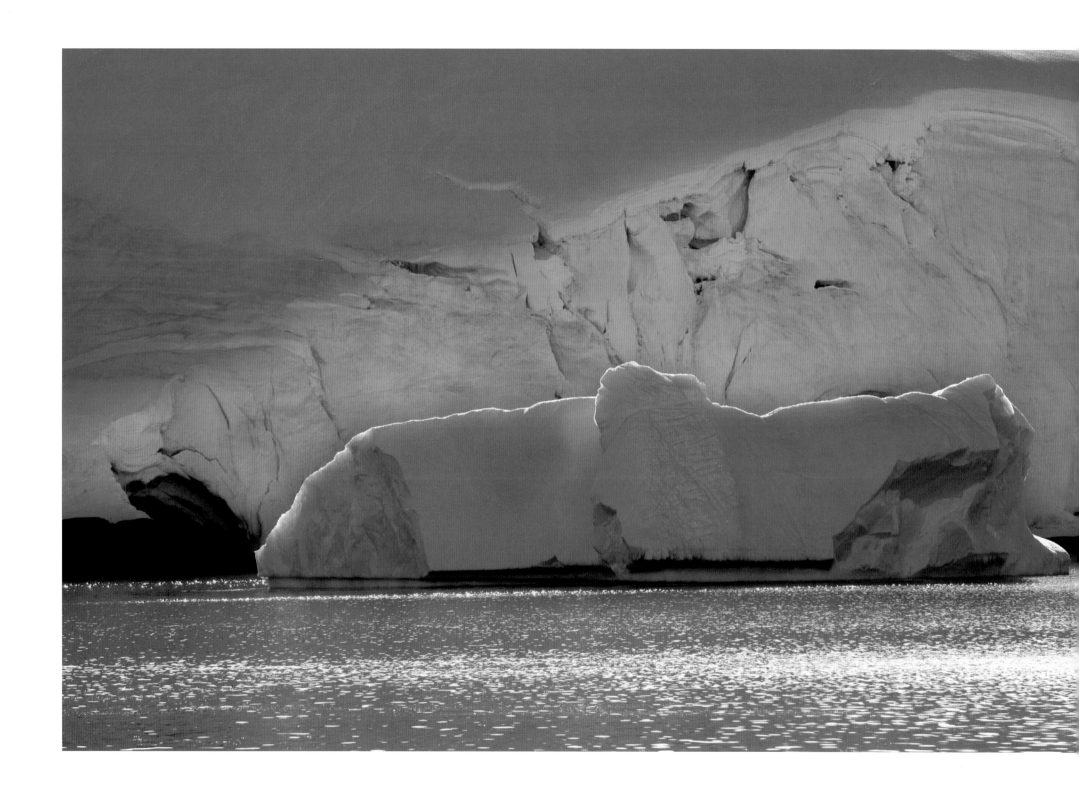

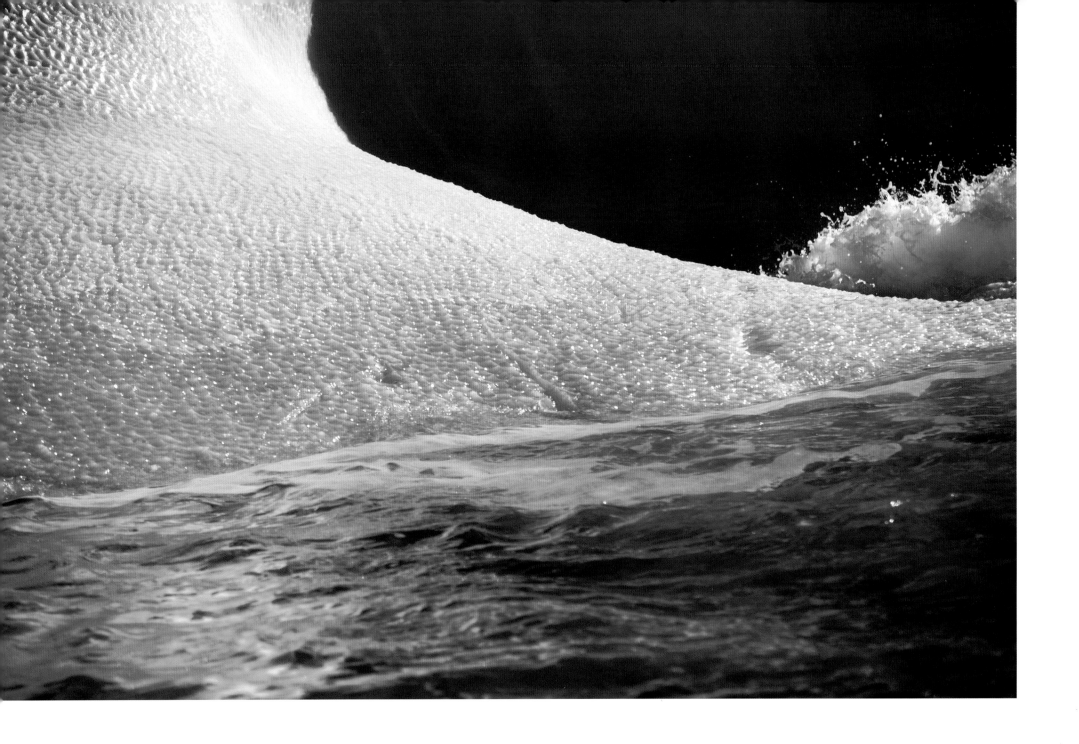

Surrounded by miles and miles of ice,
I did not feel alone.

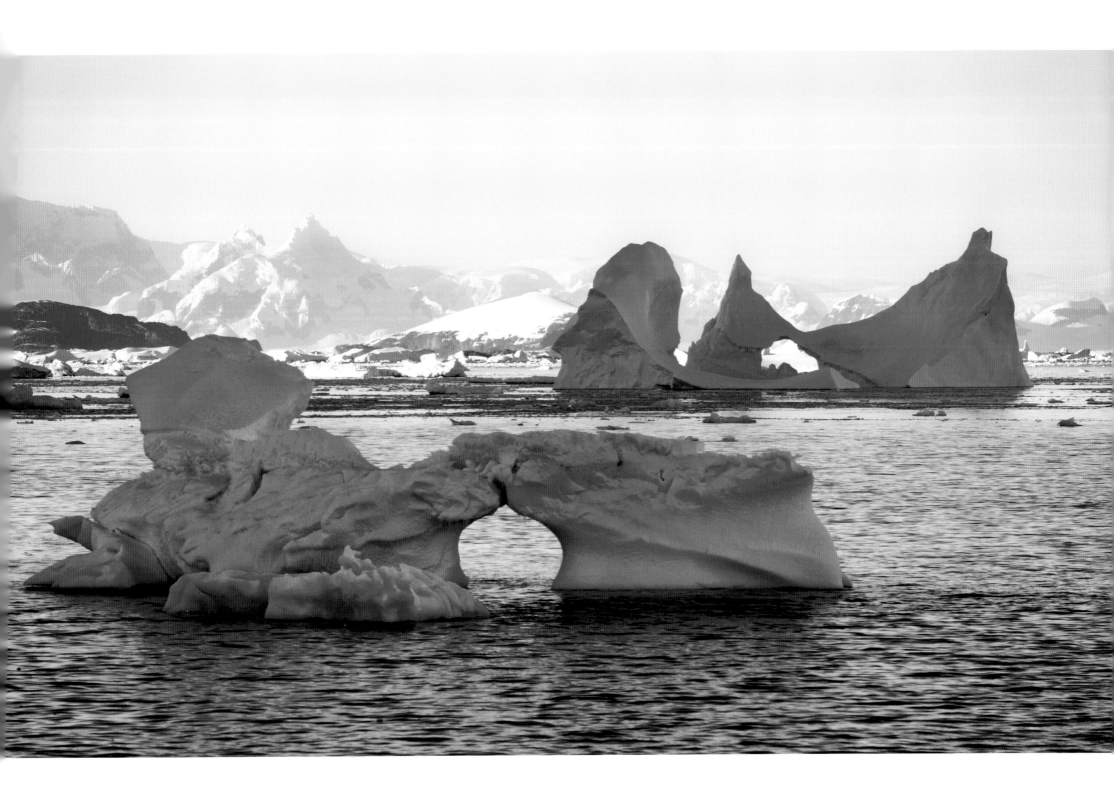

PREPARATION

The challenge was what appealed to me: the uncertainty, the danger and the mystery of the unknown. But allied to that was the artistic task of decoding the message of a complex part of the world, and returning from the trip with work that would do justice to Antarctica.

I knew I wanted to go as soon as possible. Antarctica was pulling me towards her like a magnet. It was September when I had the idea, and the best time to go to Antarctica is between November and February. I would struggle to find a crew to take me in such a short time and to such a difficult place. I therefore had two options: to plan a trip for fifteen months' time, or to organize the expedition in just a few weeks.

The prospect of waiting more than a year to go to Antarctica did not appeal at all, but everyone told me that to plan such a complex trip in such a short time would be impossible. It was too late, though – my mind had already made the long journey to Antarctica.

My list of things to do was long, and grew longer the more deeply I researched the trip. The biggest problem would be money, and I would need sponsorship for such an expensive journey. As well as fundraising and planning the logistics of the trip, I also needed to prepare my mind and my body. After all, Antarctica is Antarctica.

There was a lot riding on the trip, since I was asking people to sponsor my project – not an easy task, as I learned. I needed to convince people to send me to the end of the world to take a photo. Nothing like it had ever been done before. I told myself I would never give up, and tried all the time to keep my spirits and my enthusiasm high. That, it seems, was contagious. I was able to spread my enthusiasm for the project to those around me, to those who could help me realize my goal. Soon, things began to happen.

We didn't make our planet. We have just one responsibility: to try to protect it. I strongly believe that my research, led by the medium of photography, has its foundation in the urgent need to understand and decode the complex message of this ancestral territory, where the violence of the oceans, driven by strong winds, seems to foster the last secret of the world. The aim of my project was to try to create a real dialogue between man and nature, in which nature – Antarctica – shows its majesty and fragility at the same time. This dialogue is created through observation, the understanding of the balance of our fragile world and how essential this unique place is.

The fate of human beings cannot be separated from that of our host planet. I felt that writing a visual story might inspire people to an attitude of respect for and attention to nature in order not to hurt her. This was a very instinctive way of working, an intimate one, driven by the desire to establish a deep relationship with the environment. This work would be a synergy between man, sea, wind, ice and the signs of time. For millennia these elements have remodelled this unique place, forcing a continuous transformation. My work would be intended to block only for a split second this continuous transformation, merely observing what nature would reveal to me.

Throughout the whole planning process – those hectic weeks filled with phone calls, meetings and far too many emails – Ernest Shackleton seemed to keep me going, and his statue filled me with energy every time I passed it. On one occasion I went to the Polar Museum in Cambridge, where I began talking to a member of staff. When I told him about my trip and the inspiration I had found in Shackleton, he invited me through a private door and down a long corridor lined with many rooms. We went into one, which was full of boxes of all shapes and sizes, and he opened a drawer.

What was inside filled me with energy in the same way that the bronze statue of Shackleton does. There lay the explorer's own sextant, a complicated-looking metal instrument, the tool he used to complete his voyage. This was now a piece of history – rudimentary compared with even the most basic navigation systems today – but it was what Shackleton had used to cross 800 miles of ocean. This navigational piece of the past was pointing me towards Antarctica, urging me to persevere in the arduous task of planning the trip.

A few days later, as more research for my journey, I went to see *The Great White Silence* (1924), a documentary about the Terra Nova expedition of 1910–13. I waited in the queue to buy tickets, but when my turn came the cashier told me the film had sold out. Disappointed, I turned towards the exit, but as I did so a couple asked me why I wanted to see the film so badly. I told them about my trip and in response they kindly offered me their tickets as a donation to the project. I was very grateful, and for me, that was the point my adventure began. That cinema ticket was my ticket to Antarctica.

This project is proof that if you believe in something strongly, everything will fall into place like a perfect storm. It's a kind of magical coincidence that comes from never giving up and always being enthusiastic about your goals. There were times of happiness, and times of disappointment and disillusionment. But any negative moments were always just that, moments, and in some ways they helped to forge the project.

Antarctica is a place full of mystery. It's at the other end of the planet, and while geographical maps recognize it, it doesn't appear on many maps used in advertising. I was sending myself to a place of complete mystery, a place that is largely unknown and completely unique. Sitting in warm London offices explaining to people why Antarctica is so important sometimes made for difficult conversation. But those who bought into the idea did so with an infectious passion and positivity.

After a few more weeks of almost constant work, there came a point when I realized I had the money to undertake the trip. I would go in February, just as the window of opportunity was closing for another few months. For the first time, I was nervous. It was suddenly a reality, and that frightened me a little – not the fact that I could go to Antarctica, but the fact that I had reached the point of no return.

Despite my reservations, I never lost focus. Only once did I really worry about the trip, or, more specifically, a particular element of it. One night the reality of crossing the Drake Passage, the most dangerous ocean in the world, finally hit home. I would have to spend four days on board a boat as it battled waves the size of houses and wind that treated you in the same way as the softest breeze deals with dead leaves. I felt I needed to research this part of the trip, but the more I did, the more nervous I became. That night I didn't sleep at all, but the next day I was ready again, prepared to continue with the planning. I never mentioned my worries to Andrea Sisti and Edo Pinotti, two close friends from Italy who would be accompanying me. When they noticed that I looked tired, and asked if everything was all right, I simply blamed it on a long session in the gym.

The busy process of planning and organization inevitably meant that February came around fast. I managed to secure support from Nikon and Columbia Sportswear – perfect timing, since their equipment and expertise would prove invaluable. Before I knew it, I was in Ushuaia, on the southern tip of Argentina. From there, the next stop was Antarctica.

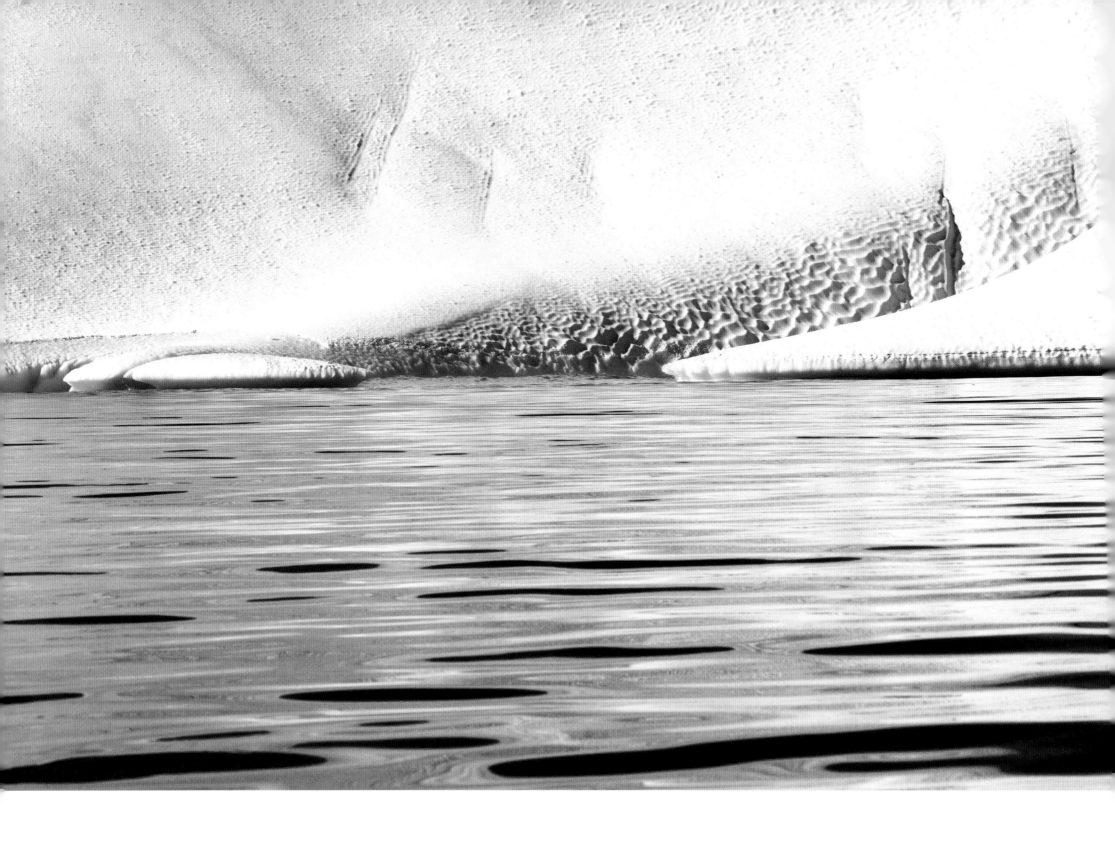

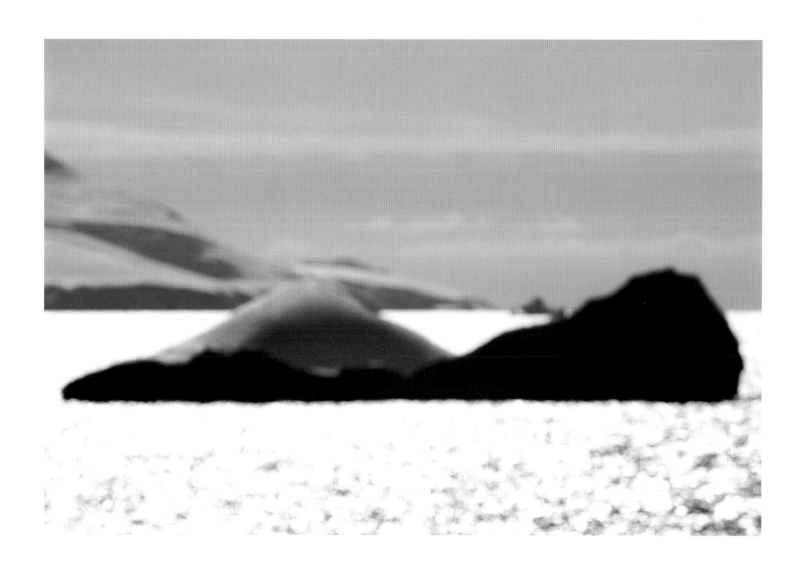

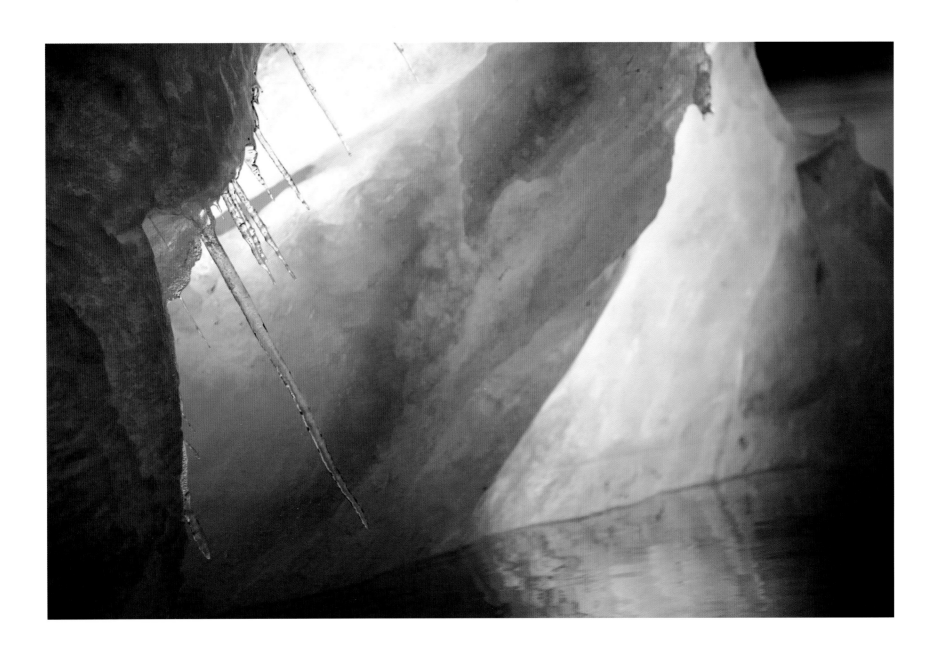

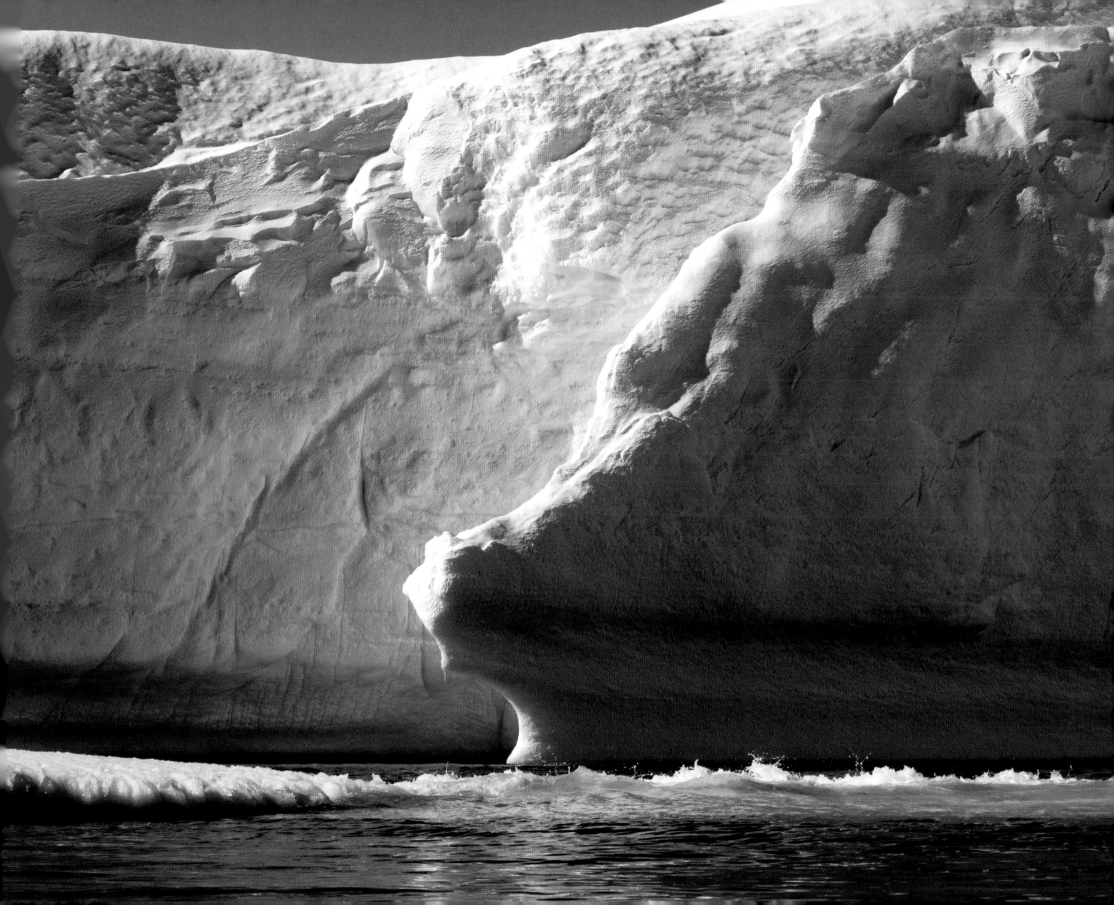

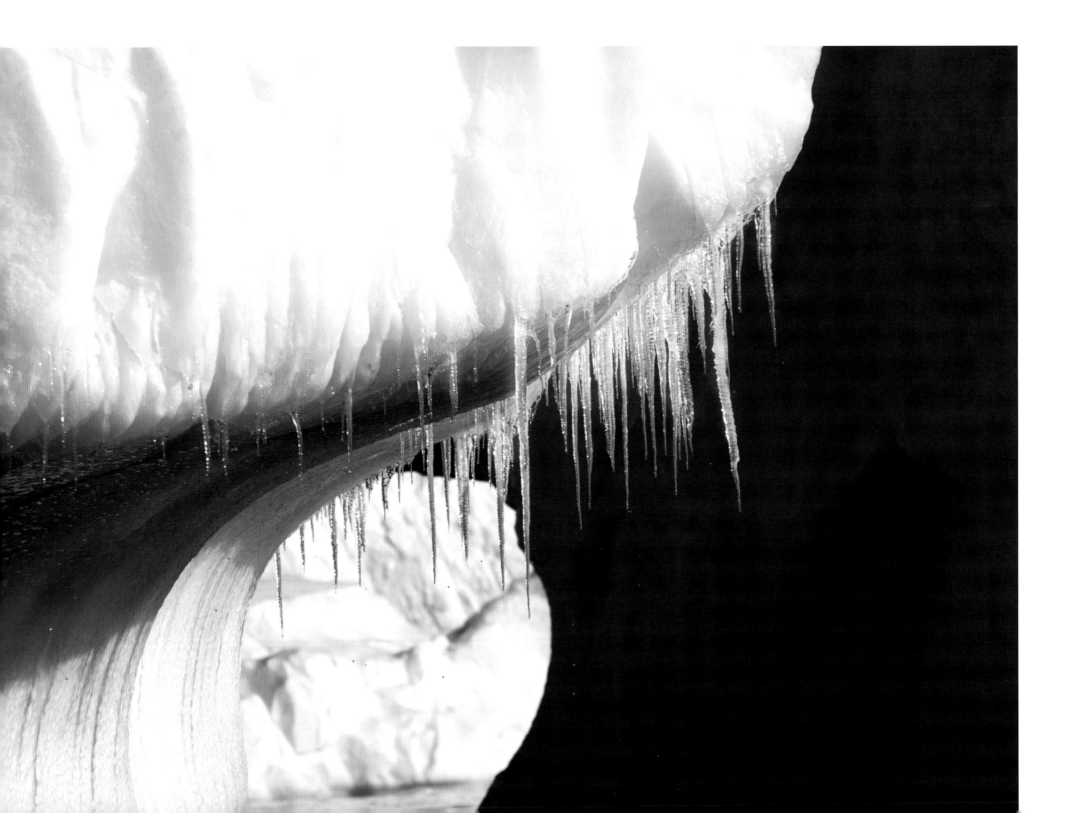

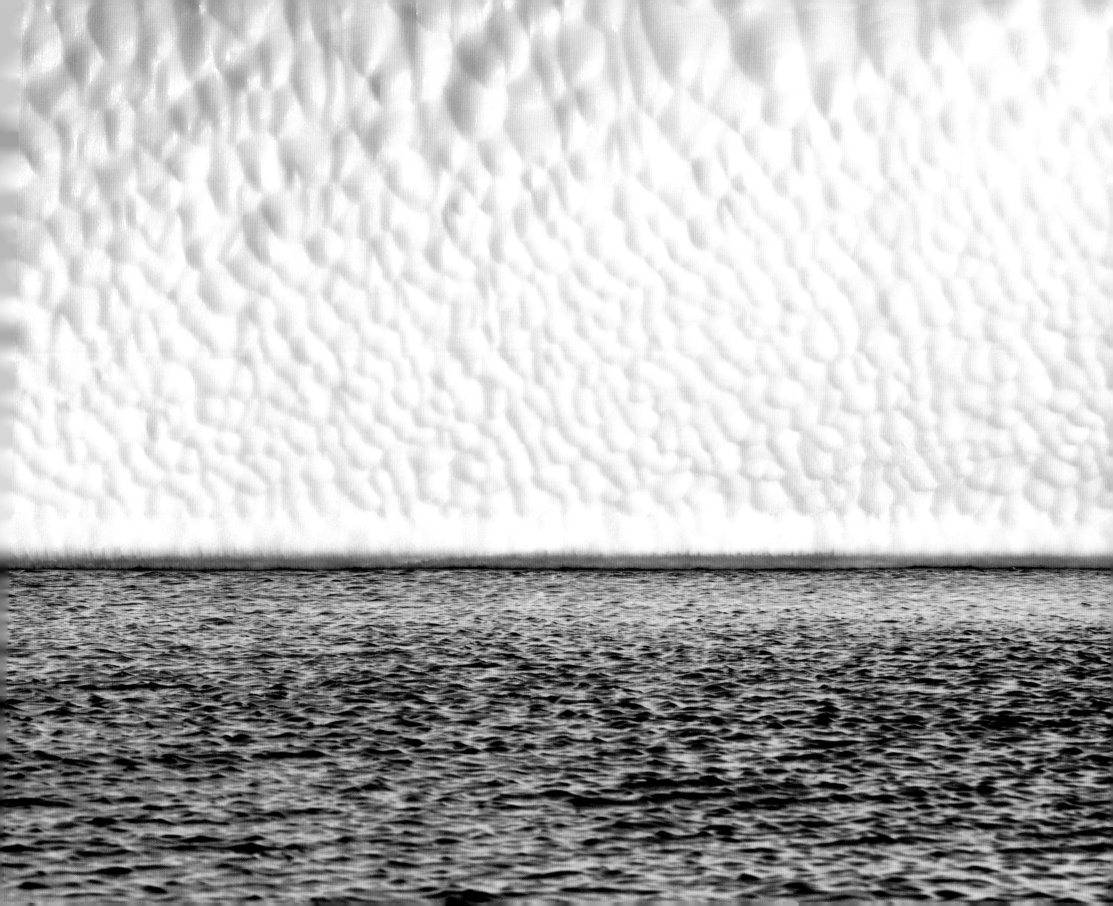

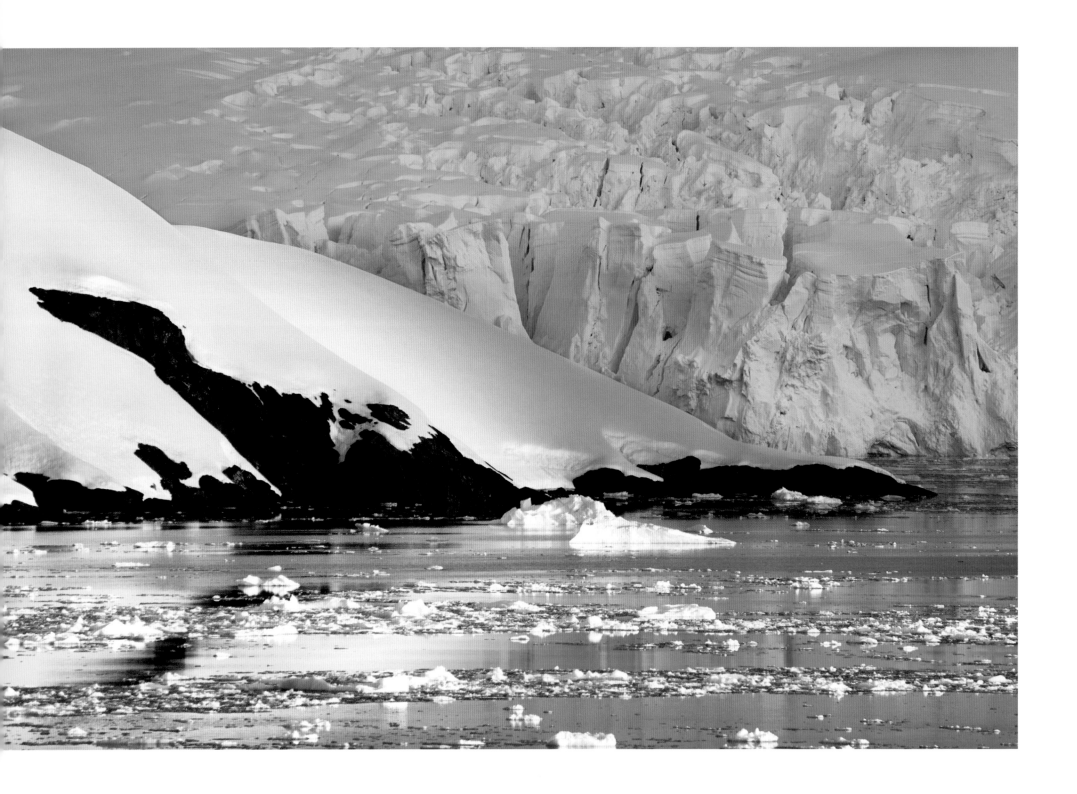

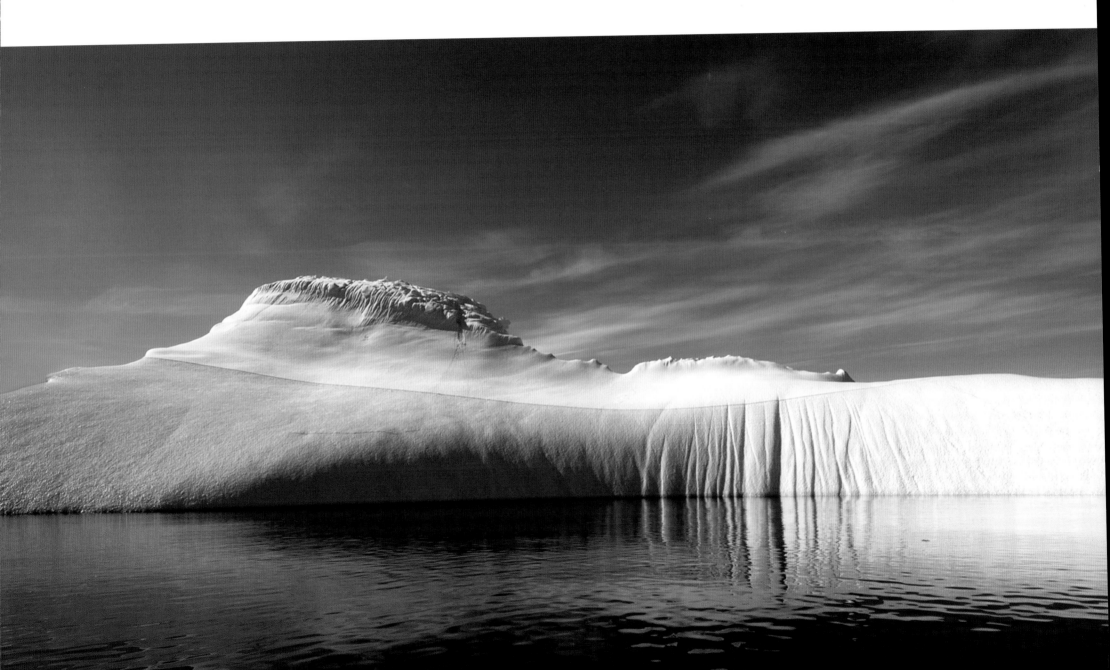

THE EMPIRE OF ICE

When I spotted this huge iceberg I decided to try to get closer to it. As I approached, its huge size and majesty became apparent. It immediately reminded me of René Magritte's set of paintings *The Empire of Lights*. Just as in the paintings, the ice was divided into two distinct parts: one part day; the other plunged into night.

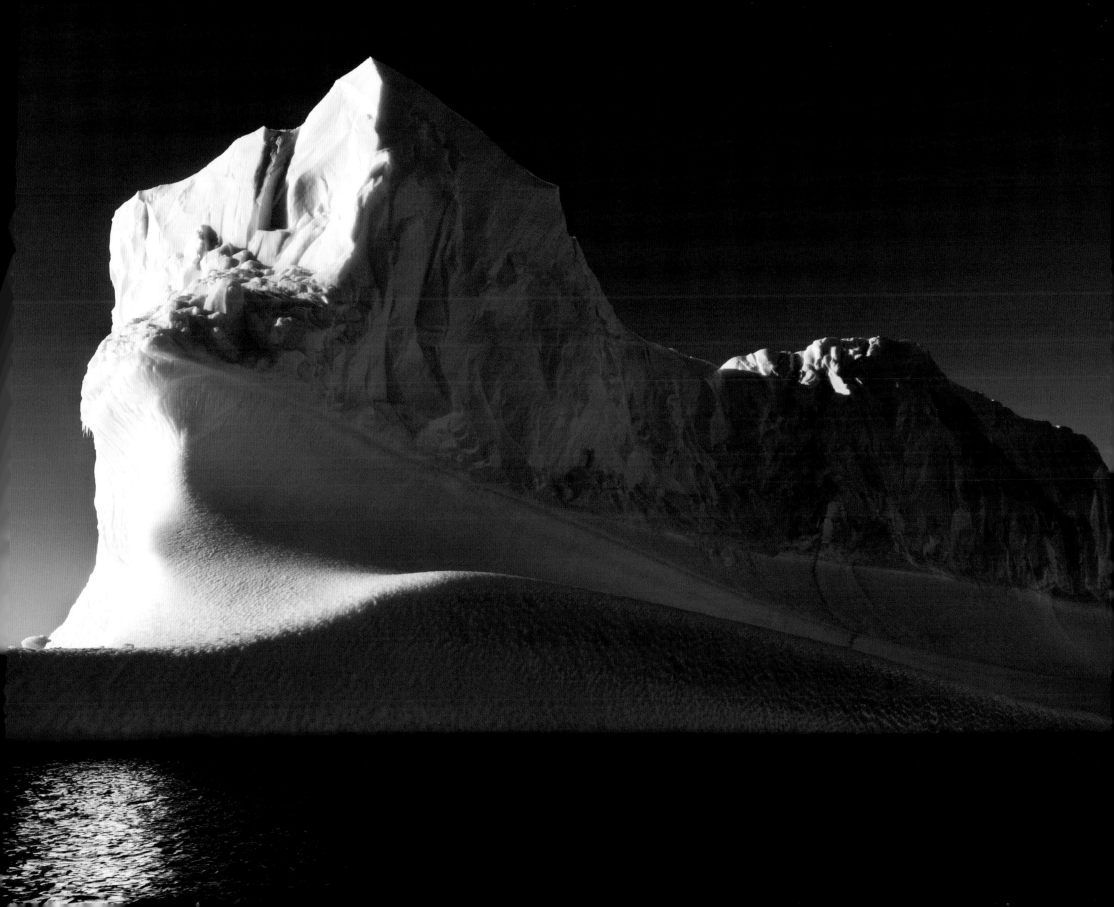

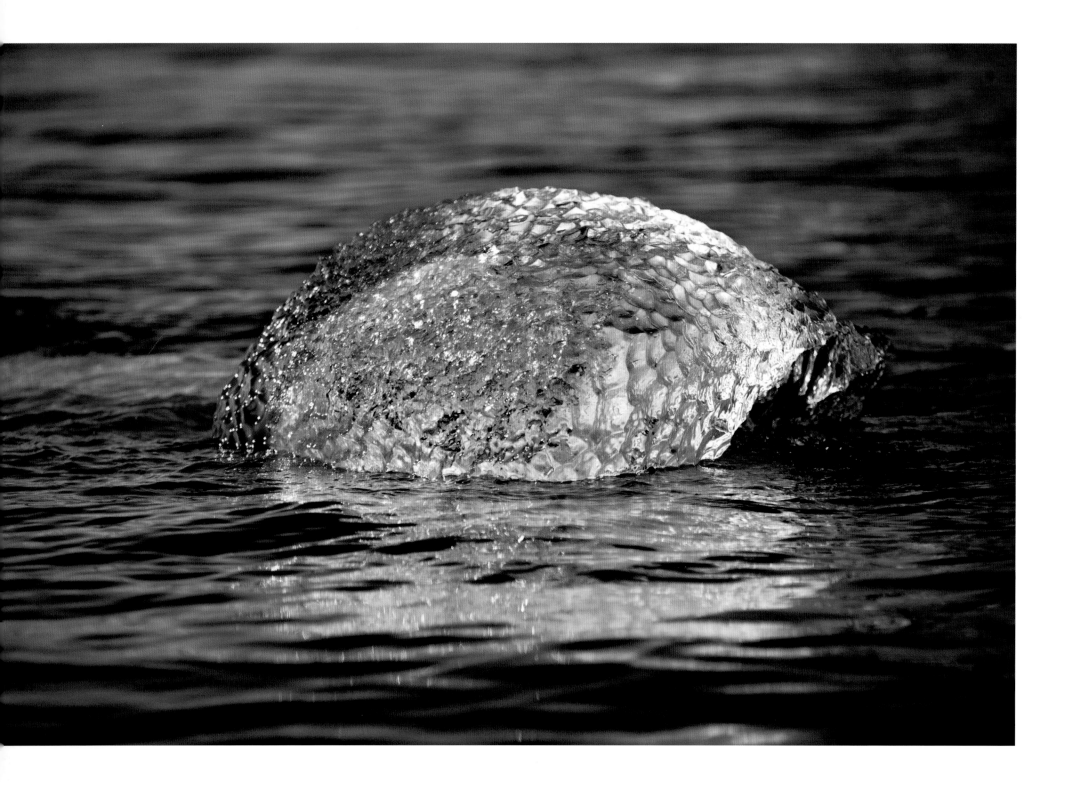

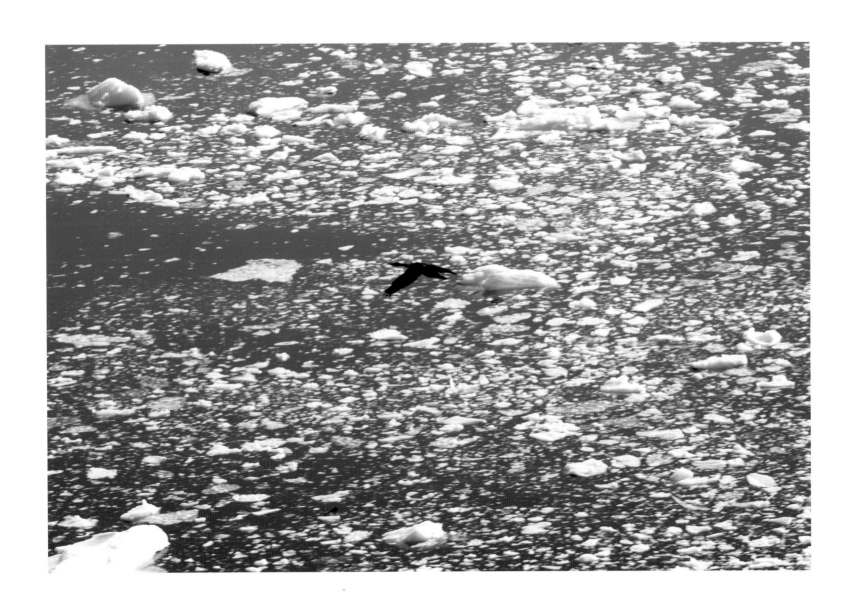

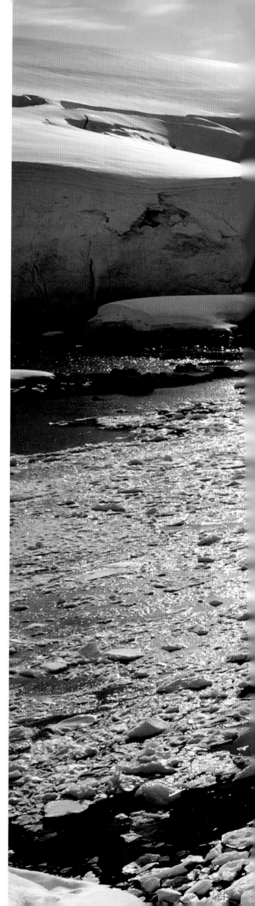

CRATER

We spent hours climbing an ice mountain, and at times I thought we were never going to reach the top. When we finally got there, a gate to another world seemed to open, as we looked down into a wide crater. Inside it was dark, mysterious water and blocks of ice of all sizes. The scene felt prehistoric, wild and impenetrable. We wanted to descend further into the crater, but the ice was very unstable. Yet again, we were at the mercy of nature, so we made the decision to leave the crater very carefully and return to sea level.

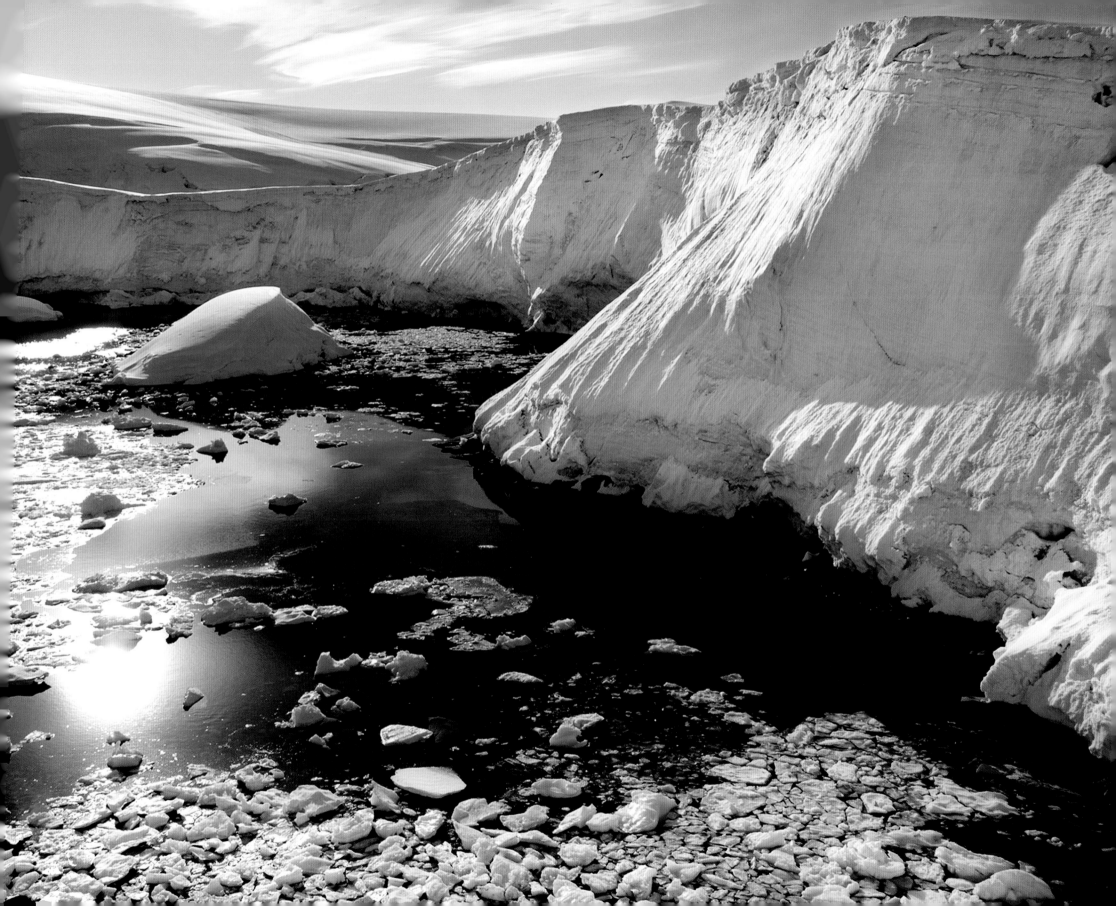

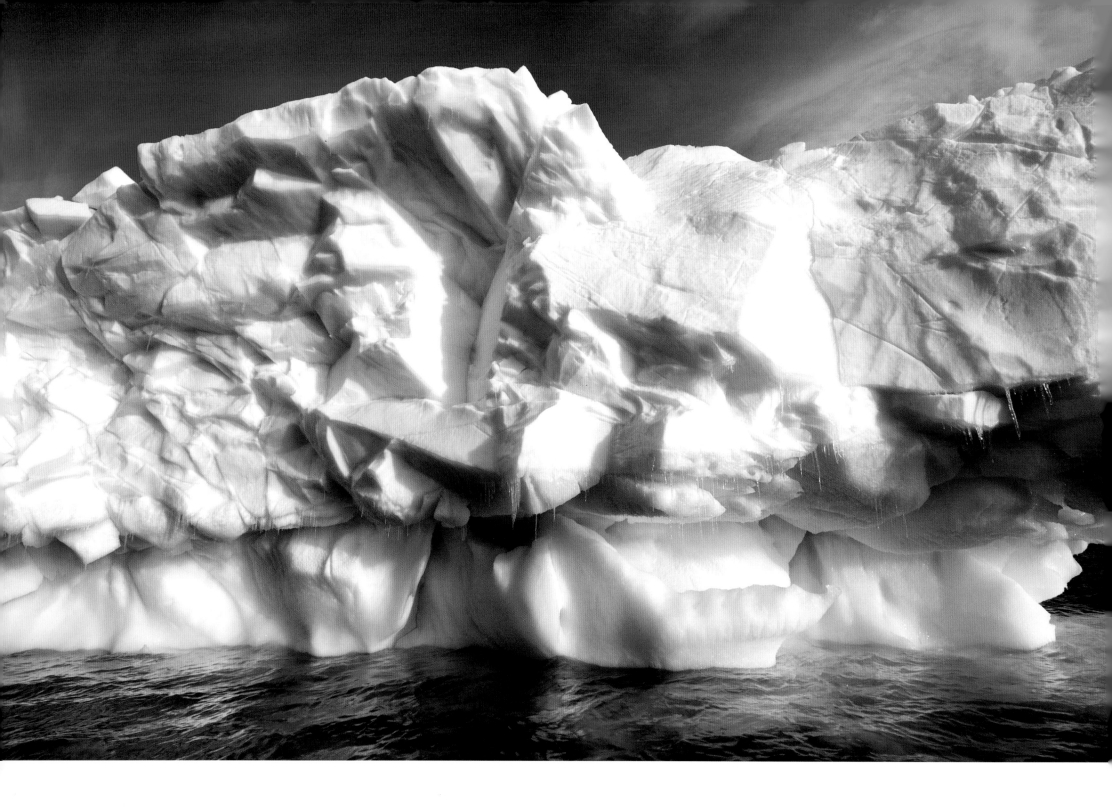

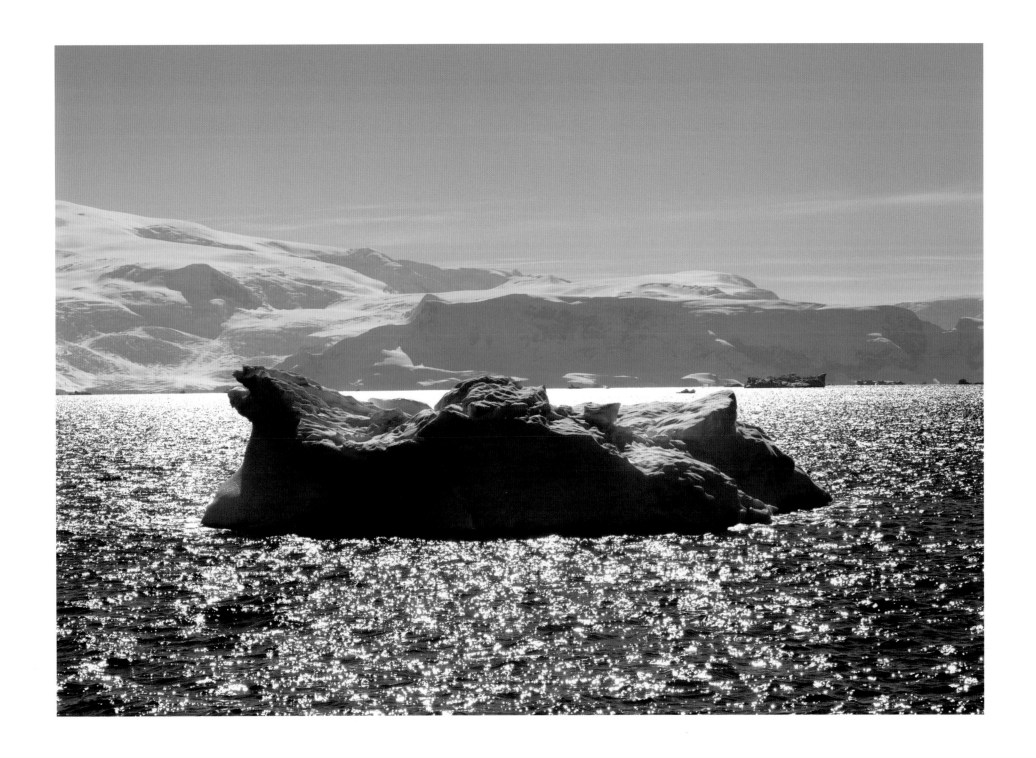

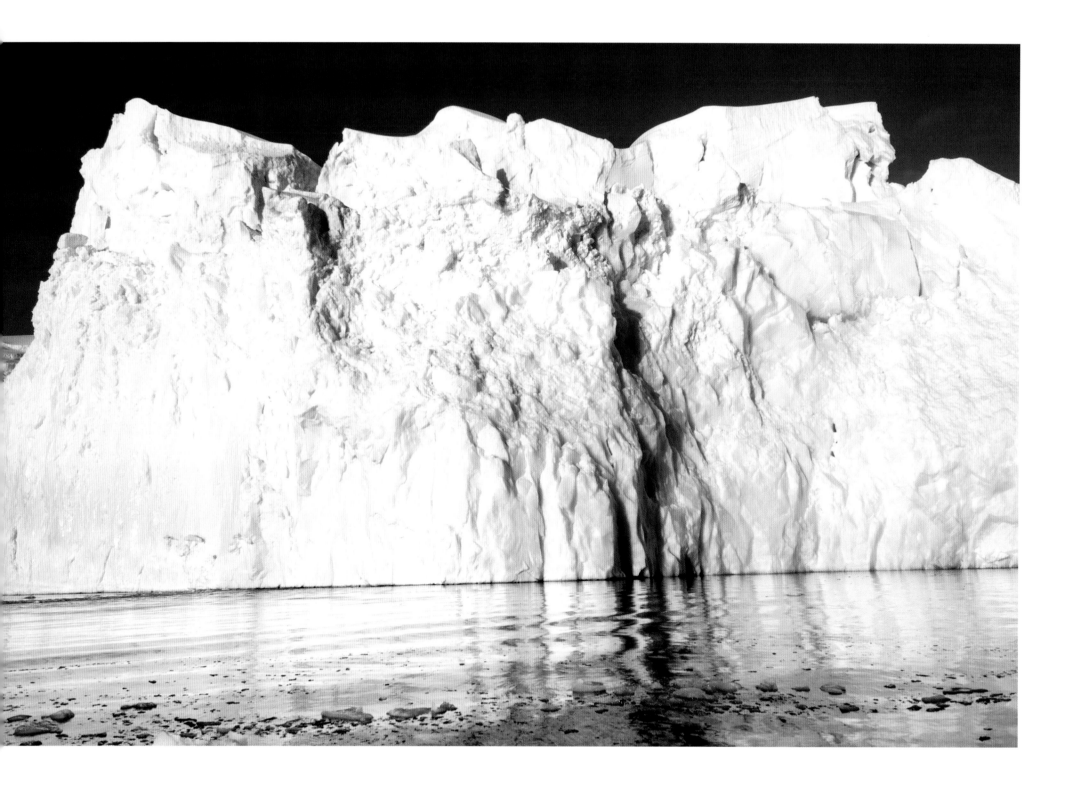

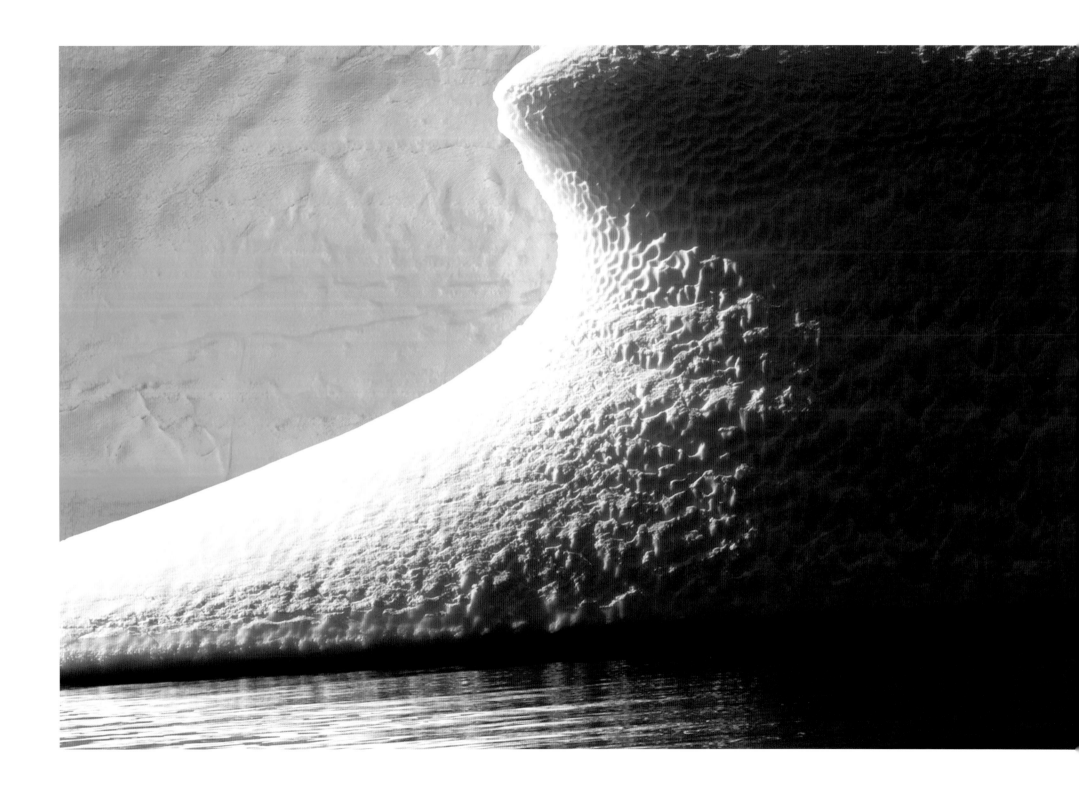

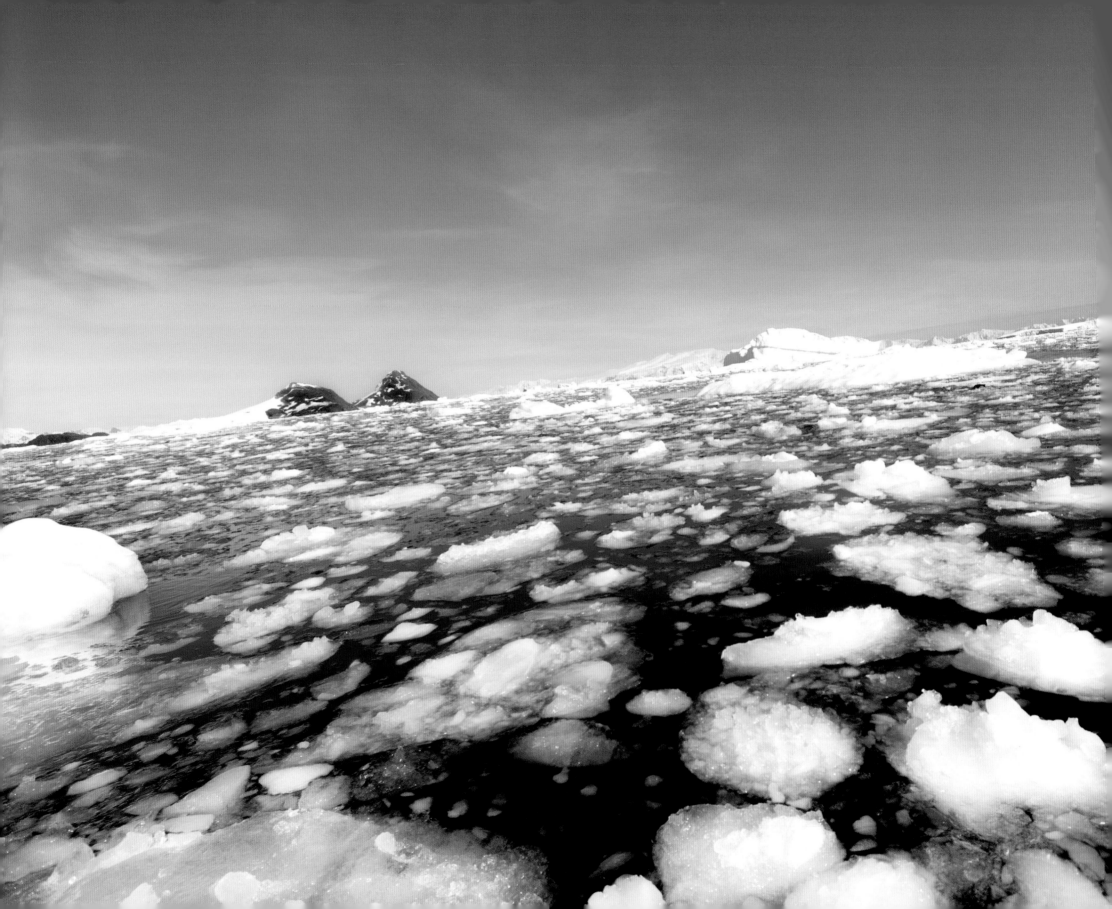

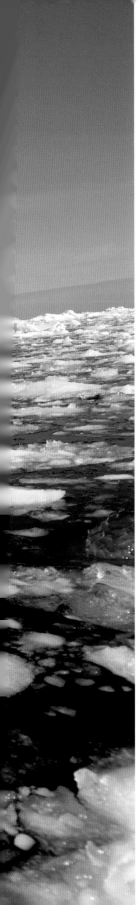

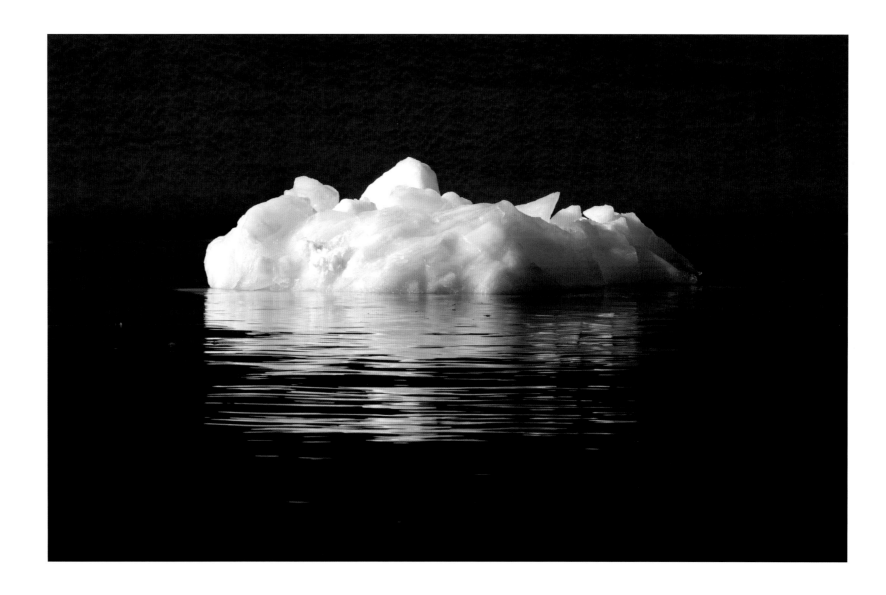

SMALL ICE

I noticed that small pieces of ice would often float around much larger icebergs, almost as though they sought the protection and guidance of the bigger ones. Inexorably sea currents, storms and the wind will divide these two pieces of ice. Eventually both will disappear, leaving no trace of their presence.

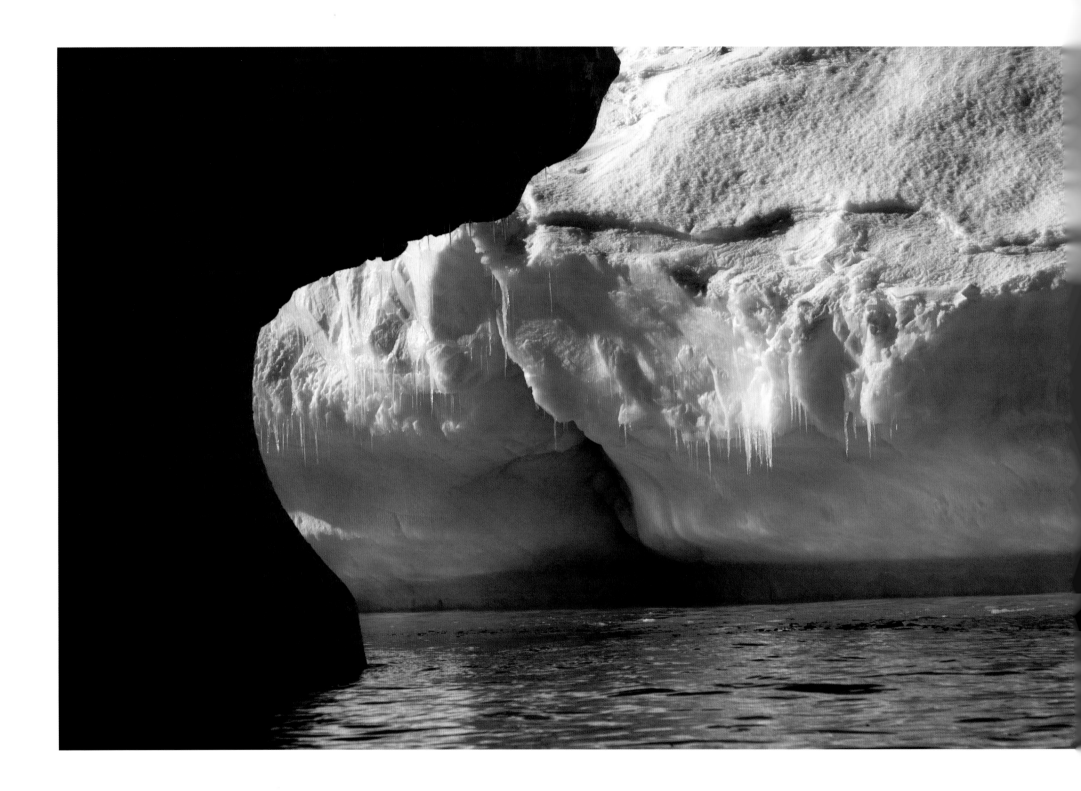

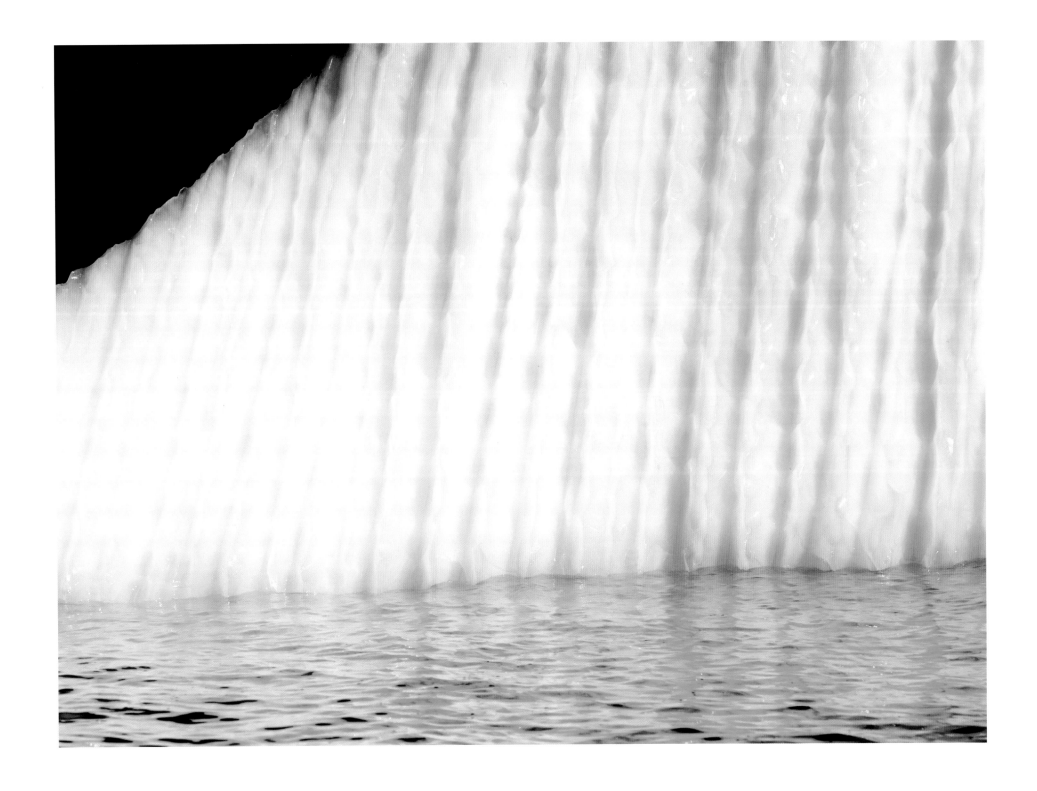

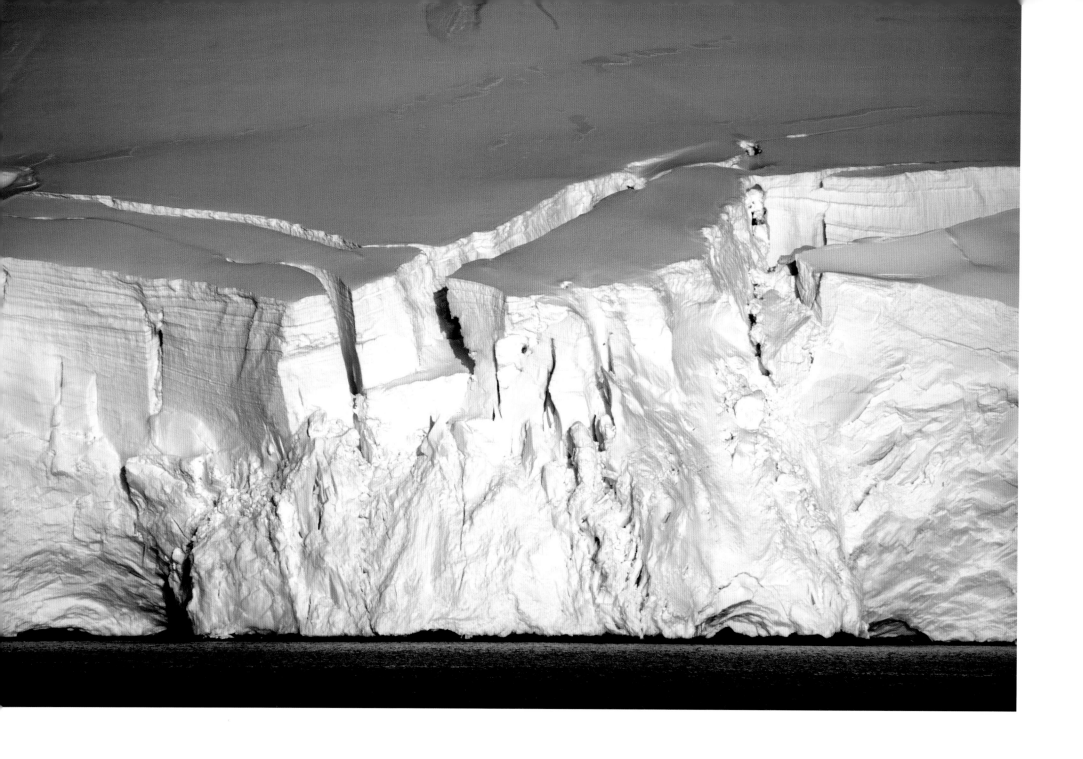

Now I know what it means to be truly scared.

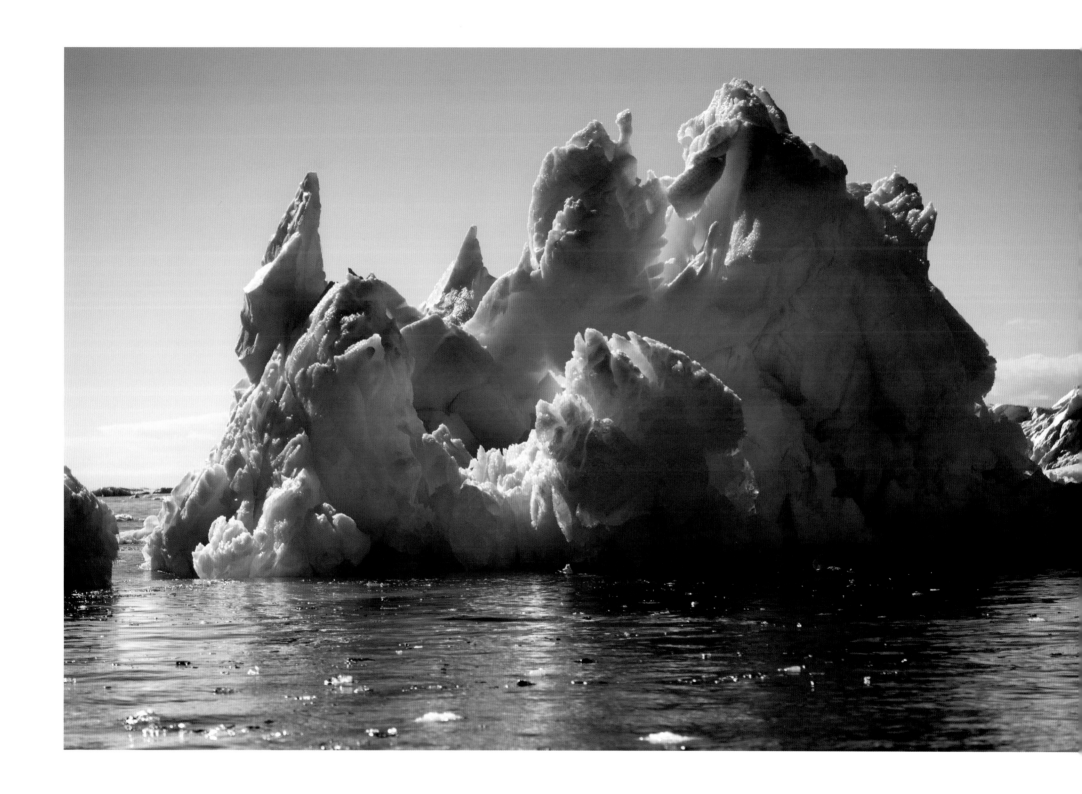

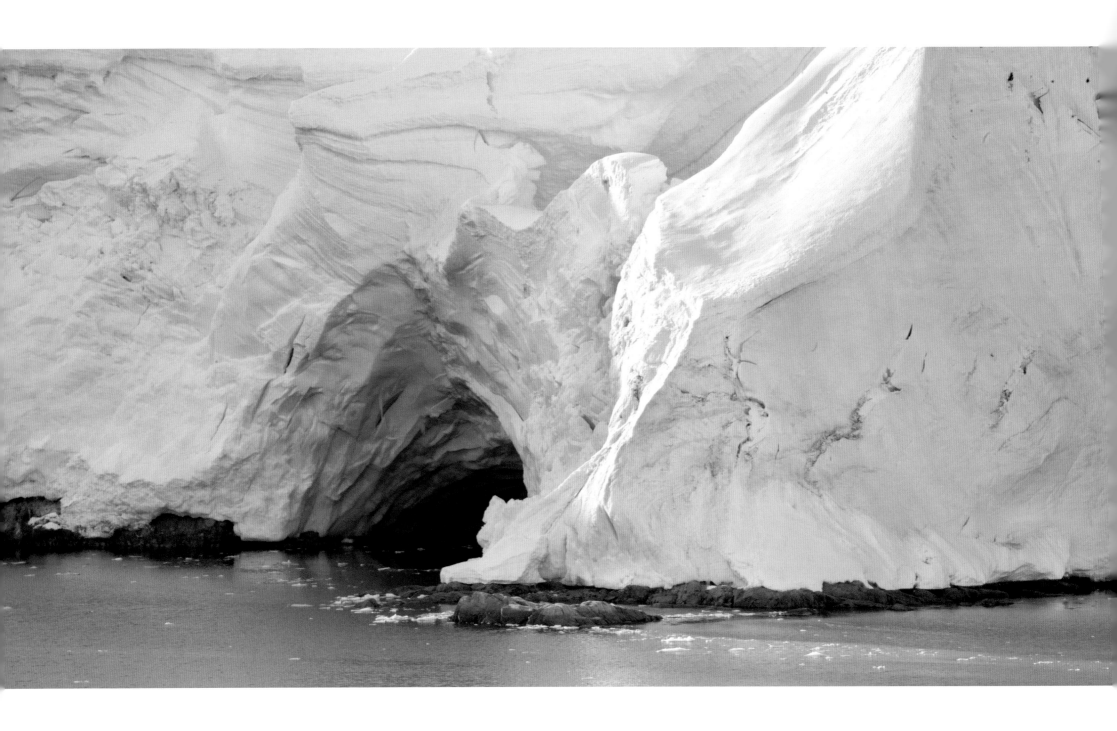

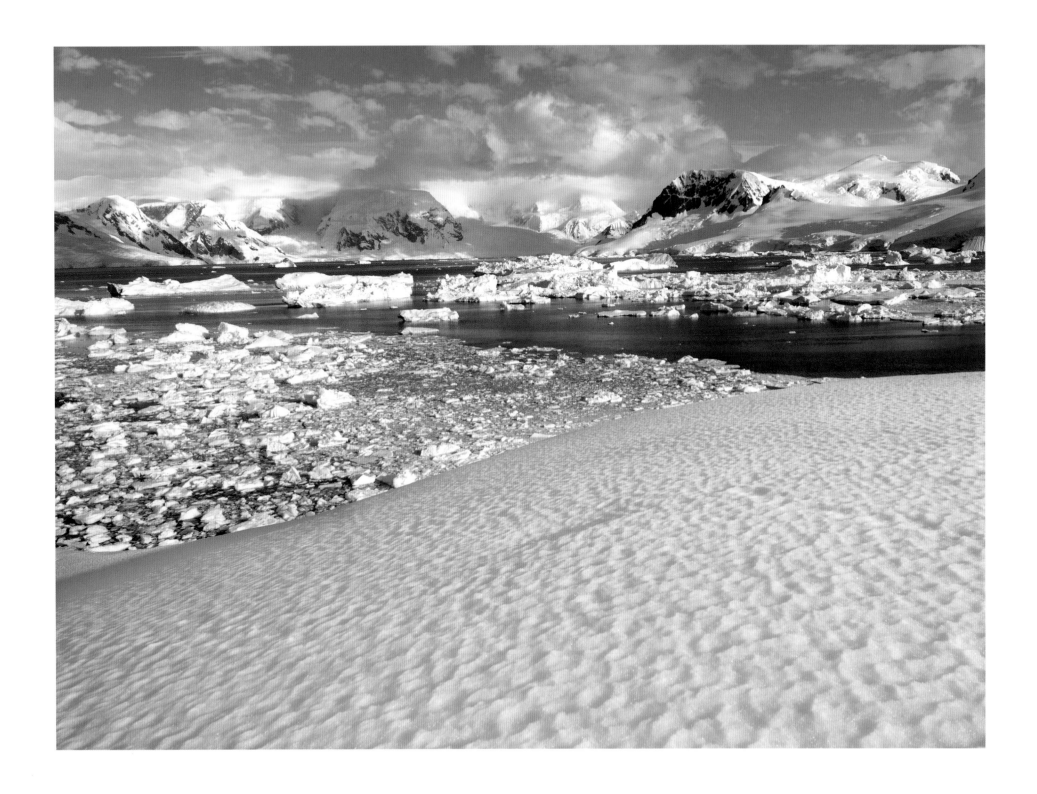

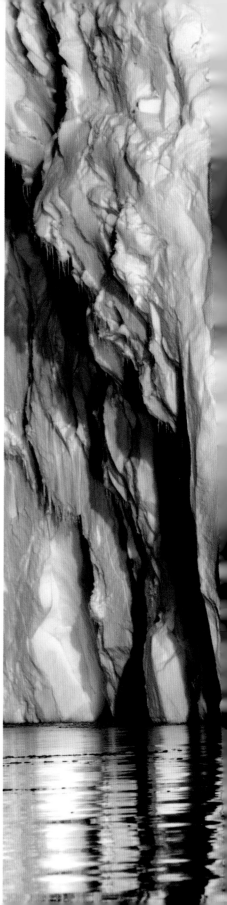

FALL OF ICE

In the small dinghy *Zodiac*, we made our way towards a huge piece of ice rising out of the water and stretching into the sky. We were just a couple of metres from this huge wall of ice, where water poured out from above into the sea below. Suddenly, all the albatrosses that had been out all day fishing seemed to disappear. As I took a number of frames on my camera, I began to feel a strong sensation of deep fear, and found myself more uncomfortable than I have ever been before. When I asked, with a worried voice, if we could move away from the ice wall, my team did not understand. They said I should keep shooting, because the light was perfect. But something inside me said we needed to leave, so the *Zodiac* was turned around and we headed away from the wall. Moments later there came a piercing cracking sound from behind. We looked over our shoulders to see a massive piece of ice falling from the wall and into the sea where we had been just seconds before.

Afterwards, I was left with a unique feeling of adrenaline, fear and exhilaration. The experience could have ended very differently. What I remember most vividly is the unique noise of the ice.

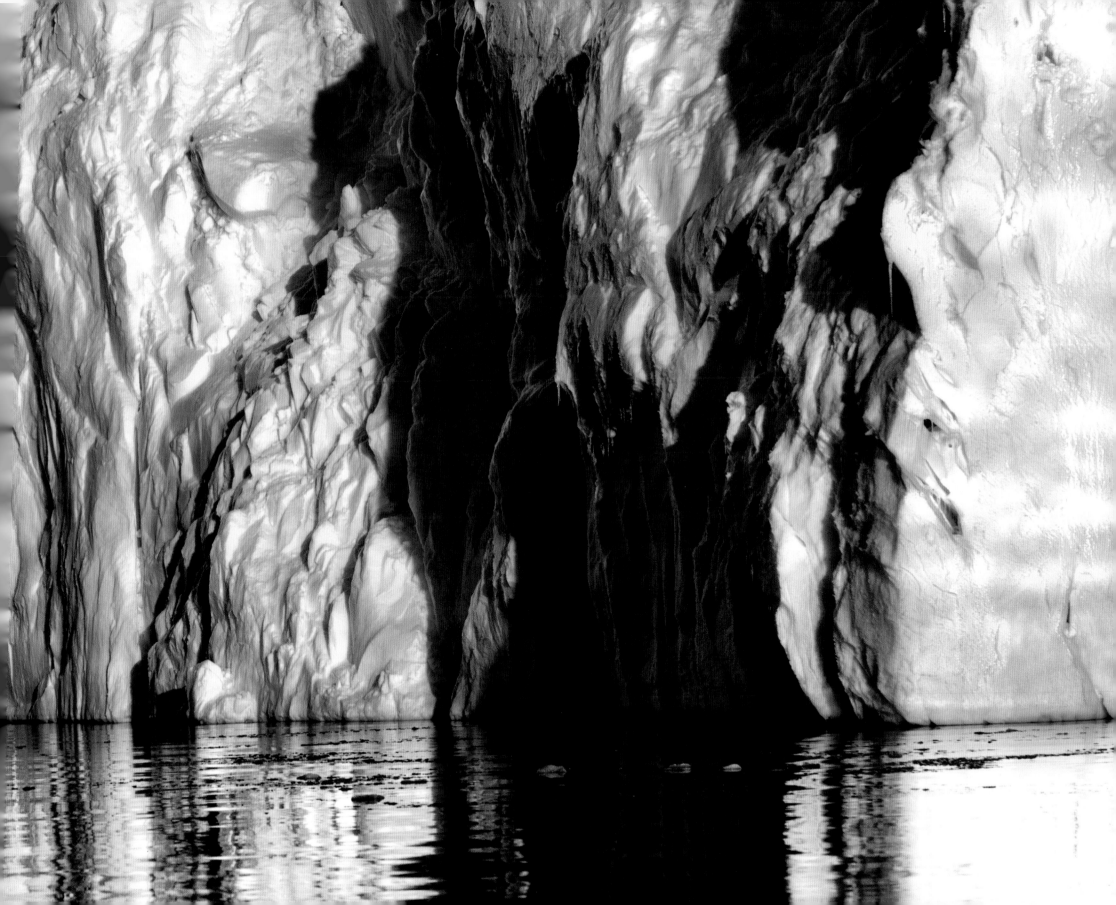

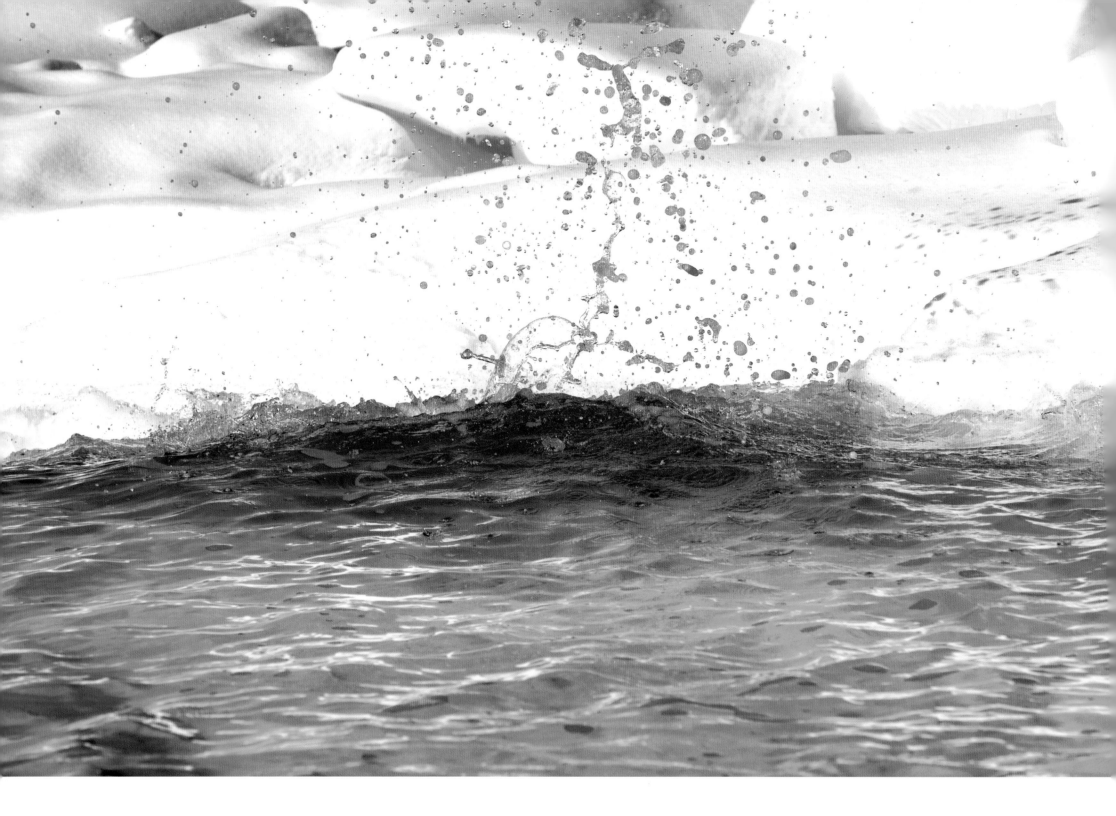

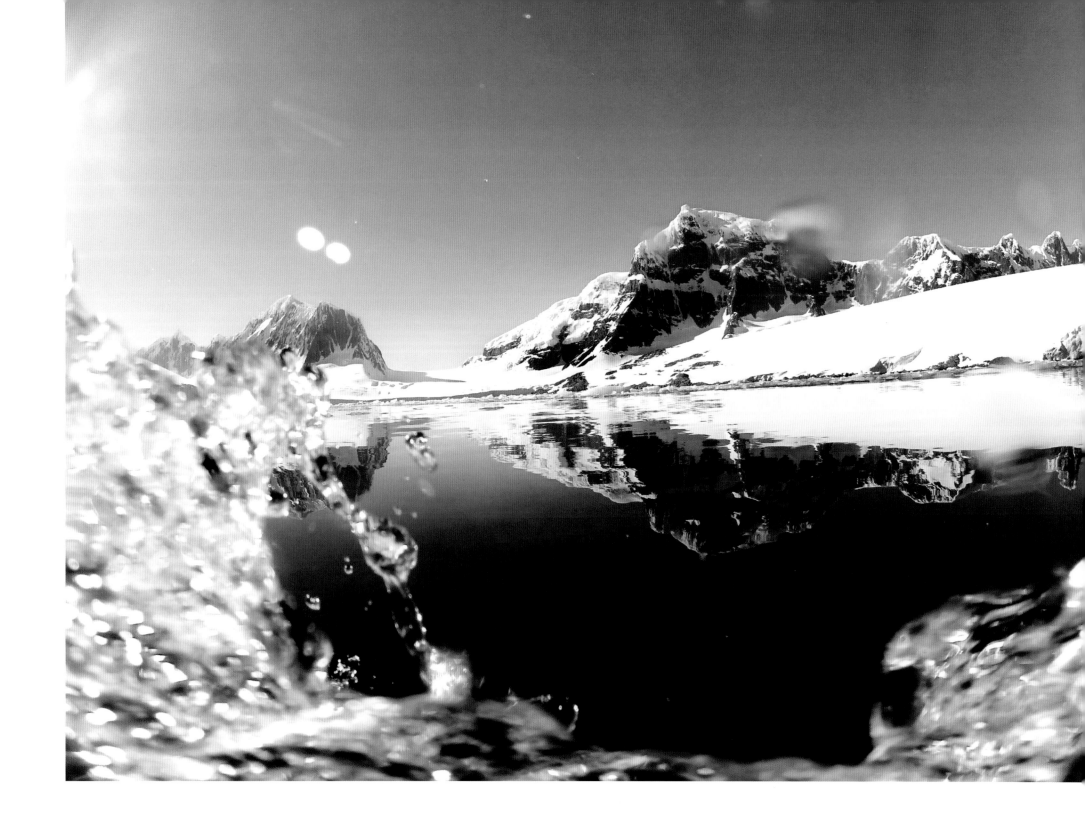

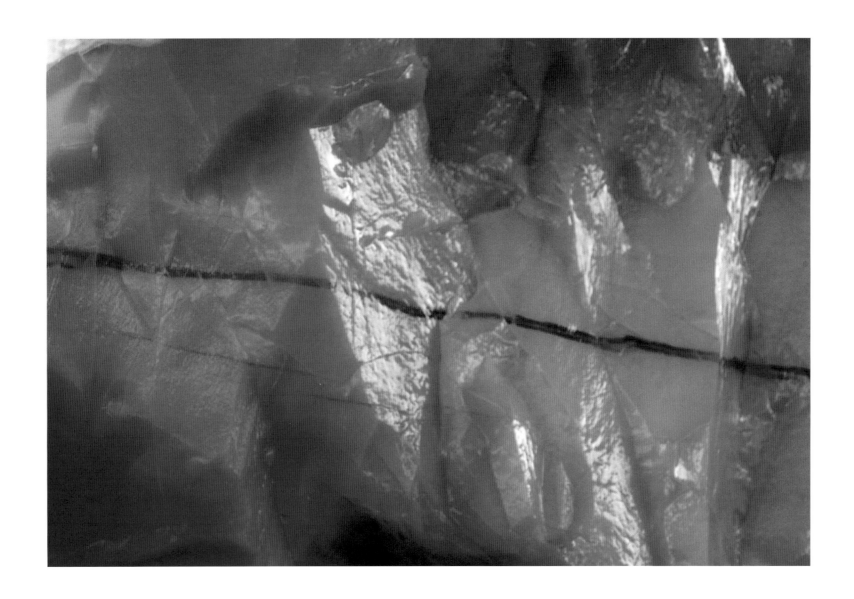

I saw the blue region, something so frightening, magical and powerful that it will stay with me for ever.

The ice is not cold, but full of warmth and energy.

EXPEDITION

If you are a leader, a fellow that other fellows look to, you've got to keep going.
Optimism is true moral courage.
I have often marvelled at the thin line which separates success from failure.

Ernest Shackleton

I met Andrea and Edo in Ushuaia. They would be my assistants on the trip, as well as keeping everyone's spirits high. Even as I waited in the hotel the night before they arrived, I was not sure whether they would actually show up. I was asking a lot of them. Such was my focus that I had insisted on bringing all the equipment out to Argentina myself, so that, if they had a last-minute change of heart and didn't turn up, I would still be able to go by myself.

But the following morning they strolled into the hotel reception full of enthusiasm and, no doubt, a little anxiety. Seeing them lifted my spirits, and as we boarded the boat, I was confident the trip would be a success.

As we started our crossing of the Drake Passage, with nothing but open water around us, we talked a lot. That time was very useful: it made everyone ready for the first day of shooting in Antarctica. It did not take long for the Passage to live up to its reputation as a fearsome stretch of water. The storm that assailed us was huge, and I have never seen anything like it before in my life. It felt as though we were inside a washing machine as the boat rolled, rose and fell, waves crashing over the deck.

But this was my first glimpse of Antarctica and, full of enthusiasm, I ventured outside to take pictures. It was a naive decision that I both regret and am glad about. The deck was a treacherous place, with water spraying from all angles and chunks of ice sliding around the slippery metal floor. As I took a picture, a wave hurled the boat to one side, and I fell. My first reaction, as I tumbled towards the unforgiving metal deck, was to protect my camera – imagine if I broke it taking the very first photographs of the trip? I clutched it with both hands, leaving my knee to take the full force of my fall. The camera was safe, but I might have put the trip in jeopardy before it had properly begun.

Immediately I covered my leg with ice, and thankfully it was badly bruised rather than anything more serious. But as I sat there, my leg surrounded by ice, I felt as though that was Antarctica's warning to me. The ice packed around my leg was preparing me for what was to come, telling me to pay more attention and to control my enthusiasm. In this part of the world, a foolish mistake could be costly.

The sea there is like no other. It felt as though we were riding on the back of a lion, as the huge rolling waves moved and crashed with great power. Crossing the Drake Passage, I witnessed the shape of energy, beautiful to see as a tangible, visual element. If the ocean had wanted to, it could have consumed us effortlessly. The only thing to do was to hope it would be merciful and to trust in myself, my captain and the boat.

After one long storm I looked out and saw a dark shape on the horizon ahead. It seemed we had made good time and arrived in Antarctica ahead of schedule. But I was wrong. The captain told me the ominous distant shapes were not mountains, but another storm coming. 'Thanks for being so honest,' I replied.

As the storm hit, we cowered inside, while an albatross played in the wind, skimming the deadly waves with the tip of its wing. It had total control, and an elegance that was difficult to fathom. This bird, which followed our boat for hours at a time, was the king of the Drake Passage.

Night was another big challenge for the captain of the ship. Antarctica never sleeps, and in the darkness we felt as though something was looking at us all the time, some strange and fascinating presence. As we travelled south, we started to see more and more icebergs – beautiful and deadly at the same time. At night, the ship's radar can mistake icebergs for waves, so an ice pilot would shine a powerful light ahead to identify the eerie white shapes as they moved towards the ship.

One night I went on lookout with the ice pilot, in driving rain. It was bitterly cold, and in the wind, for the first time, I found it difficult to breathe. This unconscious action, which anywhere else we take for granted, was proving a challenge. In Antarctica you must learn to breathe in order to survive. I had brought my camera out with me and immediately started taking pictures, but the conditions meant that the lens didn't work properly and I struggled to focus, but I continued to take photographs.

The closer we got to our destination, the colder it became. Then, two hours before we arrived in Antarctica, the sea became unusually calm. We crossed an invisible line and almost instantly the colour of the sea changed and the temperature dropped drastically. The ocean began to look as though it was swollen from inside its depths. From this point onwards, the weather would change very quickly, the sea would lurch violently and the wind would pummel everything it hit. Once again, I couldn't breathe. I felt consumed by nature, entirely at her mercy. She was effortlessly bigger than us and all we could do was try to cope with what she threw at us, whenever she chose. It's a strange sensation, to feel so small, in a landscape that is so prehistoric.

In the early hours of one morning, as we made our way between the clouds and the fog, we arrived in Antarctica. We were truly there, and my first thought was just how far from home I was. The sea was calm and the sun had not begun to exert its influence over the landscape, but as I took my camera and started taking pictures, I found the lens was frozen. I realized that I had to look at Antarctica not as a continent, but as a creature that changes constantly. It was up to me to change with it and adapt to survive.

In Antarctica, I learned that my senses should be ready to accept and deal with any aspect of what was happening around me, otherwise I risked missing an extraordinary show. It is a show that might last just a few seconds, a show that does not necessarily need an audience but which undoubtedly requires respect.

The control Antarctica had over us became apparent just days after we arrived there. We might have a plan for the day, but ultimately if the weather and the surroundings were not right, we had to change our arrangements. It was nature – not work, watches, meetings or trains – that dictated how we lived. The native creatures were also at the mercy of their surroundings: there was a time to eat, a time to hunt, a time to rest, a time to play. I found it amazing to watch leopard seals, the top predators in this part of the world. They would hunt penguins ferociously when they could, but when it was time to rest, predator and prey did so together, as the rules of this wild society temporarily changed. For that time, the penguins were unafraid to be close to an animal that could, and in another instant would, eat them.

As I observed Antarctica during those first few days, it soon dawned on me what a great responsibility we have to nature. She never judges people or animals; there is never any compromise on her part. Here nature is before you, presented without confines.

The changing scenery, weather and mood of Antarctica distinguished each set of my pictures from day to day. My biggest worry was my memory cards. I was so frightened at the thought of losing them or damaging the invaluable information on them that I went to great lengths to protect them from the elements. They were the diamond penguin egg that I cradled for the entire trip. I joked when one of my team fell over near a big crevasse – 'Is the equipment all right?' – before asking if he himself was okay.

To walk on glaciers, each one thousands of years old, was to feel as though we had gone back in time to discover the secrets of our planet. The mountains in Antarctica are huge, but the gruelling, energy-sapping climb to the top of each one was worth it. Every time we reached the top of a mountain a gate to another world would open, revealing a landscape totally different to what we saw behind us. From the top of one we looked down and saw Antarctic ducks sweeping into the frozen valley we had just left. Then we looked up to see satellites orbiting in the clear blue sky above us. Here we were, between twenty-first-century technology and untouched nature at its wildest.

The sense of being far away from anyone and anything familiar is hard to escape. But sometimes I felt comforted by the way Antarctica was in control of everything. In some ways, she was guiding us as we explored, determining what we could and couldn't see. Antarctica would alternate between wonder, when she would display the beautiful side of her character, and magic or even sorcery, when the danger of all that was around us became apparent.

The best example of the dangerous side of Antarctica's character came one day when we were in the *Zodiac*, our small dinghy. We made our way close to where a huge glacier, several hundred metres high, met the ocean. I sat in the bow of the boat, and the rest of the team was spaced around the sides for balance. Looking up at the ice towering above us, it was hard not to be in awe – it was like the grandest, most dominating tower block I had ever seen, rising vertically out of the sea. Water merged into ice, ice melted into water.

Perched at the tip of the boat, I began to take pictures, all the time balancing to keep myself steady. But after a few minutes I felt too close, too deep in the shadow of the glacier. I was uncomfortable in front of such a huge thing, and the feeling soon shifted to the most intense fear I have ever encountered, a fear that grew by the second. The rest of the team did not understand when I told them that we must get away immediately. The Earth went quiet for a moment, as an albatross flew above us in the clear sky.

Sensing my panic, the *Zodiac* was promptly turned and we made our way from the glacier, just as we began to hear the noise of ice cracking, as the glacier began to shift. When ice breaks, it first groans, then snaps, as the air is pierced by the sound of the release of pressure. No sooner had we left the base of the glacier than we heard that noise. Continuing to move away, we turned back to see a section of ice the size of a huge building come away from the glacier, smashing into the water where we had been moments earlier. We weren't out of danger even then: the force of the splash sent waves racing out, each one carrying huge ice boulders like double-decker buses hurtling towards us. Gripped with fear, we slalomed through the ice to calmer waters.

In the moments that followed, we all felt the same contrast of emotions course through our bodies. The adrenaline brought with it white-hot fear, the common acknowledgement that we had been metres away from death. But the moment was also undoubtedly euphoric. Every heartbeat made the feeling stronger, to the point that by the time we had reached complete safety we were all laughing hysterically.

I've experienced a lot of extreme sports in my life, so I thought I knew how danger felt, but nothing comes close to the buzz I got from this experience. I kept thinking about how far away from help we were, how completely at the mercy of Antarctica we were. If she had wanted to kill us, it would have been effortless. We would have sunk into the sea in an instant.

After that incident, I always thought twice about exploring big caves and glaciers. Antarctica had taught me another lesson that I would never forget. I like to think we were spared because we respected the nature around us. Despite being surrounded by it, I never touched the ice with my fingers. I always remembered that I was simply the observer.

In Antarctica, the perfect shot disappears into mediocrity in a moment. Animals slip silently in and out of vision. The constant metronome is the weather, which brings with it changing light, vicious winds and new skies. All the time I was using every sense to try not to miss those great shots, the images I had set out to capture. But those same senses were also needed to keep us safe, since cracking ice, moving water and incoming weather systems all brought danger with them.

It's impossible now for me not to feel closer to Antarctica, even though I never touched the ice. I appreciate her, not just for her beauty and power, but also for the important role she plays in the balance of the rest of the planet. This is such a primordial part of the world that it feels as though all things start there.

I could have stayed longer in Antarctica, and leaving was an emotional experience. On the last day we walked close to a caldera, with its warm black sand, a stark contrast to the white snow that had been under our feet for most of the trip. I would have liked to have seen the snow just one more time, but putting this niggling regret to one side, I continued to take photographs, my eye glued to the viewfinder. I didn't see the weather turn, but it happened in an instant, as it so often did. A huge snowstorm approached, forcing us to race back to the boat. It was the last time I set foot on Antarctica, and I feel as though I didn't properly get to say goodbye.

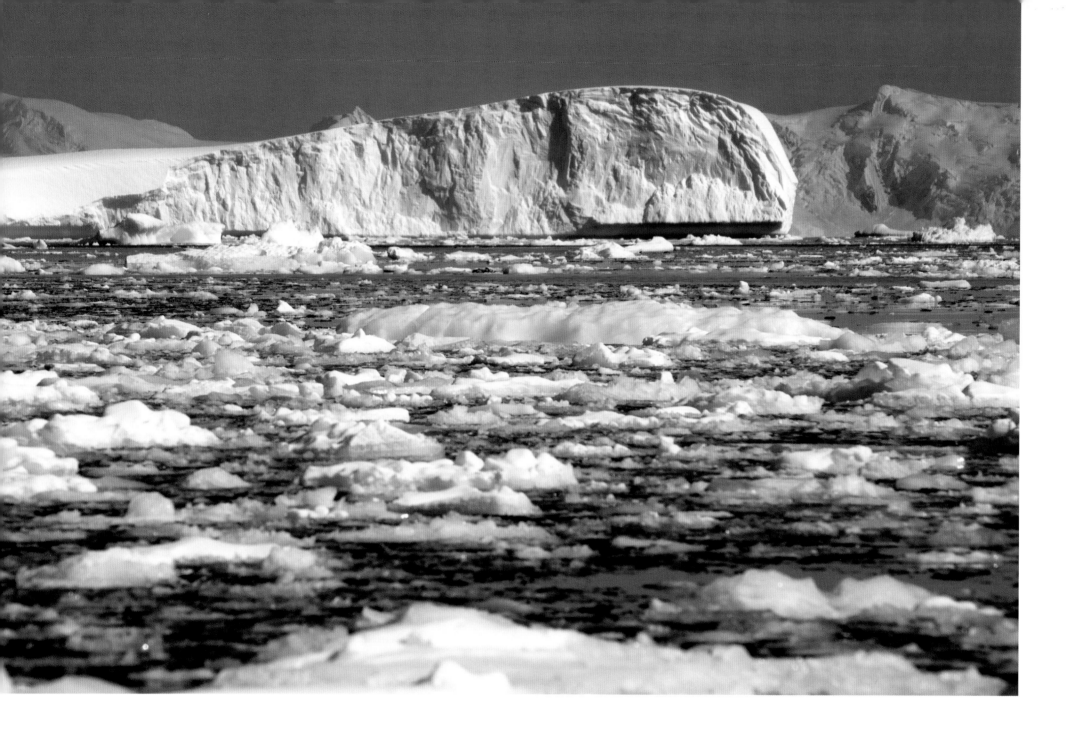

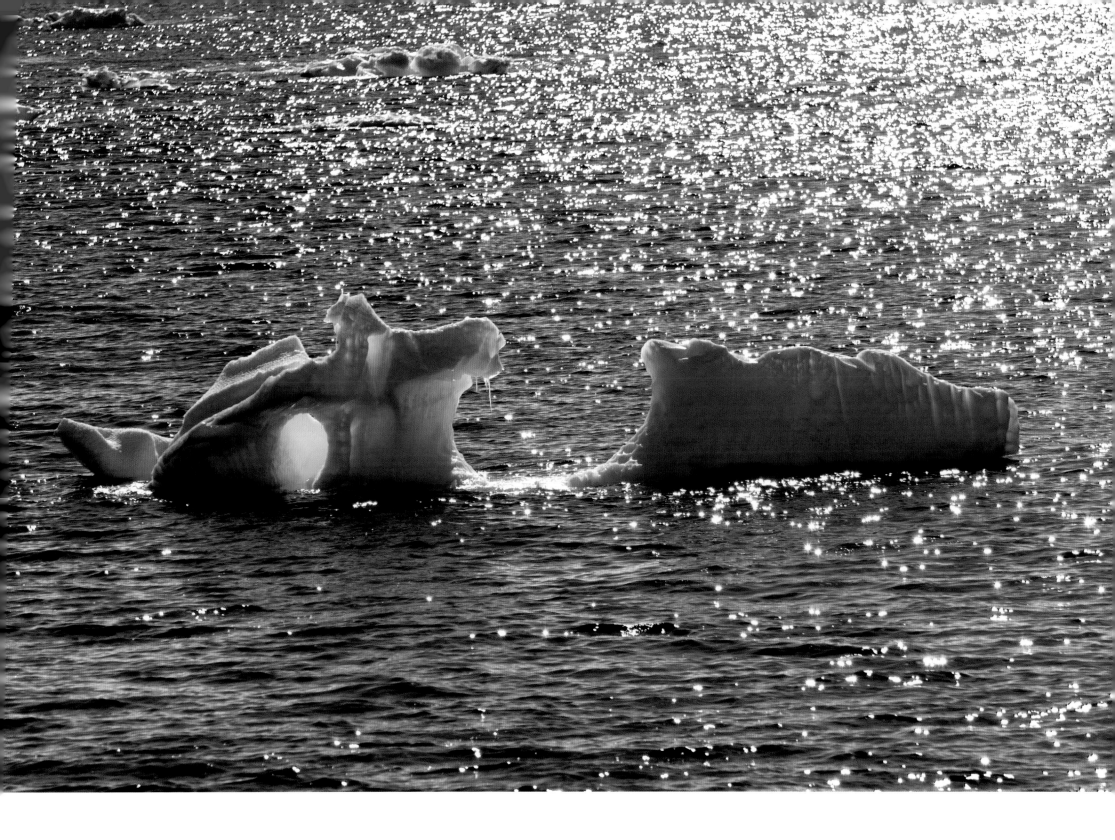

I discovered how to breathe to survive.

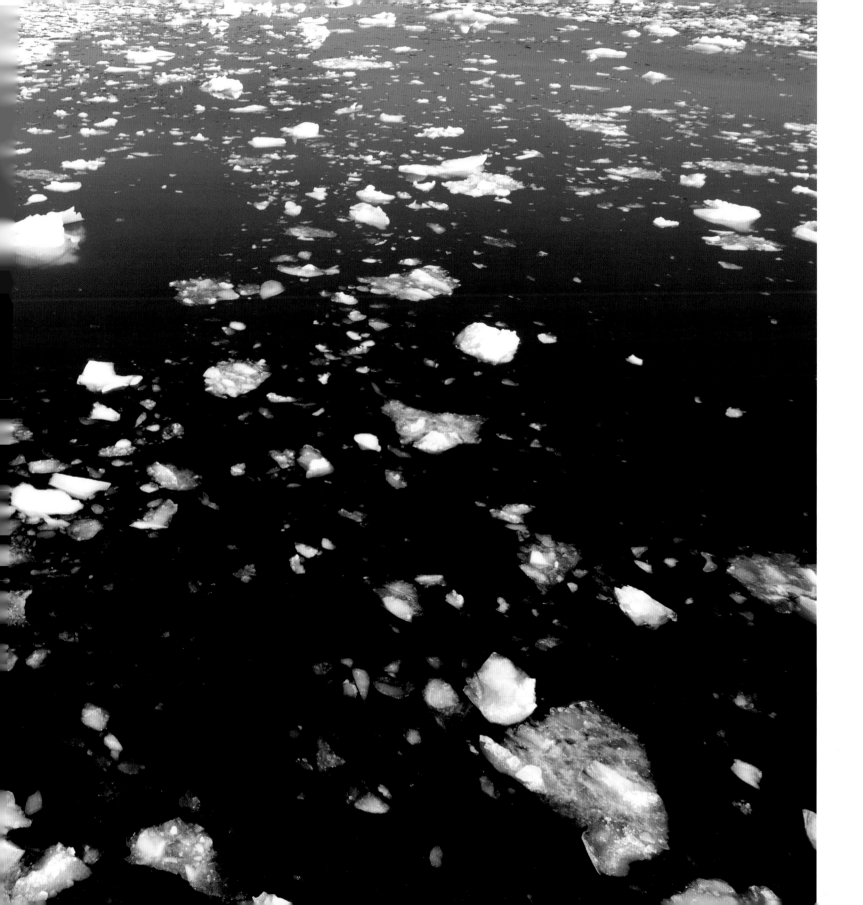

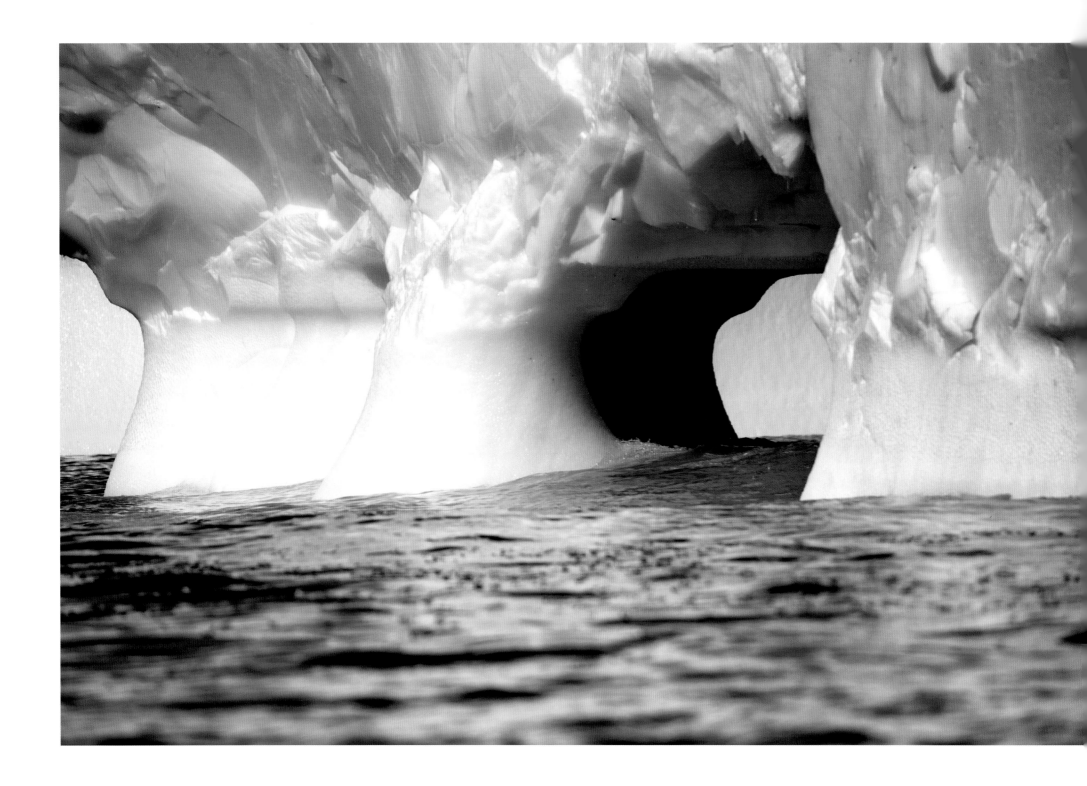

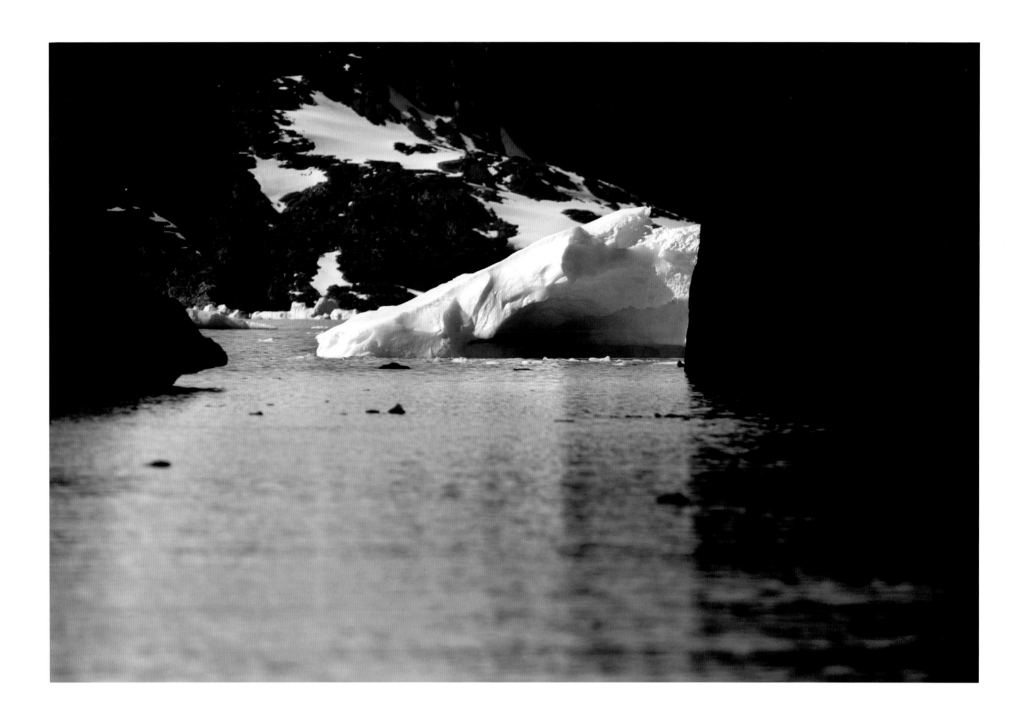

I was witness to the journey of the ice – one of constant surprise and change.

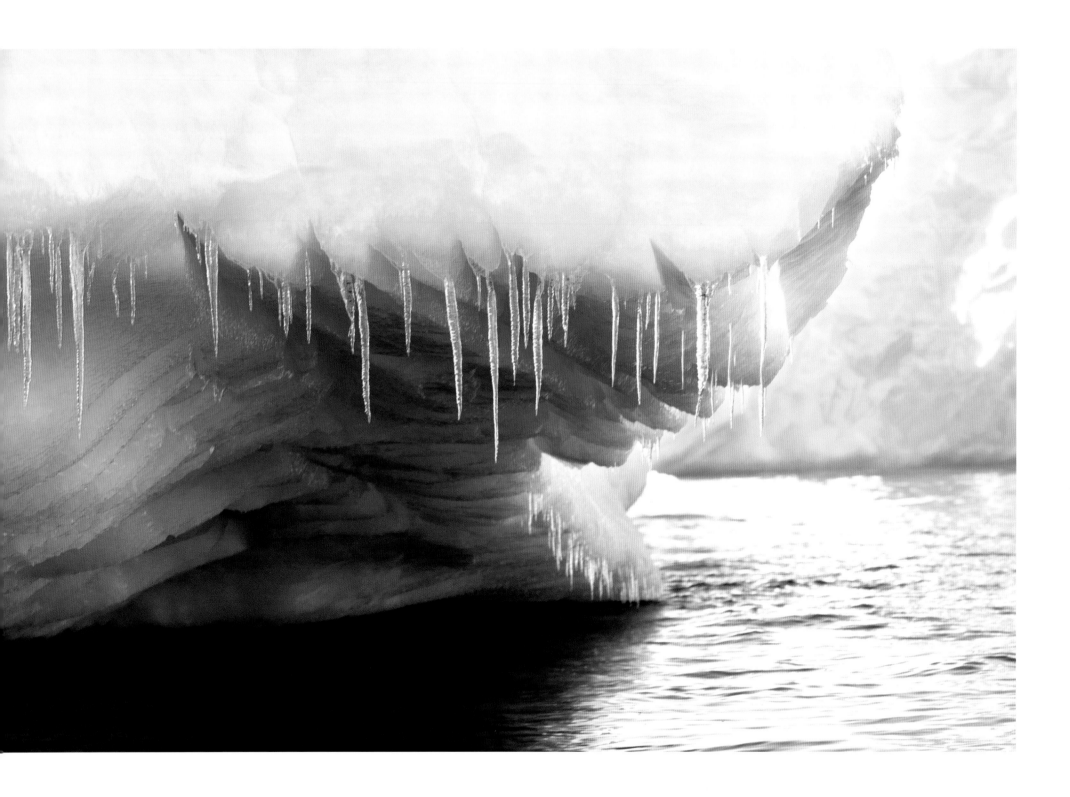

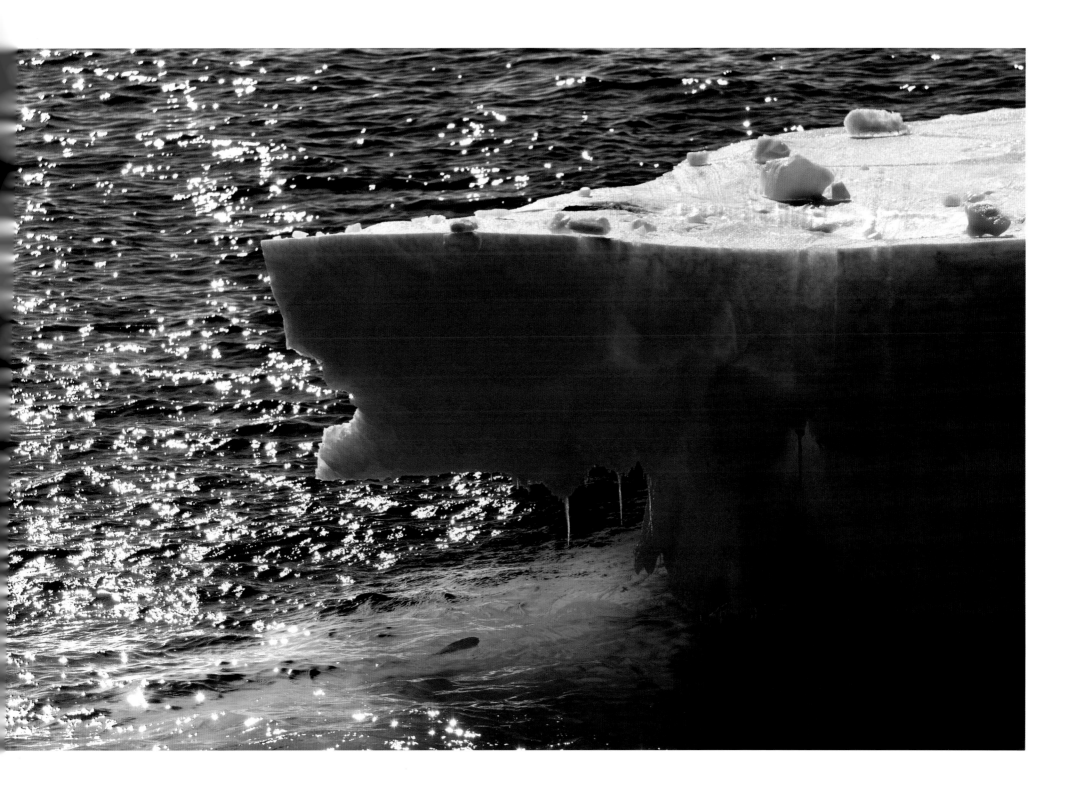

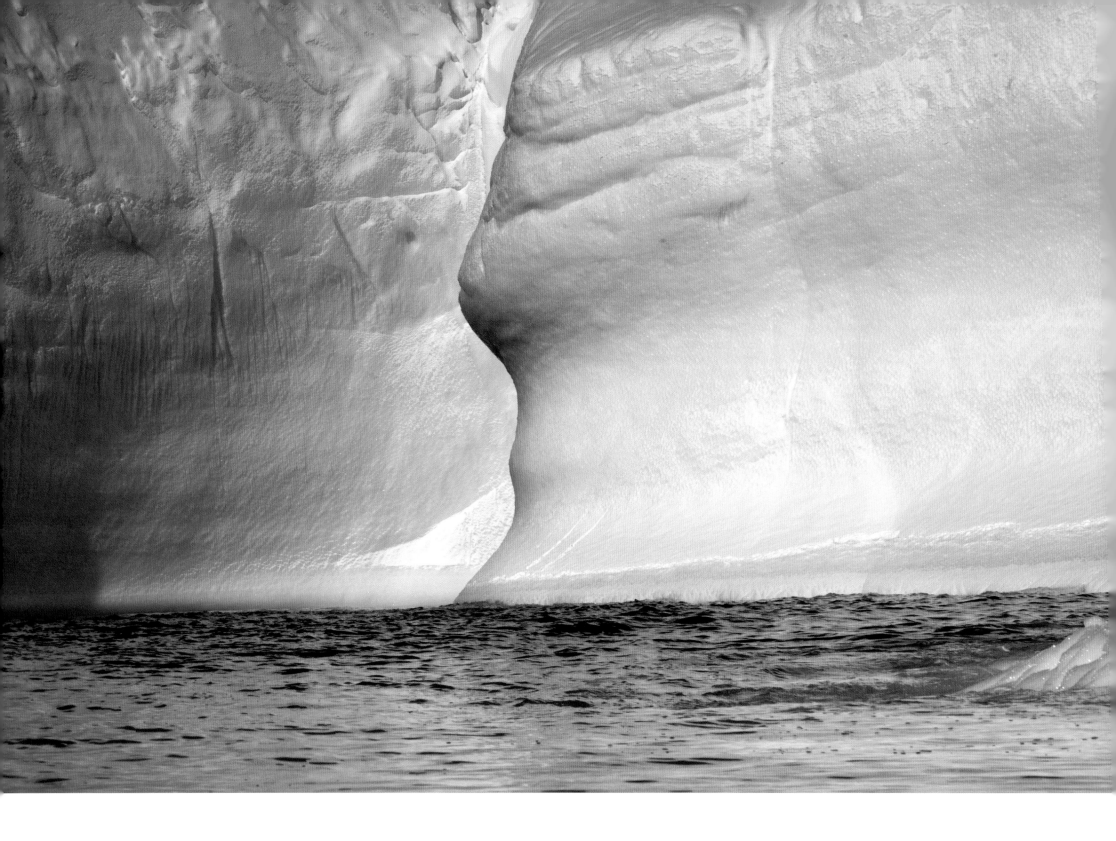

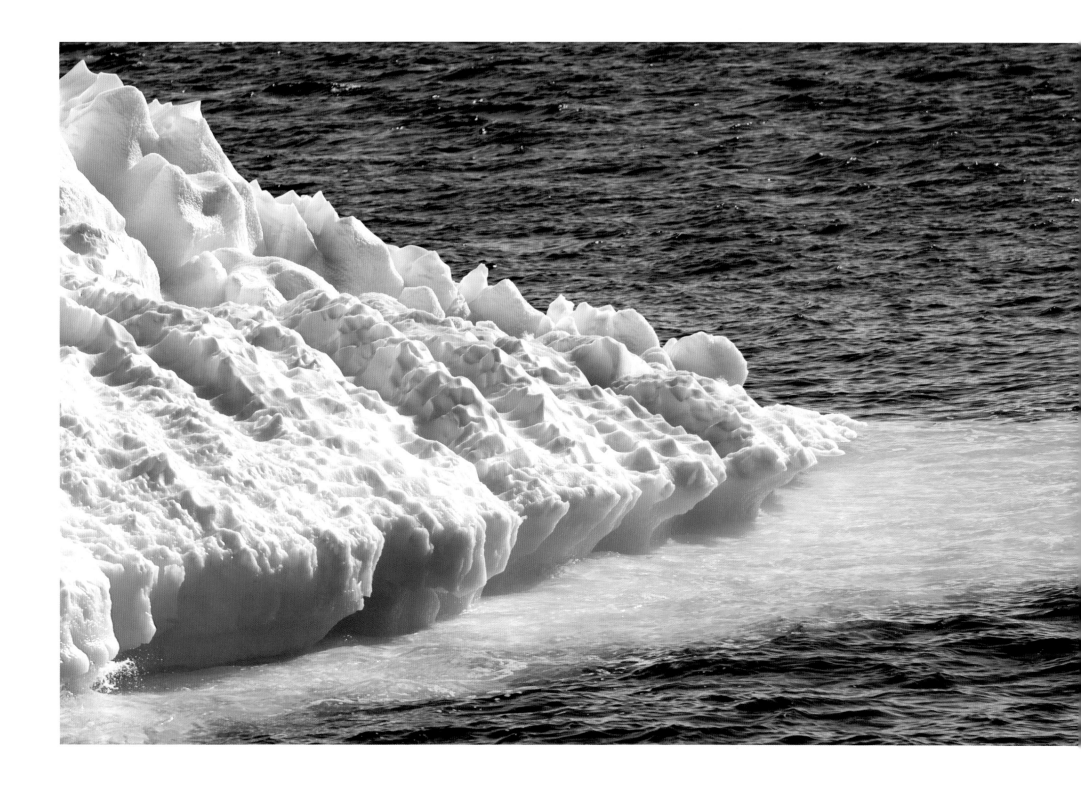

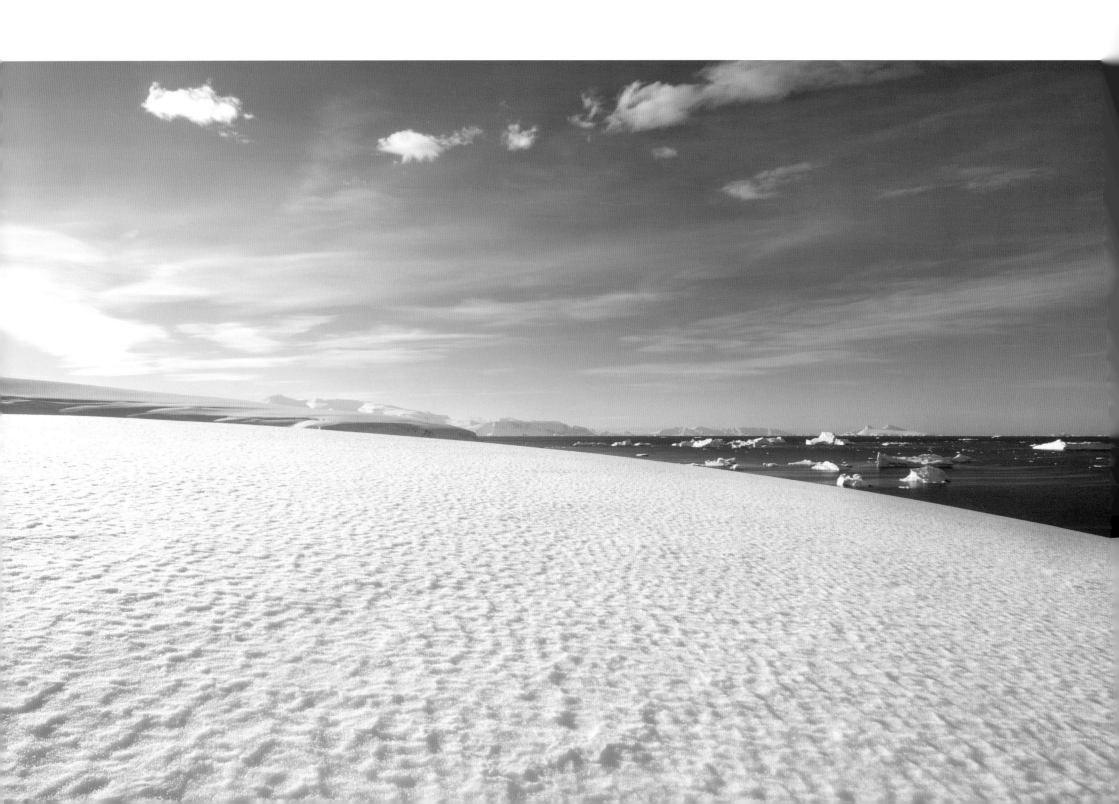

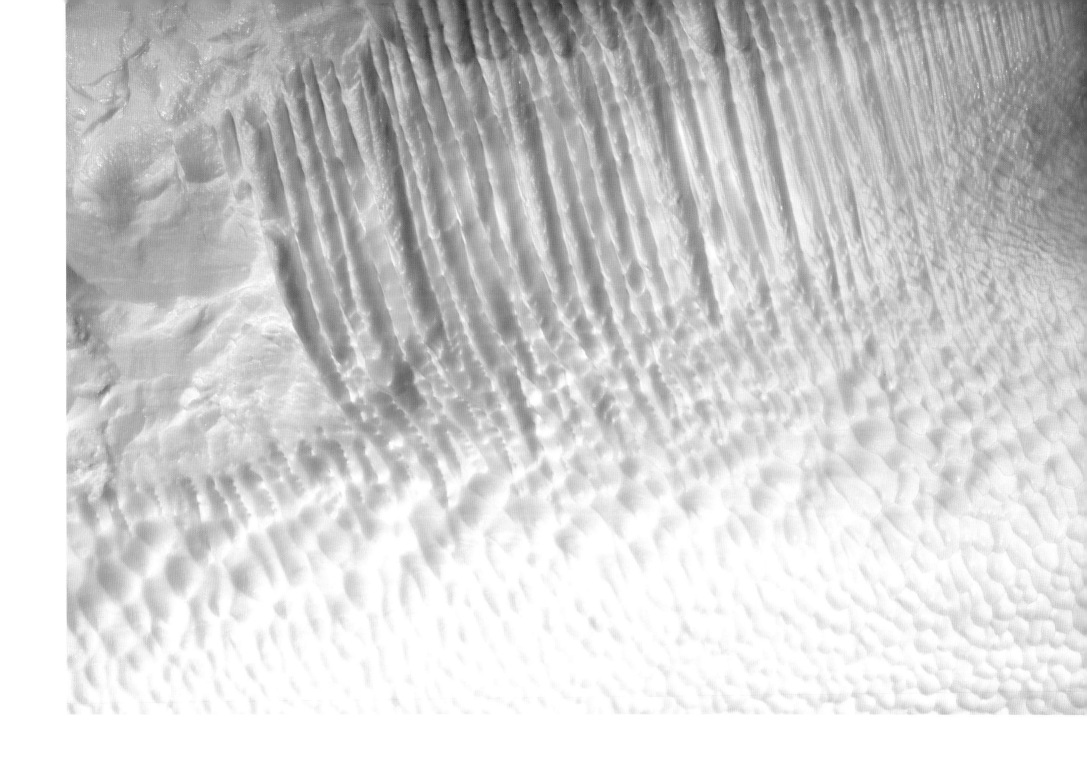

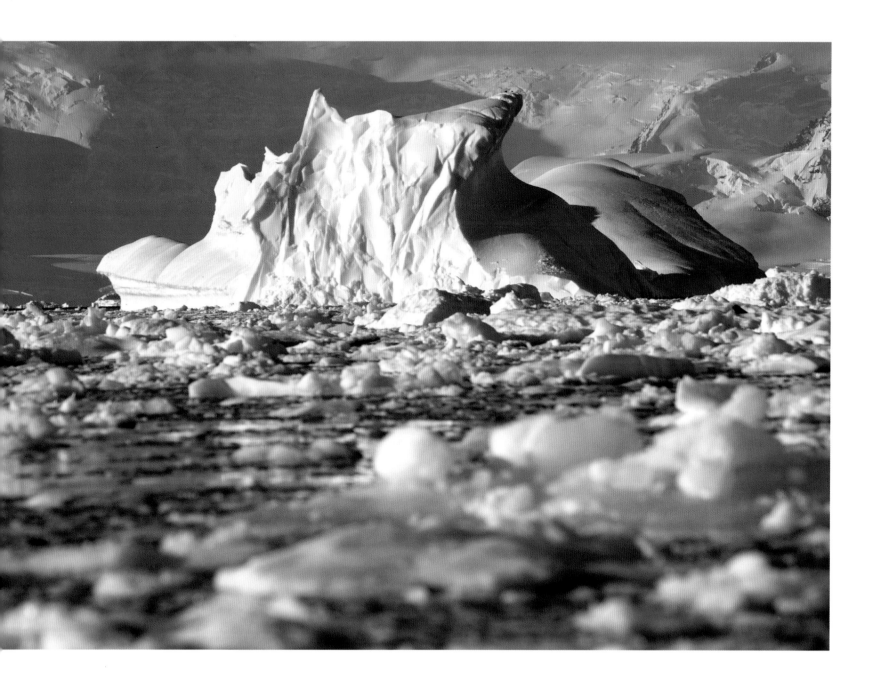
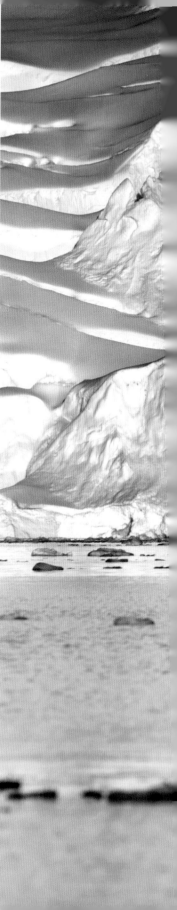

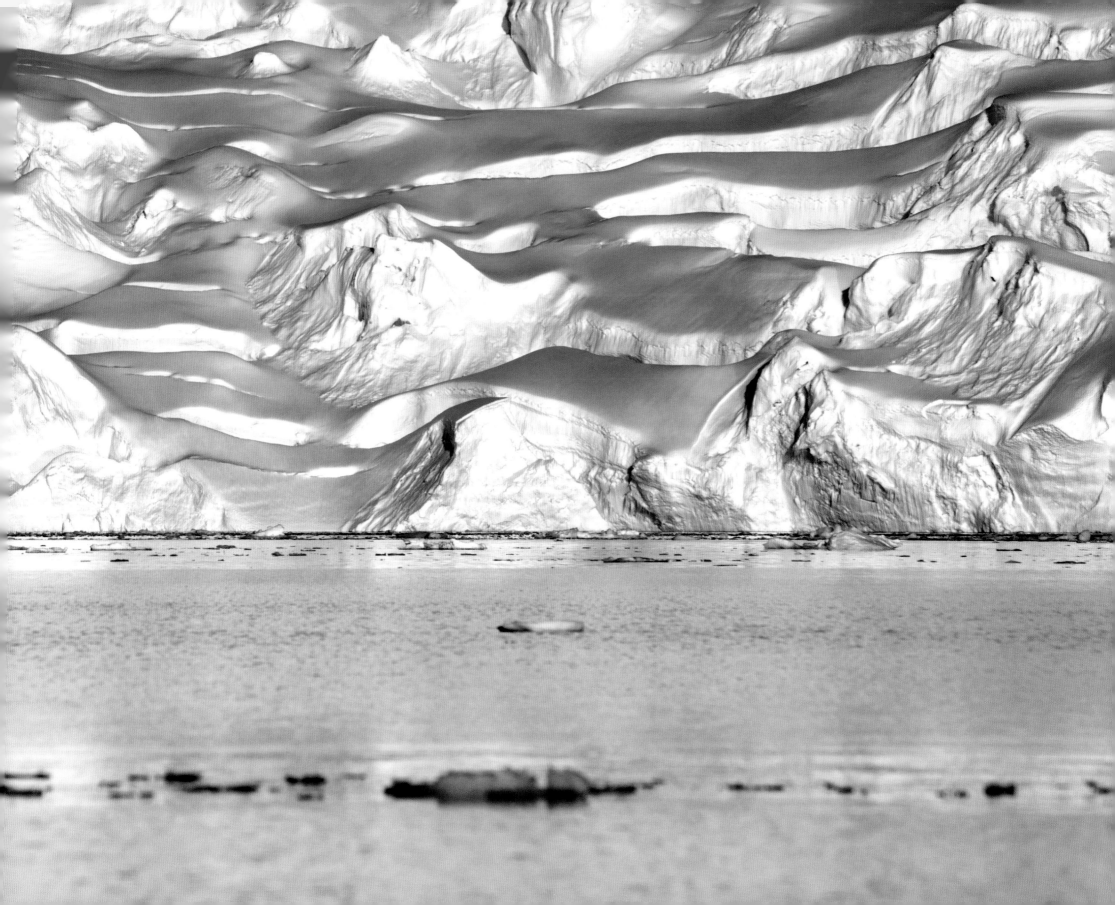

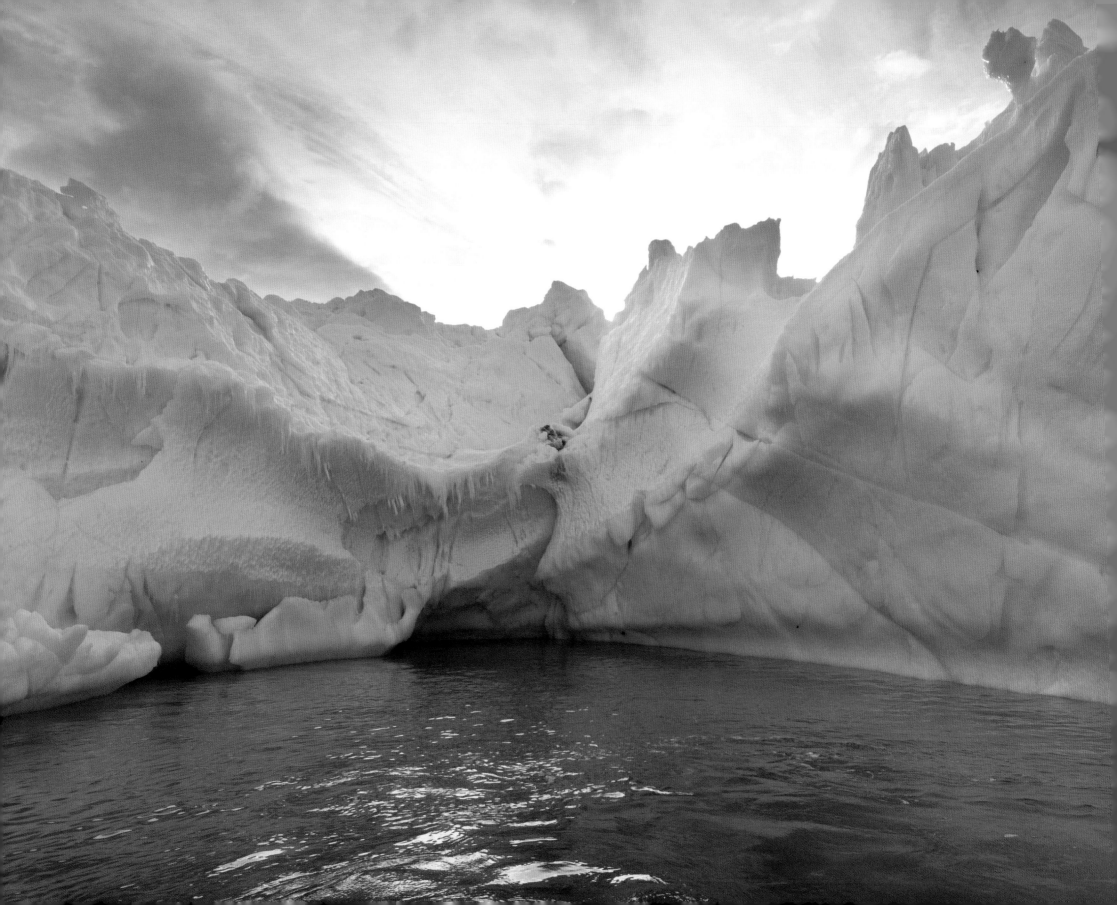

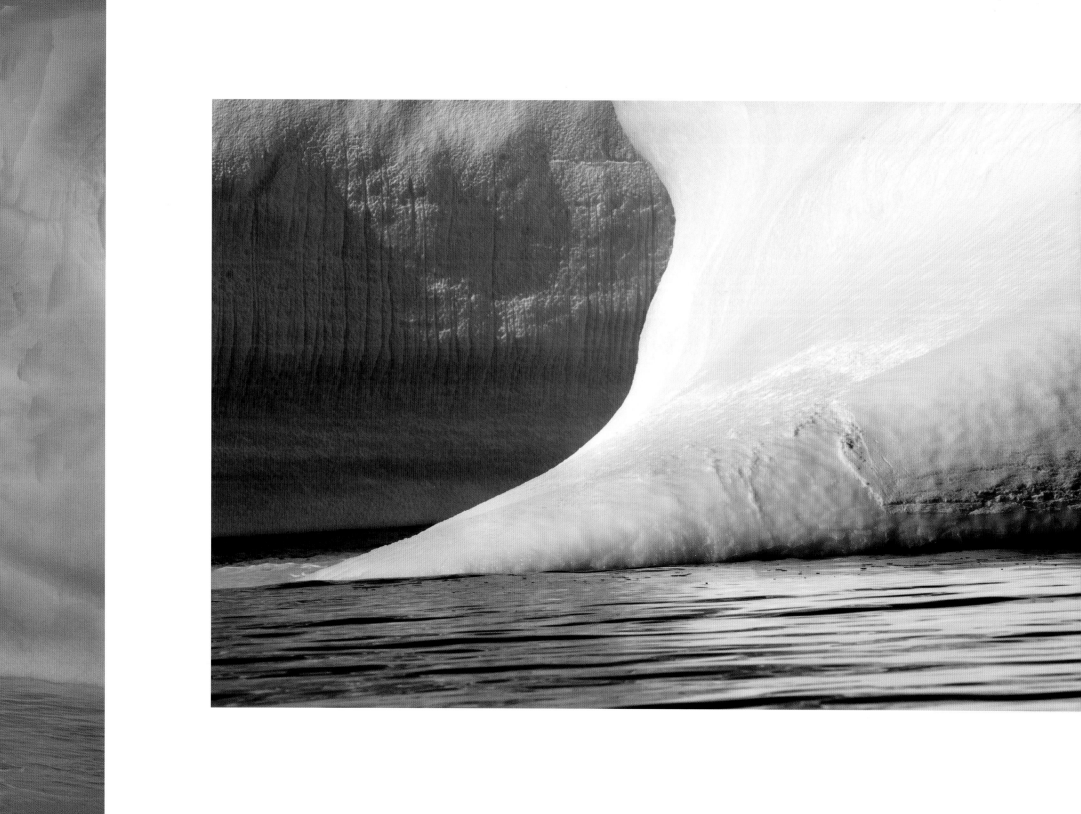

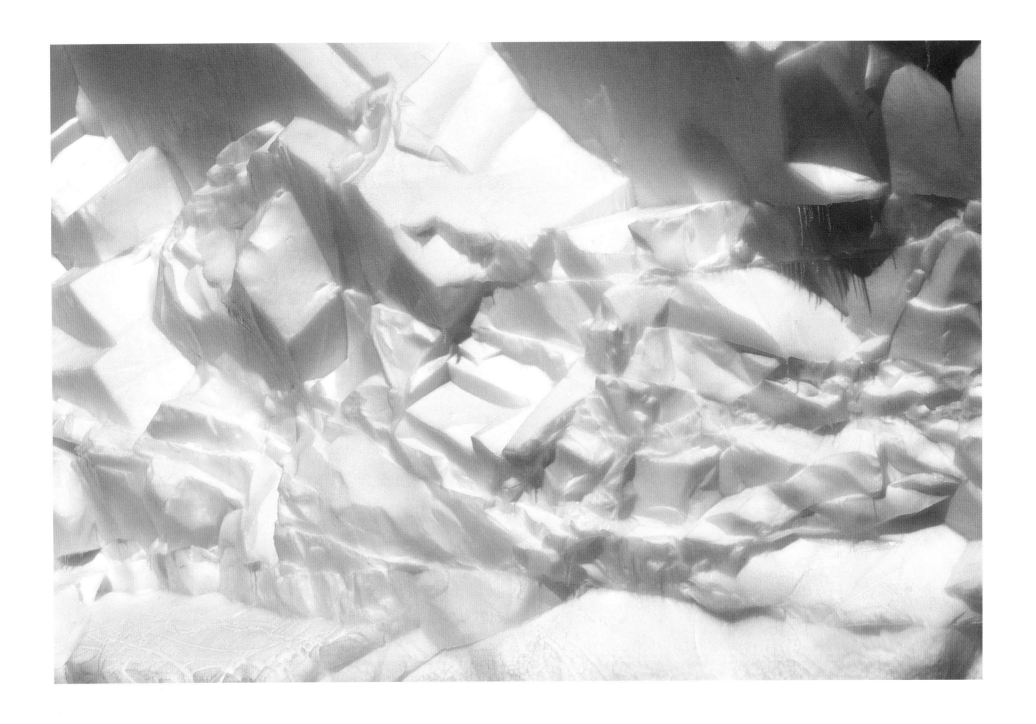

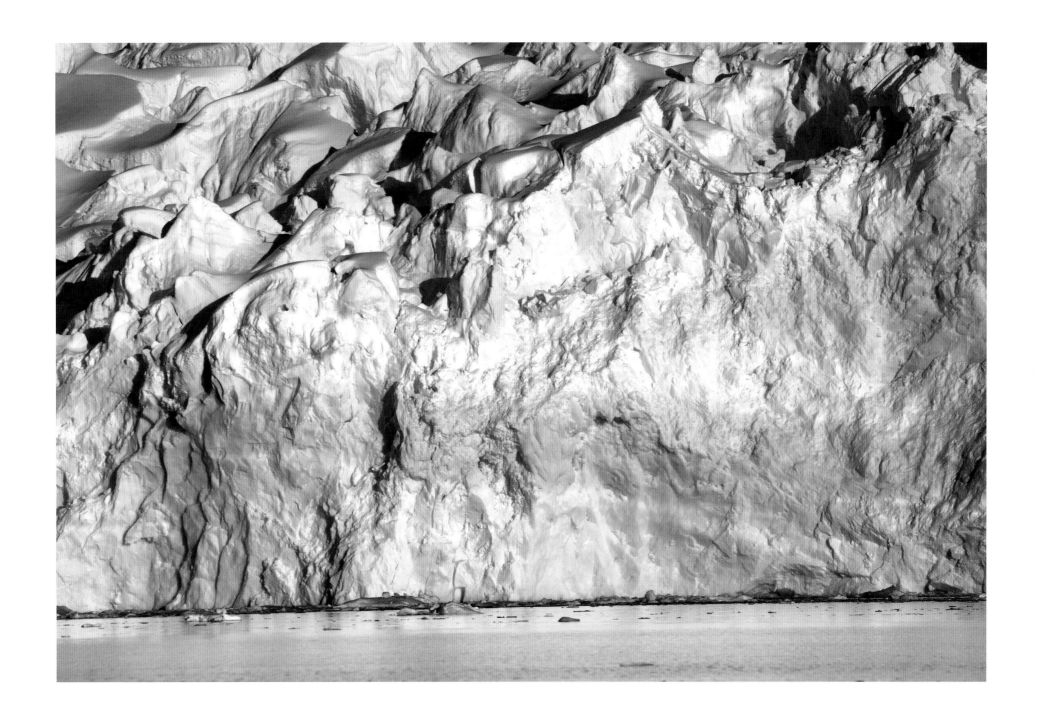

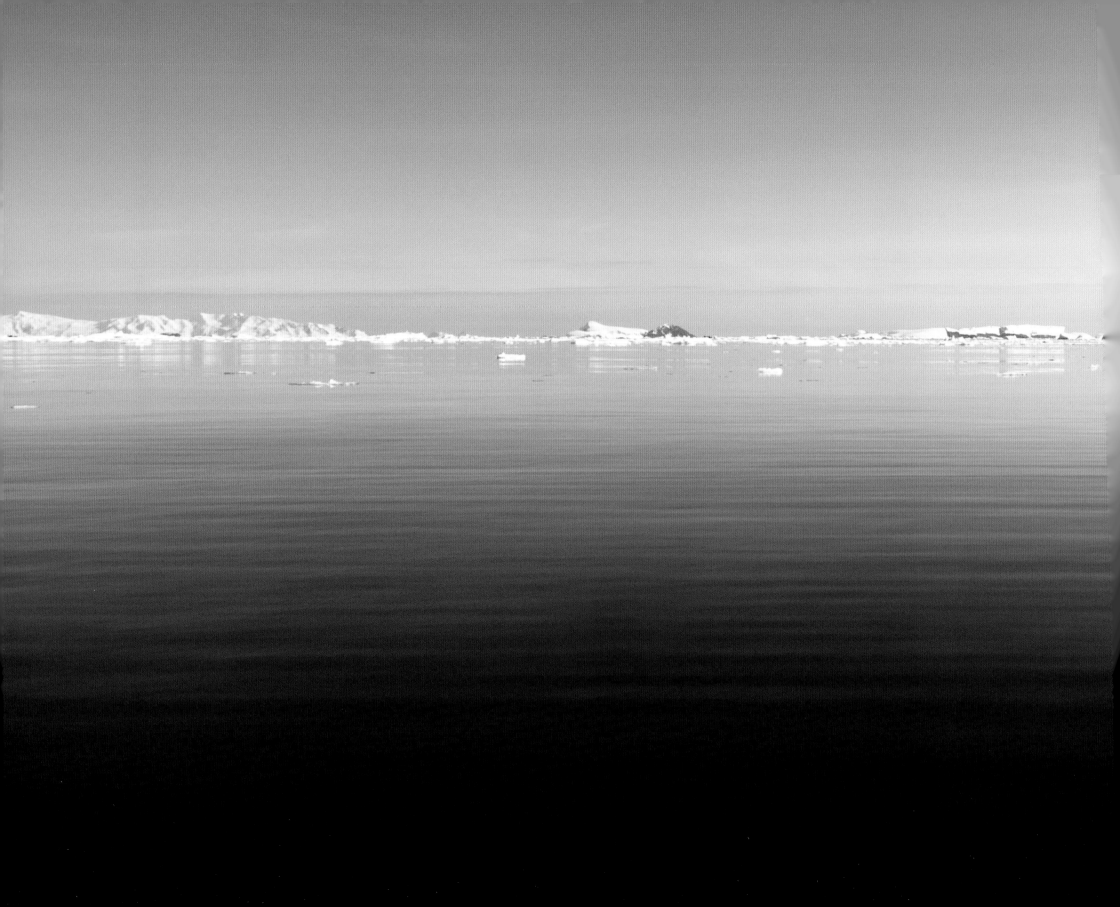

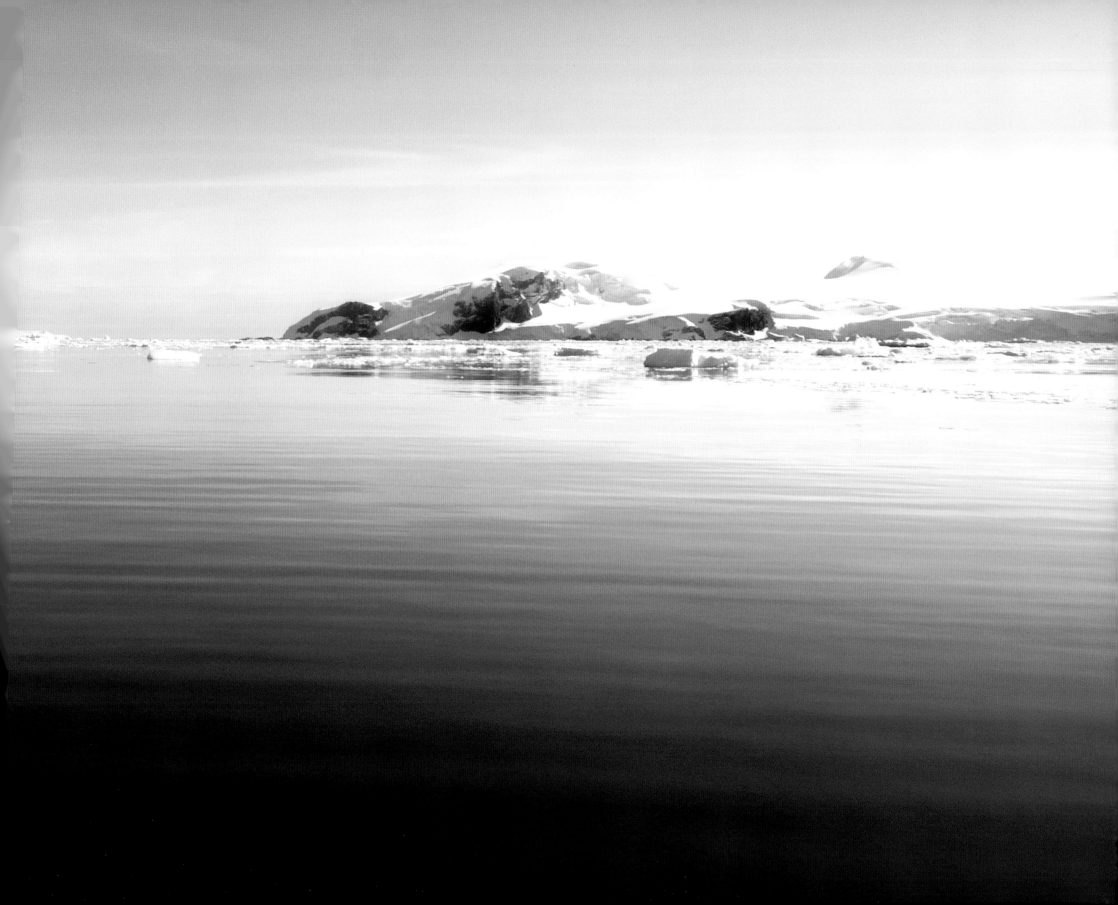

LEGACY

Sitting at home, surrounded by the comforts of civilization, it is hard to imagine being somewhere like Antarctica. I struggle to believe that I was ever there. I still yearn to go back; I would love to return without a camera, just to witness it again. It's intriguing which senses have left the boldest memory: it's the noise of the Antarctic wind contrasting with the silent energy all around that will stay with me for ever.

I was greeted at the airport in London by my friend Debbie. Very weary, I jumped in a taxi with her and set off home. As I recounted my experiences to her, I noticed that the taxi was being made to take a number of diversions owing to roadworks. The driver told us it was impossible to avoid the roadworks, and after a few minutes I looked up to see a familiar face – the statue of Ernest Shackleton staring out from the wall of the Royal Geographical Society. It was as though he wanted to welcome me home. I told myself that the first place I would exhibit the photographs of my trip would be the Royal Geographical Society.

My return from Antarctica was hard. I instantly missed the panorama, the wide, expansive vistas and the knowledge that at any one moment you were sharing a space with just a couple of other humans. For a few weeks it was difficult to look at the photos I had taken, such was the strength of my emotions. For me, it was important to dispose of those feelings gradually before I could start working on the photographs professionally. I was full of excitement about what lay ahead and nostalgia about what I'd just gone through. I would tell everyone I met about my trip, in a storm of excited tales that was difficult to quell.

Once I started looking at the pictures and began the lengthy process of sifting through day after day of photographs, I began to feel happier. Of course, I still missed Antarctica; even now, every time there is a windy day I think about her. But I felt satisfied that my trip had been a success. While some photographs would bring back memories, others would make the whole experience seem unreal.

The temperature was well below freezing throughout my stay, but when I look back at my photographs, I seldom feel cold. To me, the ice had warmth, and seemed to glow. How can something so full of energy, so full of power, ever be considered cold? It's the wind that lingers in my mind when I think about the overriding character of the weather. It was frightening at times, a tempestuous governor that could change everything, could put our lives at risk by whipping up waves and pushing icebergs the size of houses across the crystal ocean. I have never felt wind like it. At its strongest, it felt as though it had come directly from the core of the Earth – raw and aggressive, power made manifest.

Once home, I knew my work was not finished. In some ways, I was only halfway through my expedition. There was a great deal of work to be done, and that is still the case today. On top of processing my pictures and weaving my way through photo after photo, I also had to organize an exhibition, to generate more enthusiasm about Antarctica. I owed it to those who had supported me, but I also felt obliged to continue the hard work for Antarctica – and all the time my hero Shackleton was in my mind, his statue still reminding me of my role.

The exhibition took place at the Royal Geographical Society, just a few metres from that spot, and it was opened by Alexandra Shackleton, granddaughter of the great explorer. It was another emotional moment along the journey. As I prepared for the show, I met some of the most amazing people I have ever encountered: the director, Rita Gardner, Alasdair MacLeod, Denise Prior and Luciano Figueira. Everyone worked very hard to help me to organize the exhibition, and now, for me, this extraordinary place, filled with amazing people, is like home.

It is, of course, difficult to communicate exactly what I felt, but I hope my photographs give a sense of the emotion and desire that are so important in this dialogue. A love affair that started with a book about an explorer certainly did not end when my photographs were exhibited. The sense of fulfilment when people congratulated me on my work was not enough to slake my thirst for Antarctica. Far from it. My stay in the frozen continent strengthened my bond with nature and reinforced my determination to encourage people to think about how their actions affect this delicate part of the world. Our story is in the ice. A change in mentality is required, since living in a sustainable way is vital if we are to protect places such as Antarctica. Shackleton never thought in this way when he put his life and his reputation on the line to venture to the South Pole. But things have changed. Almost everyone is aware of the way our actions can affect an area that seems, at first thought, to have no significance for our daily lives. Perhaps there is a planet that is more beautiful than our own, but it may take millions of years to find, so until then we must protect what we have.

The true power of nature is love, and Antarctica gave me the opportunity to discover the profundity of life. In some ways, with this book, I have closed the cycle of my journey to Antarctica. But I will soon open another cycle. Antarctica is Antarctica. I miss my Antarctica.

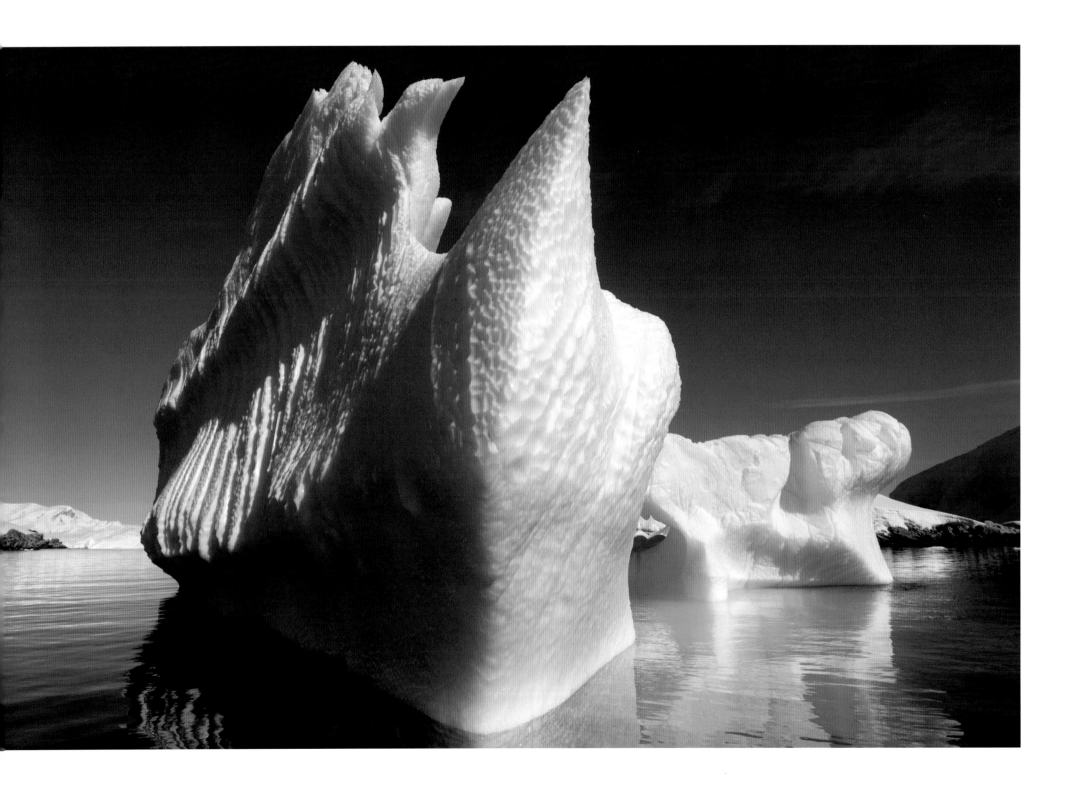

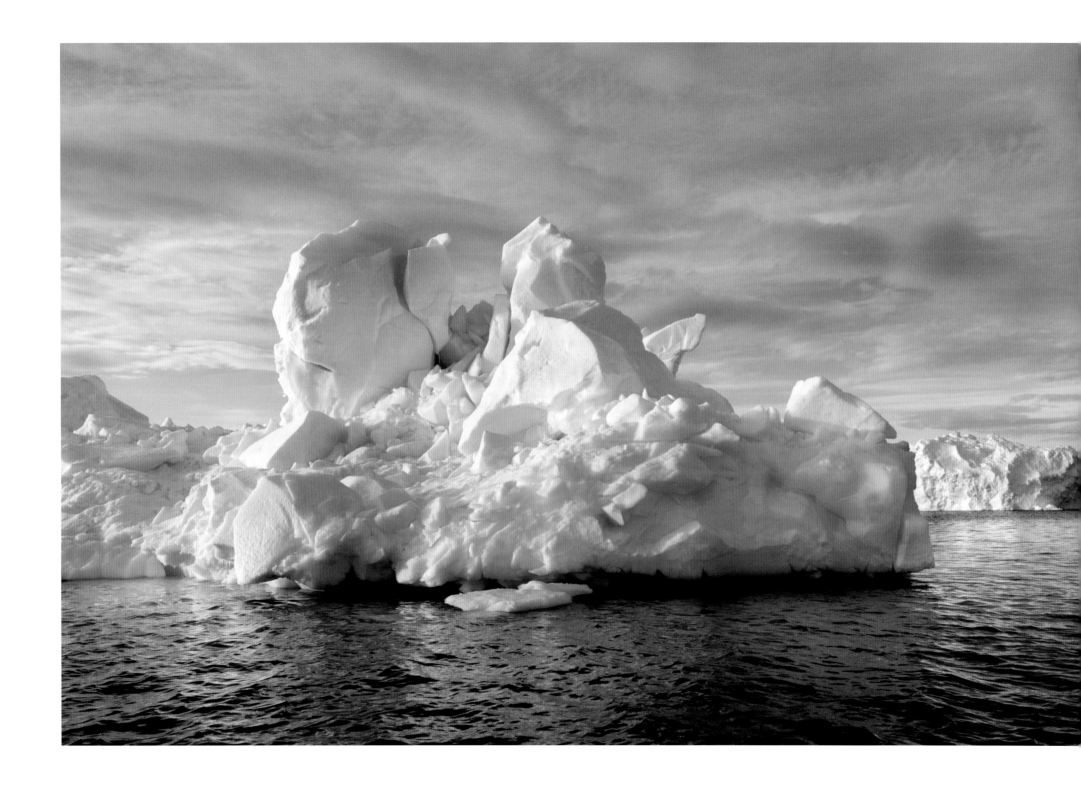

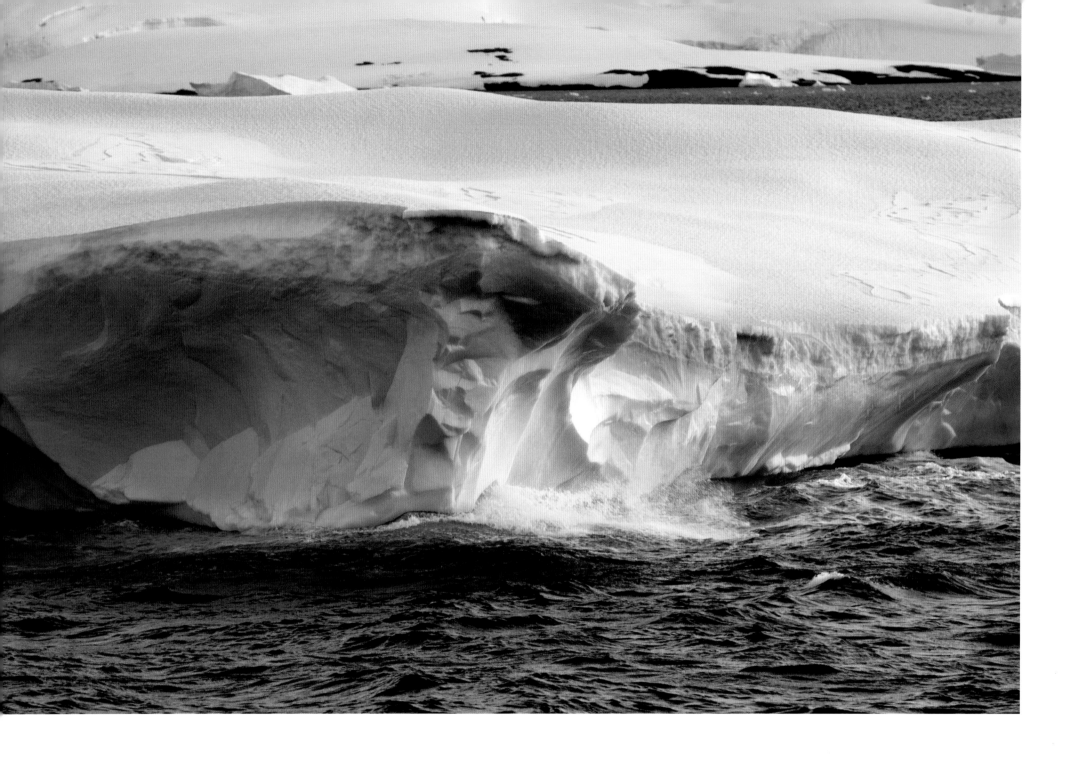

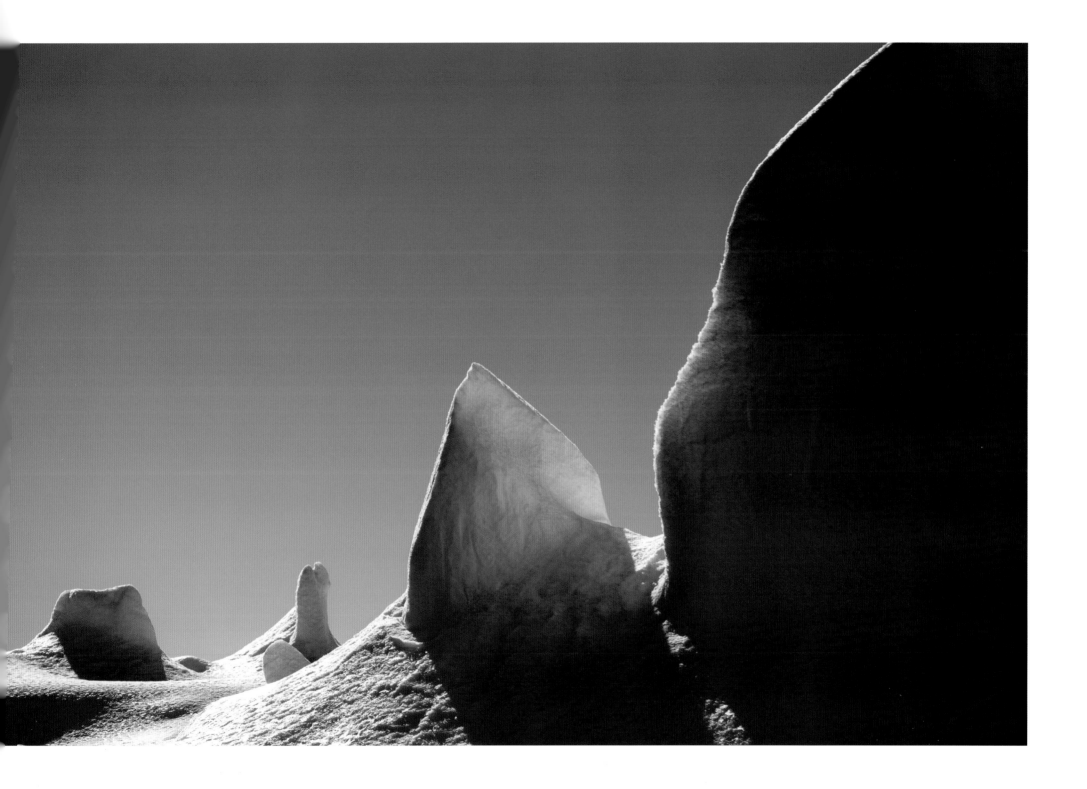

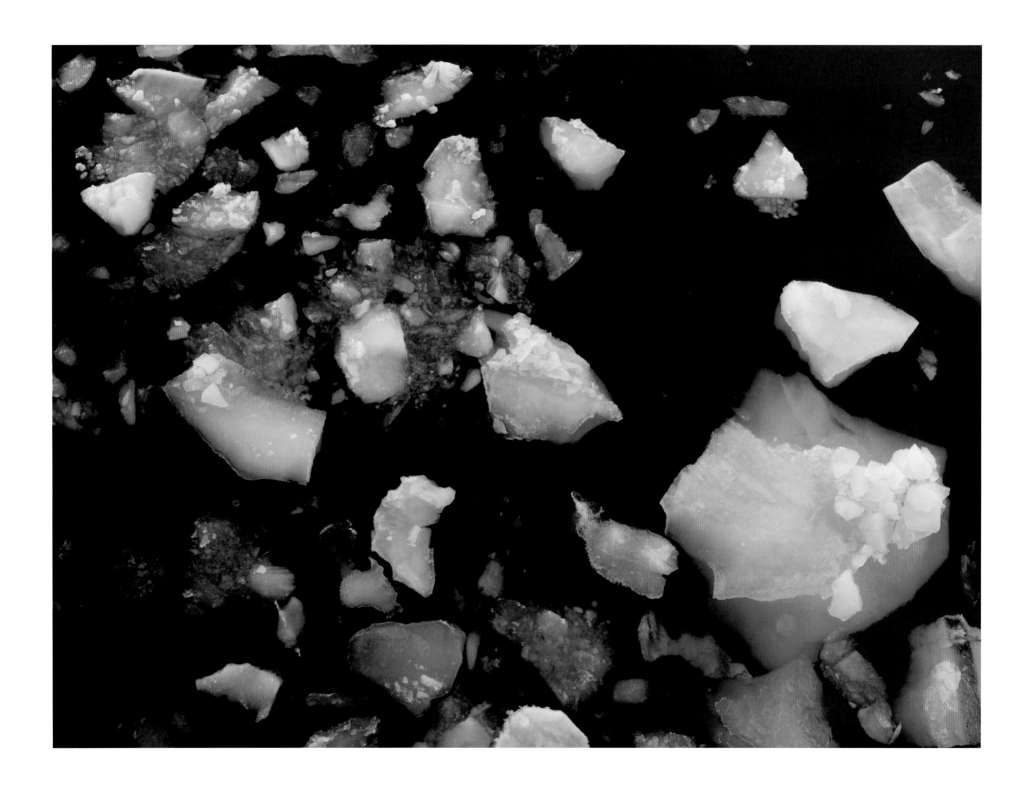

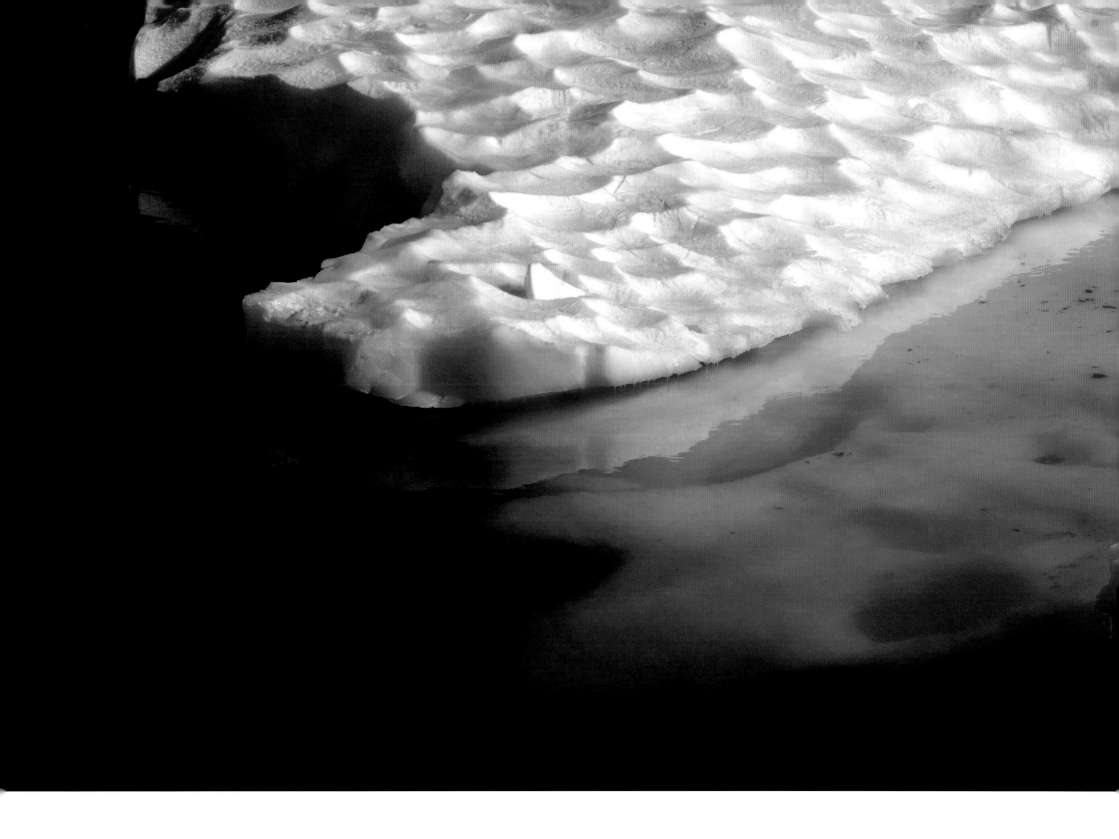

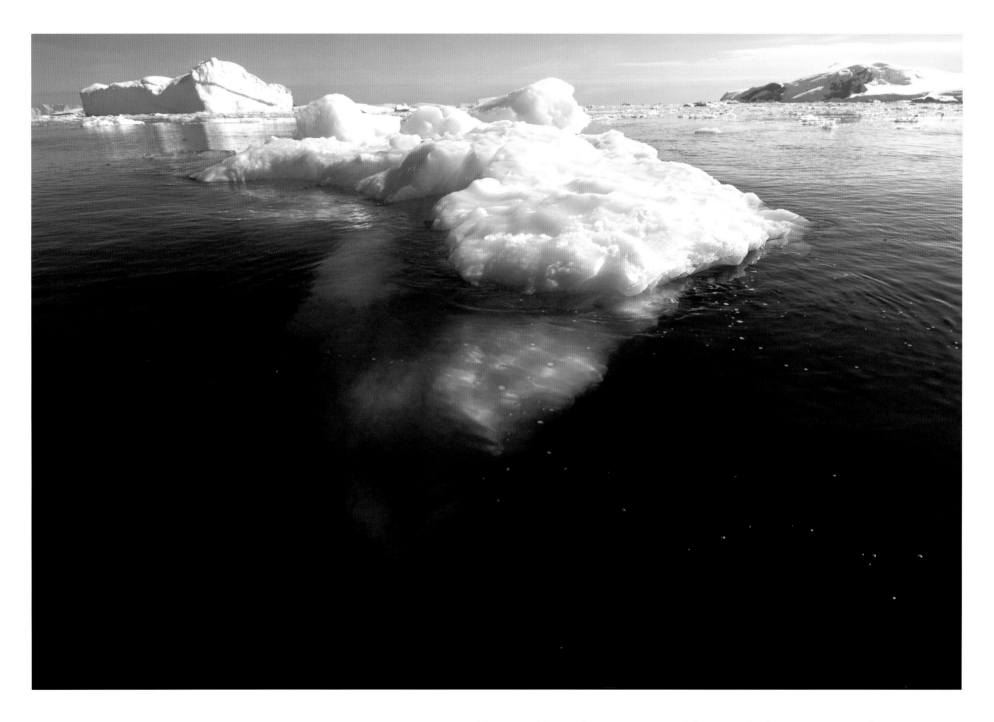

I learned how the extreme wilderness helps us to use all our senses.

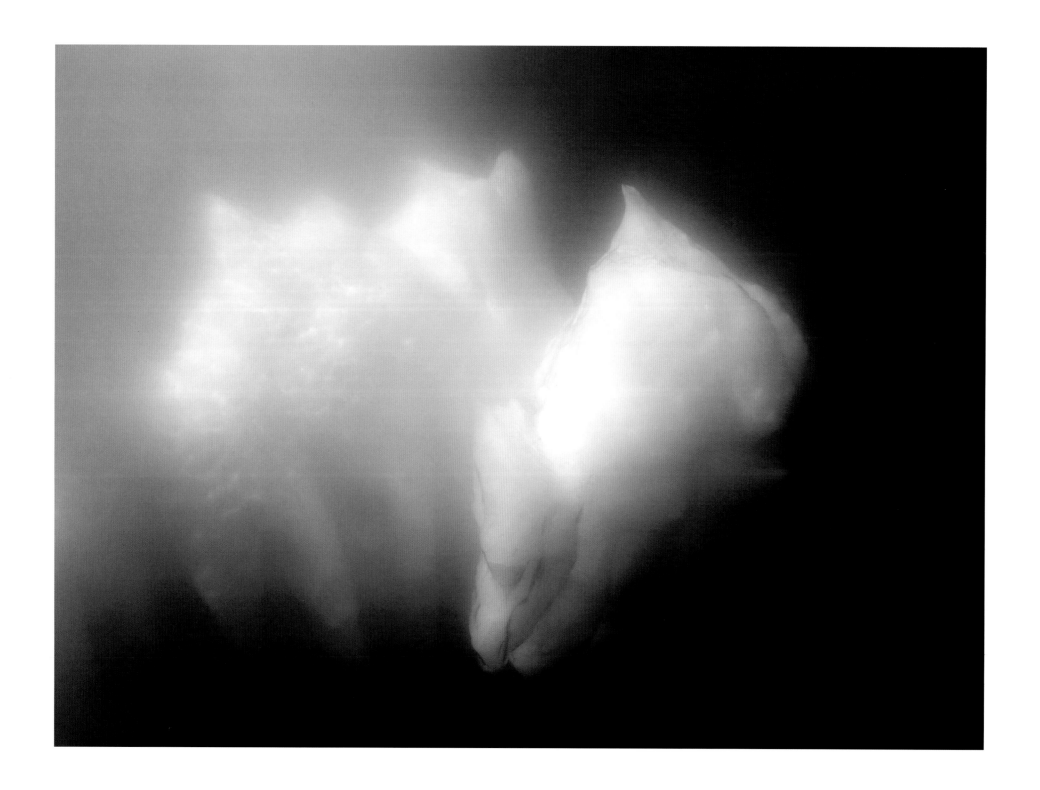

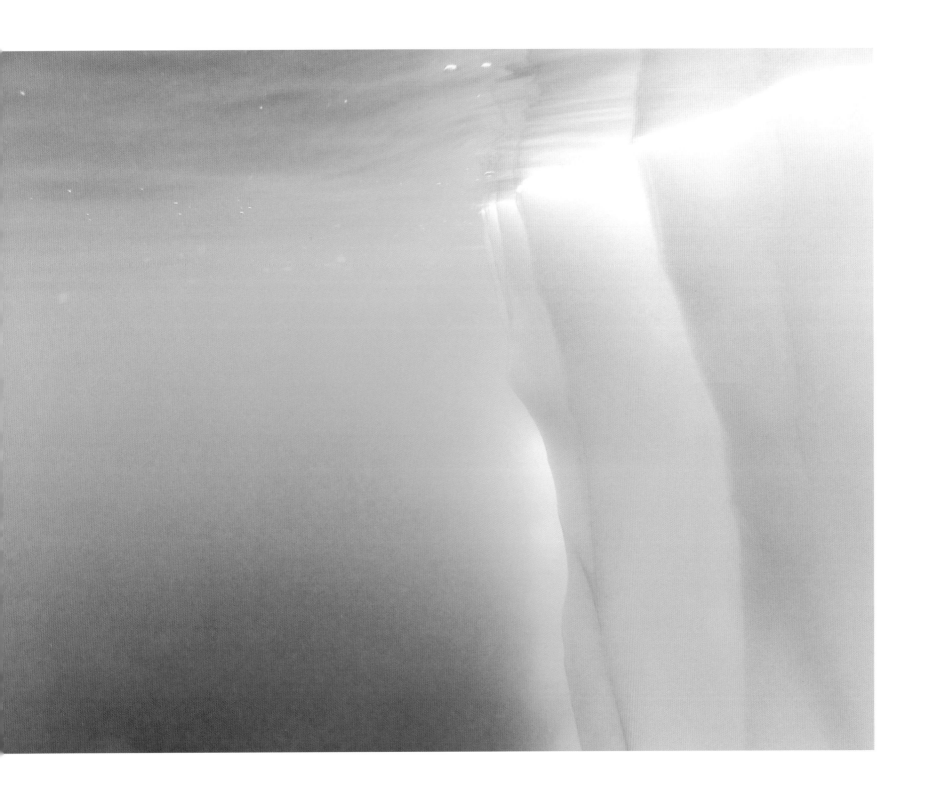

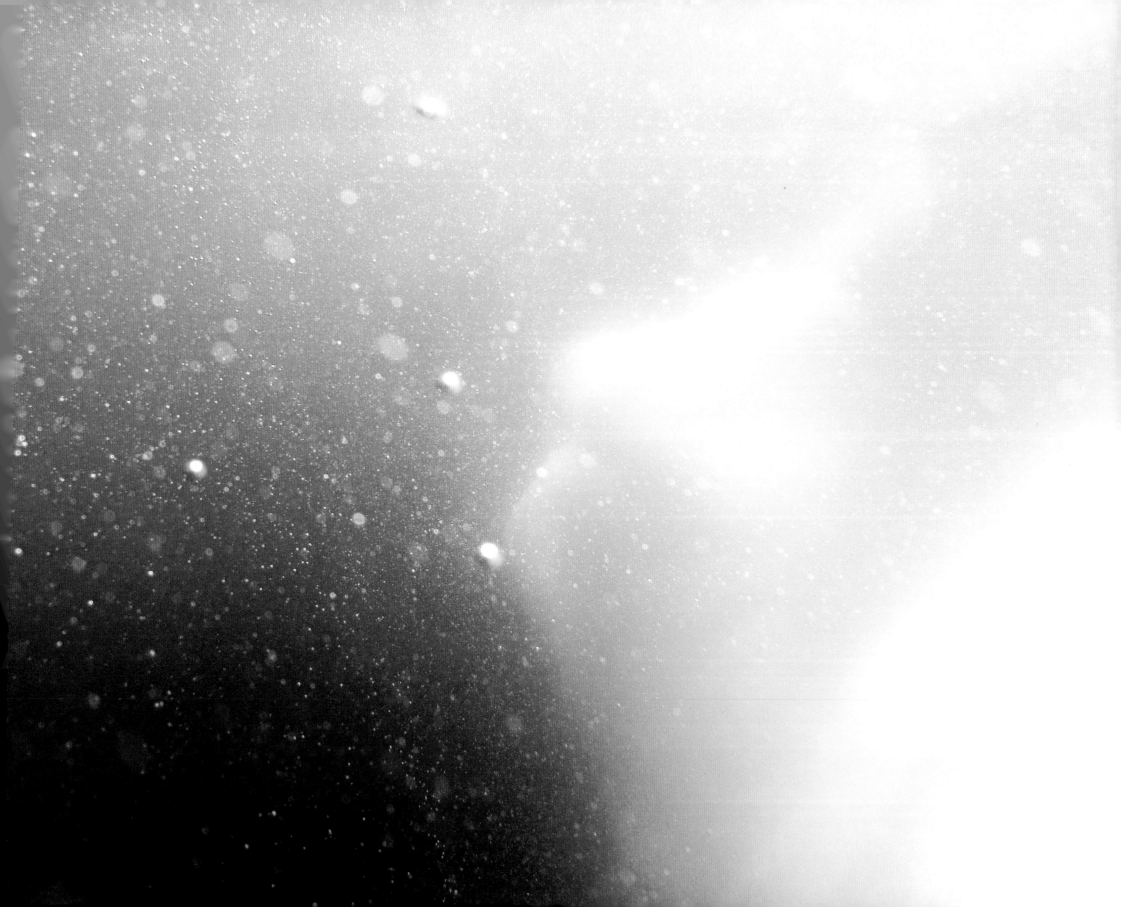

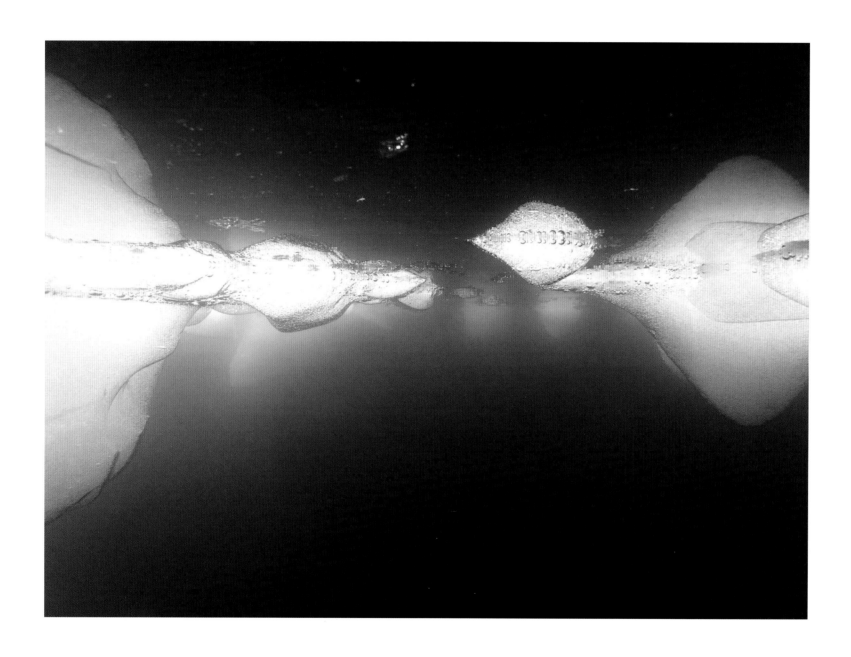

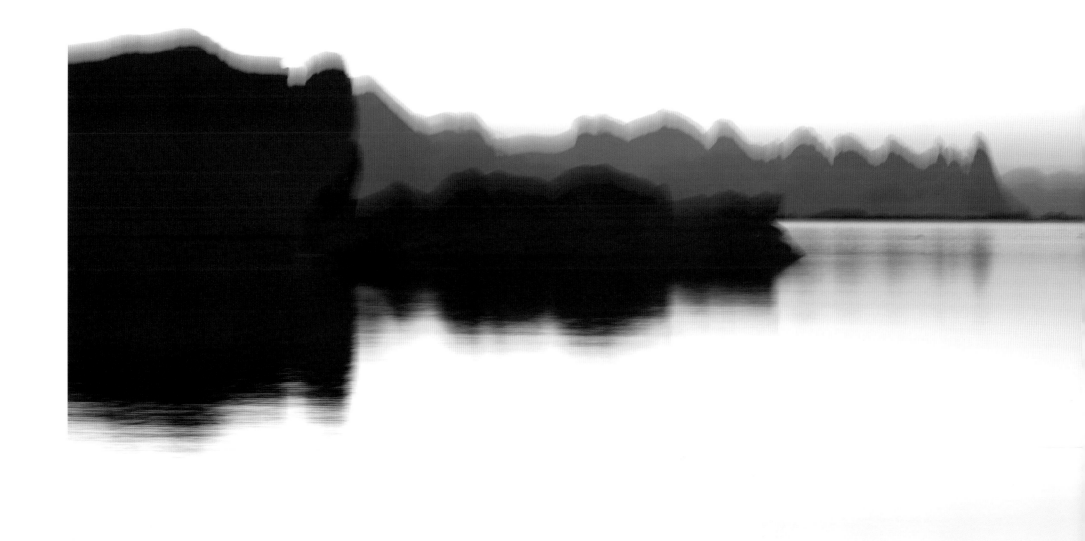

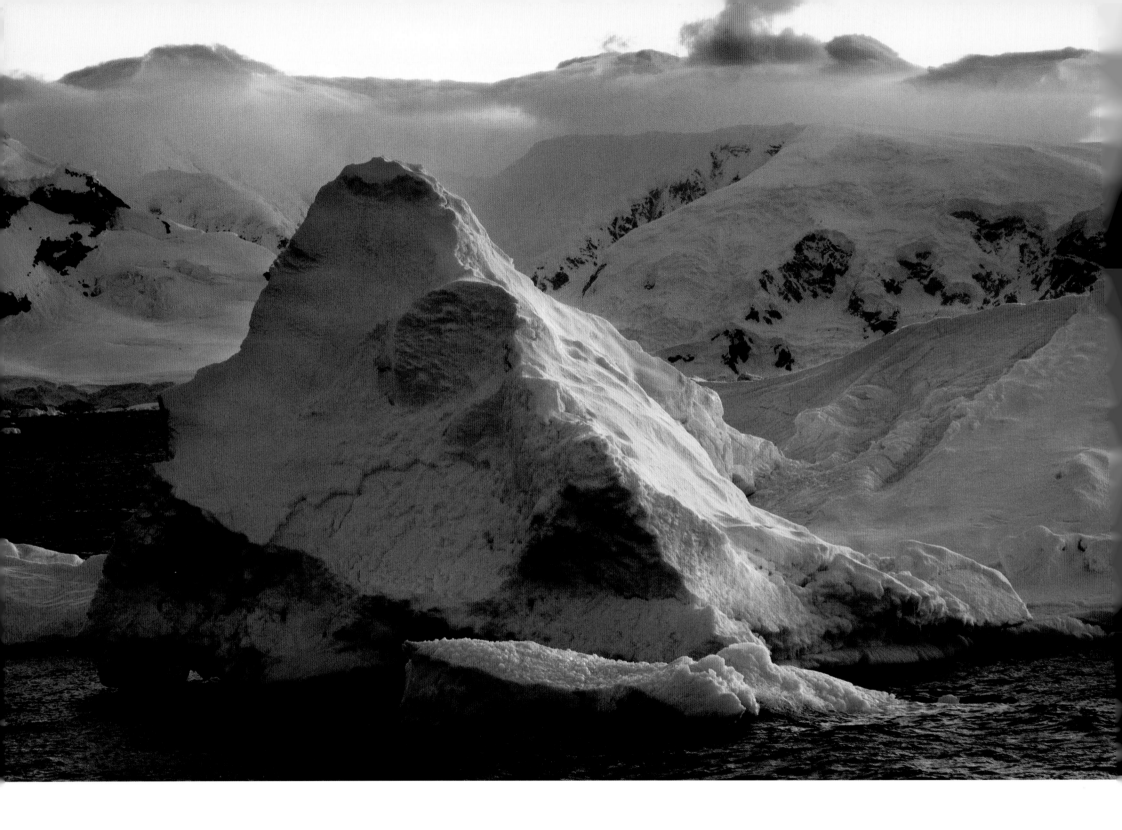

CONSTANT SURPRISE

However well we think we know our planet, it seems nature always has the ability to surprise us and, sometimes, scare us. This photograph is a perfect example of that. Just a couple of minutes before it was taken, the sky was a dull grey. Then, seemingly out of nowhere, the heavens were flooded with unusual, magical colour, first blue, then a wonderful shade of pinky red. This photo demonstrates another side of Antarctica: that it is subtle and surprising in equal measure.

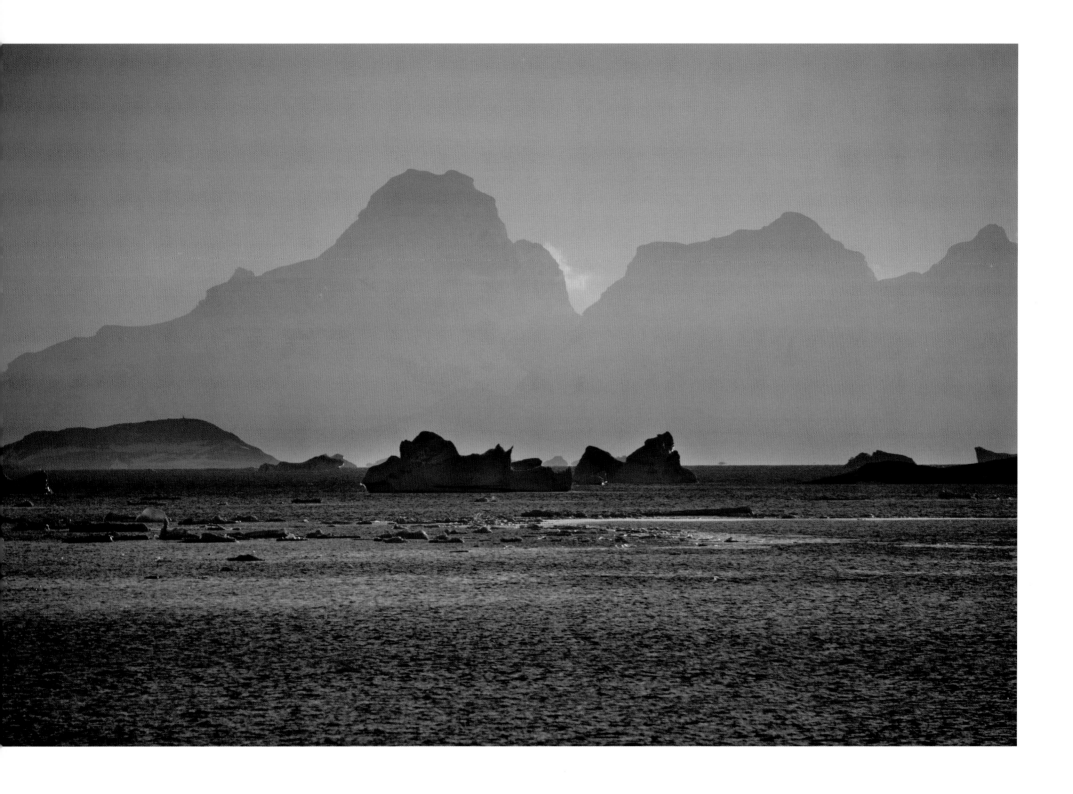

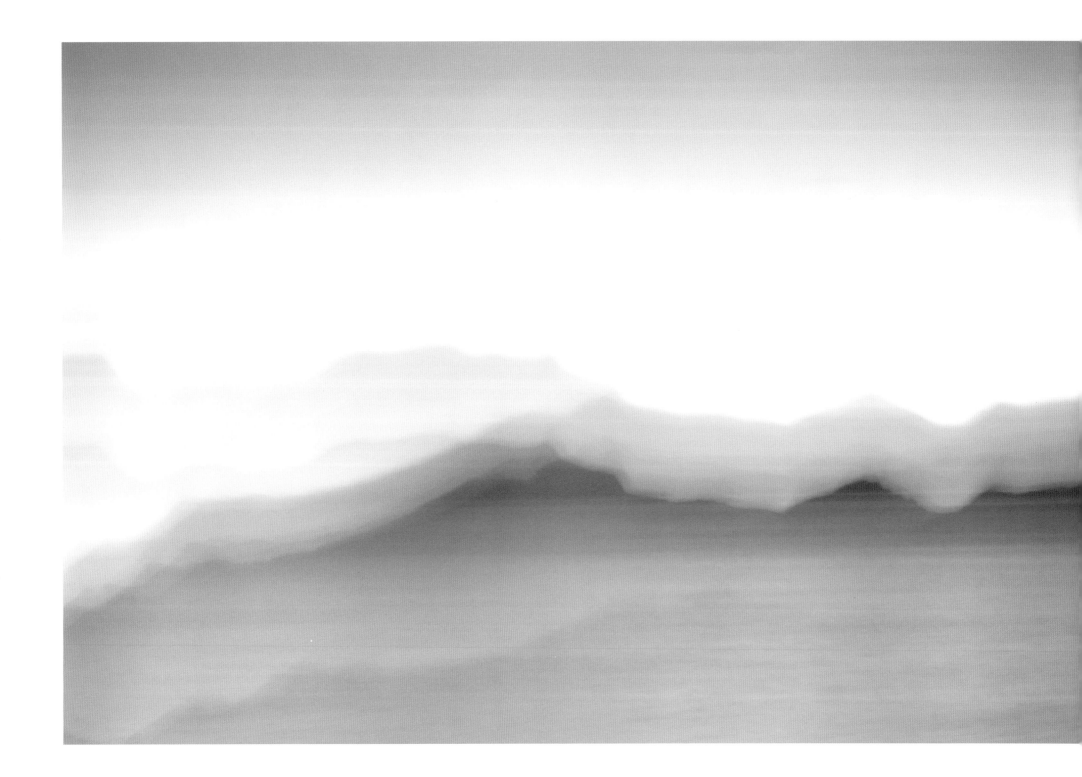

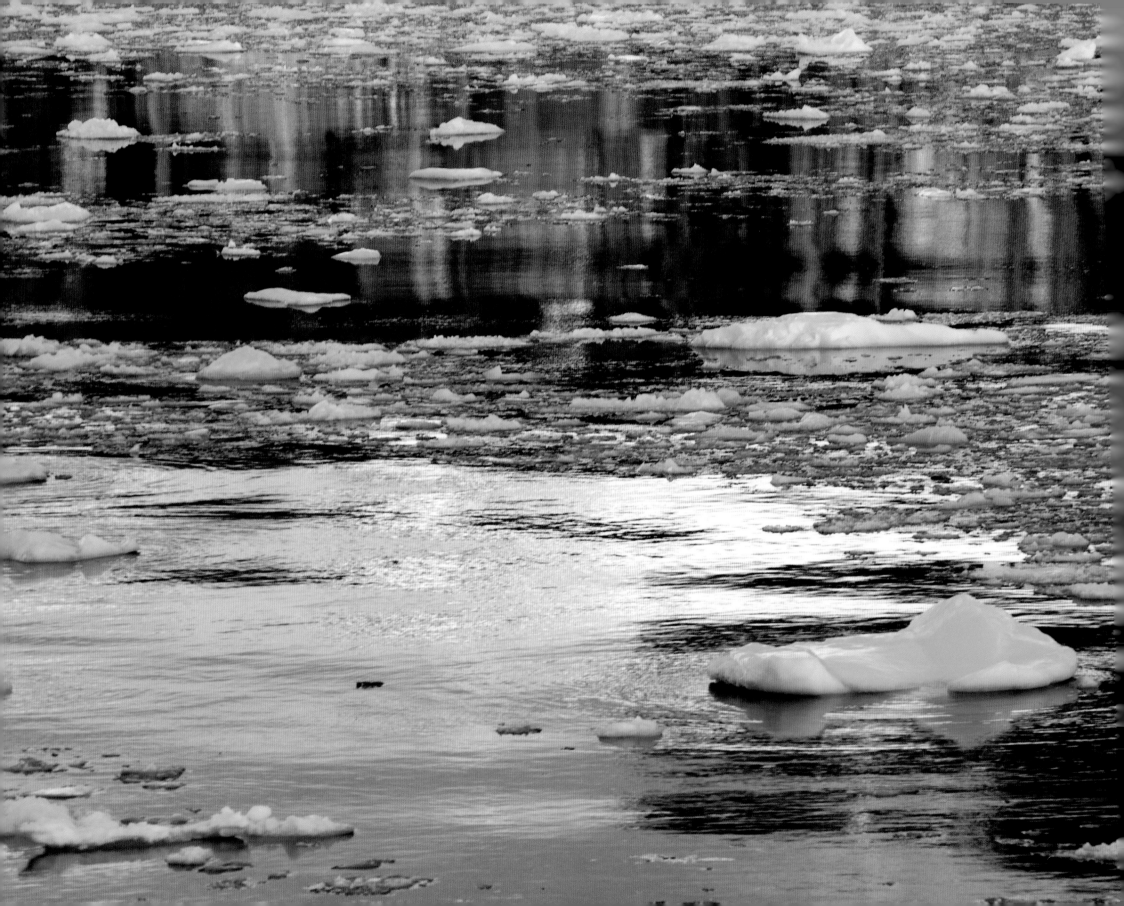

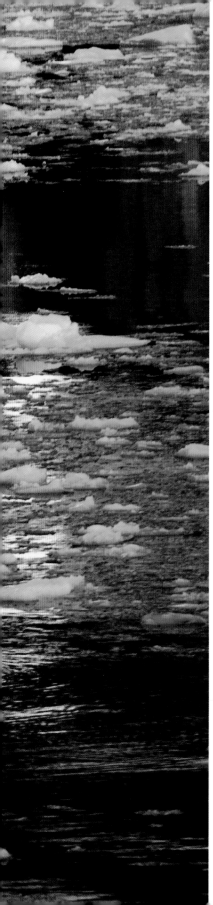

SUNSET

After many long, intense days I finally saw my first sunset in Antarctica, and it was certainly worth the wait. We were surrounded by mile after mile of sea dotted with floating white ice. When the sun set, it turned the sky a burnt orange, which was reflected in the water. Meanwhile that same, late light instantly turned the ice a vivid cobalt blue. It was an unreal, magical scene.

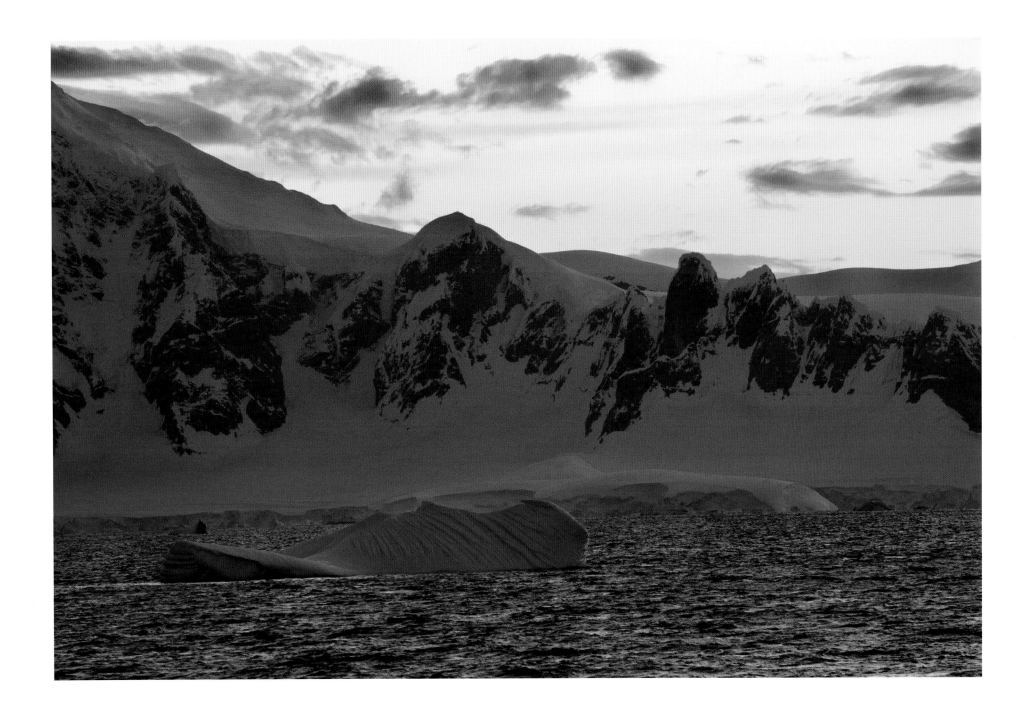

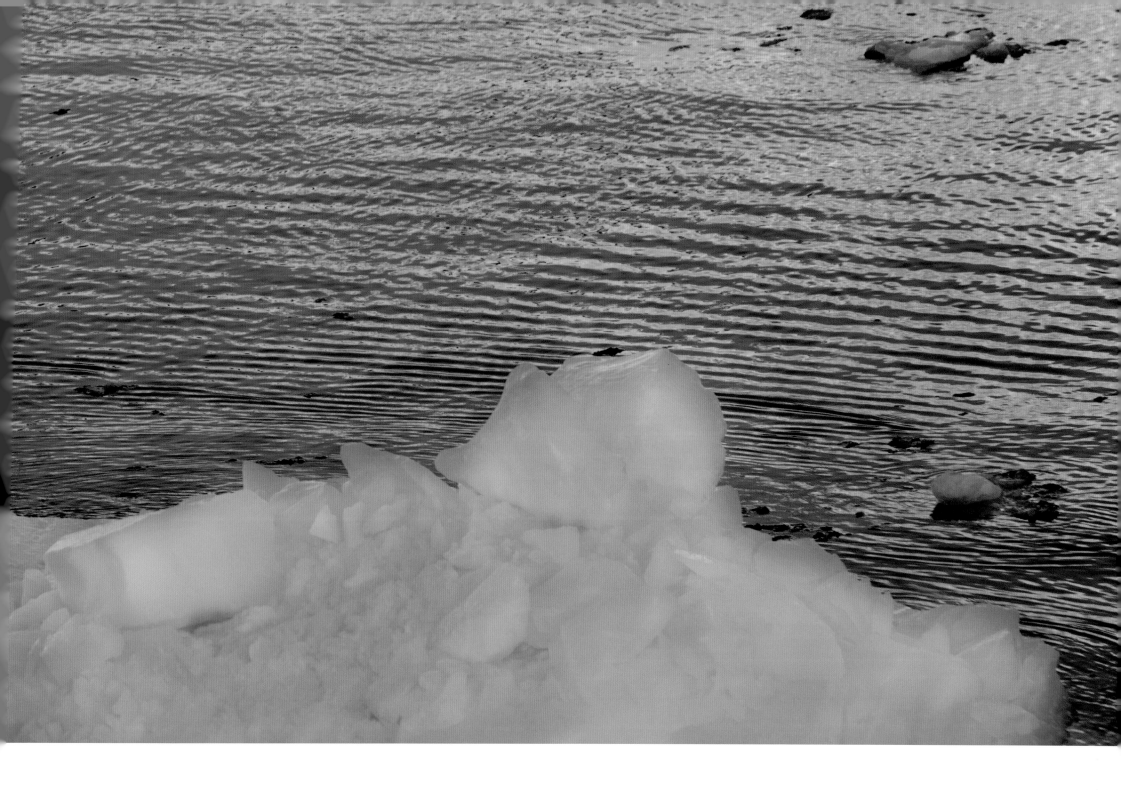

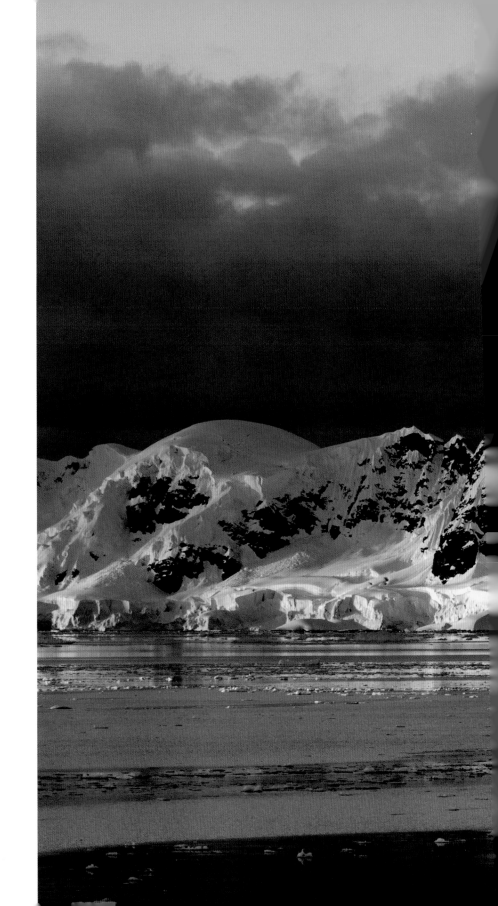

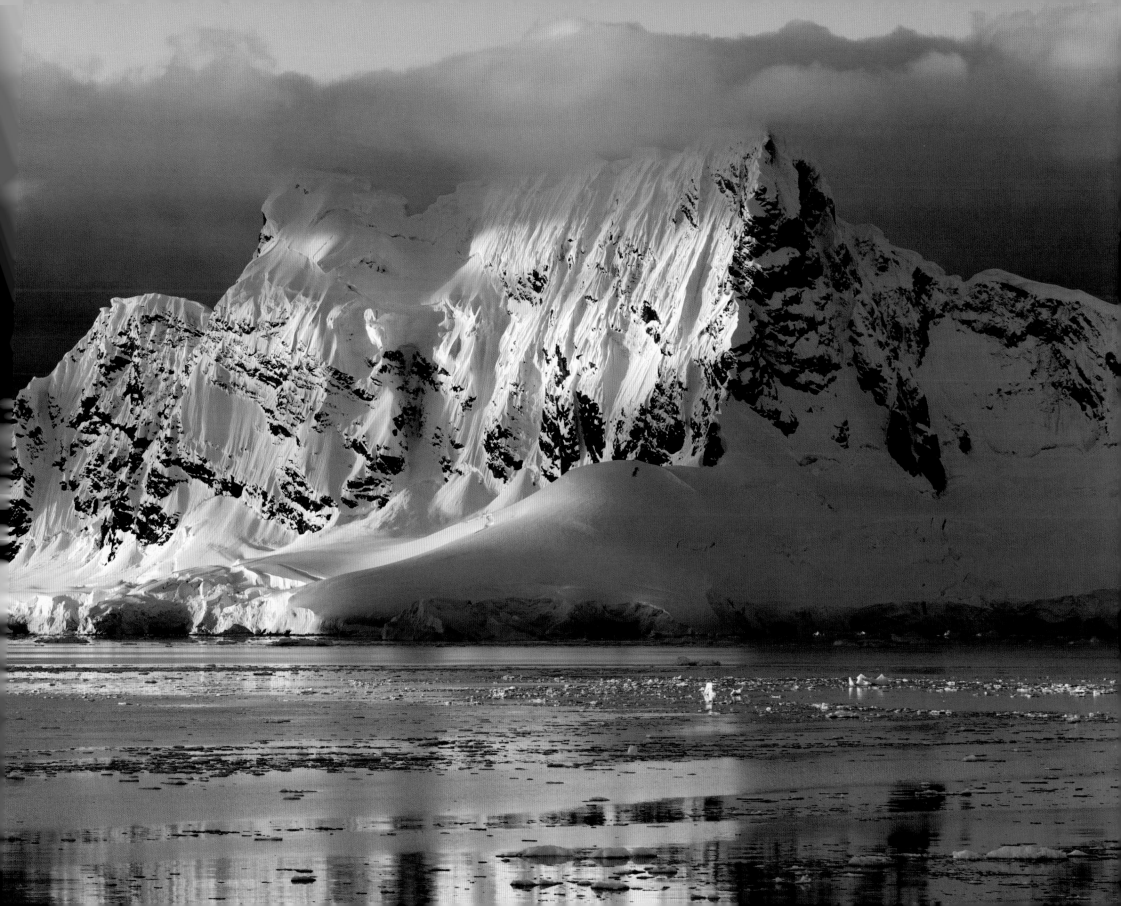

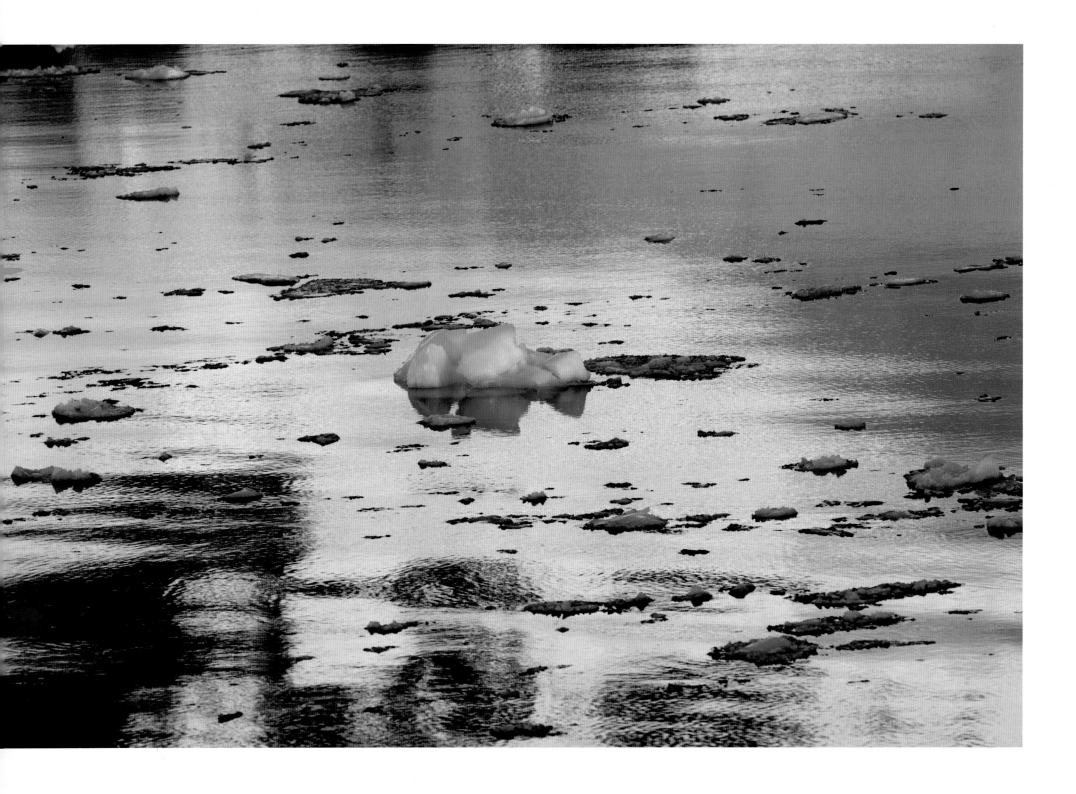

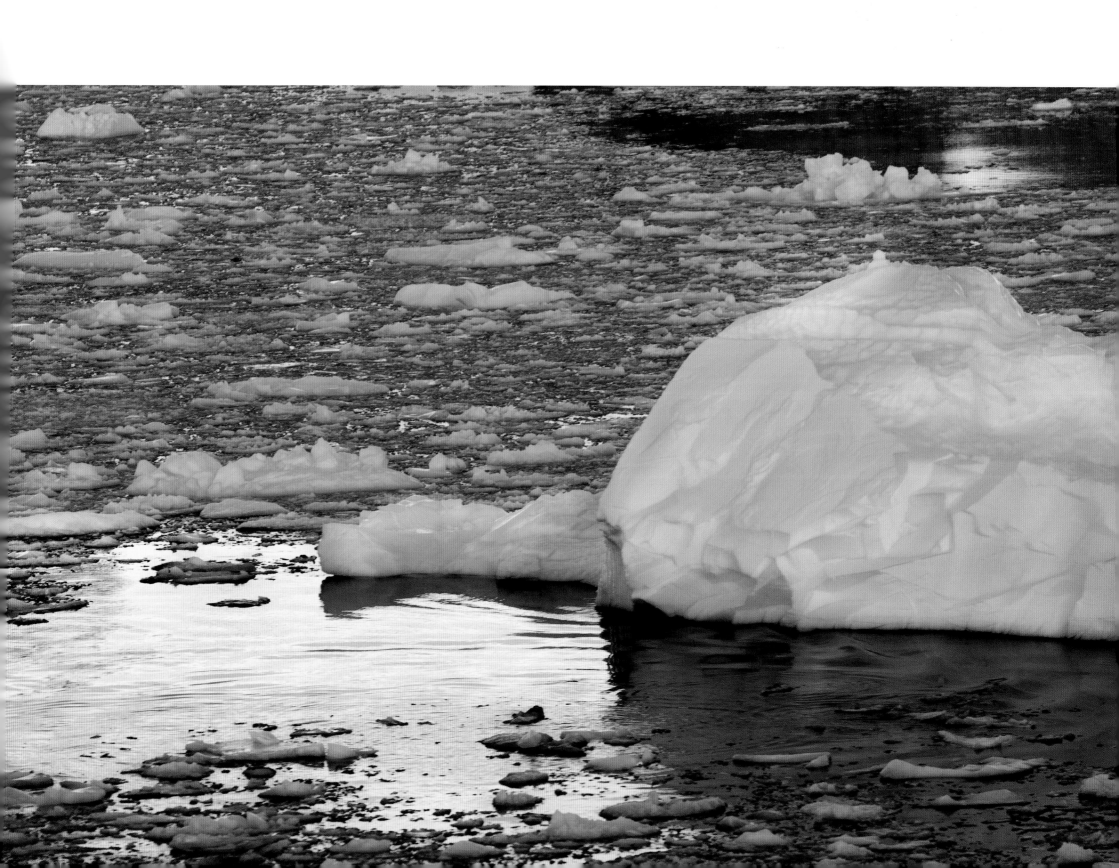

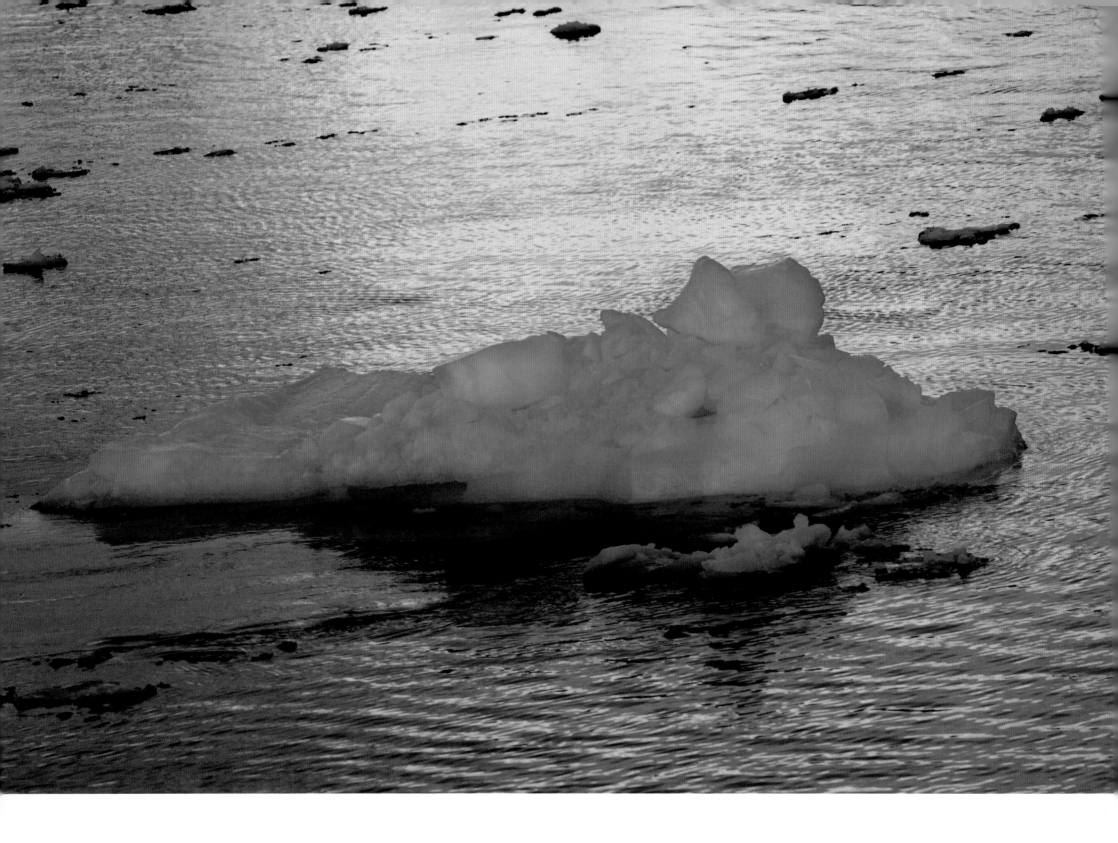

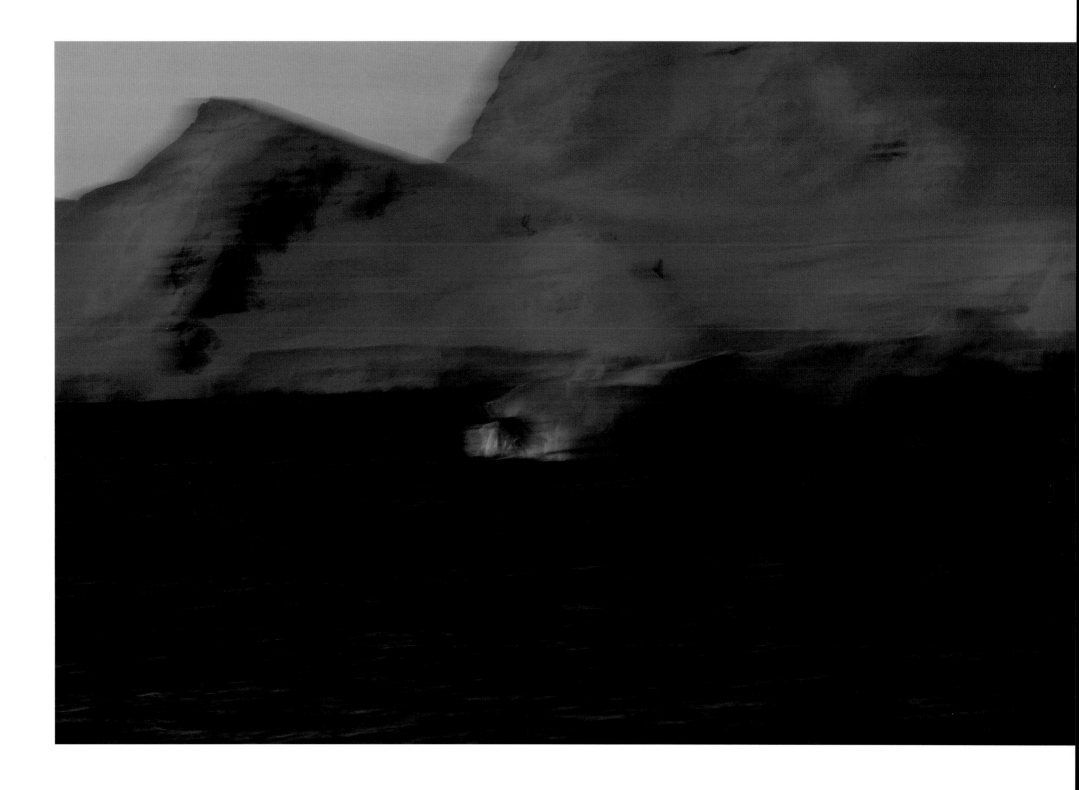

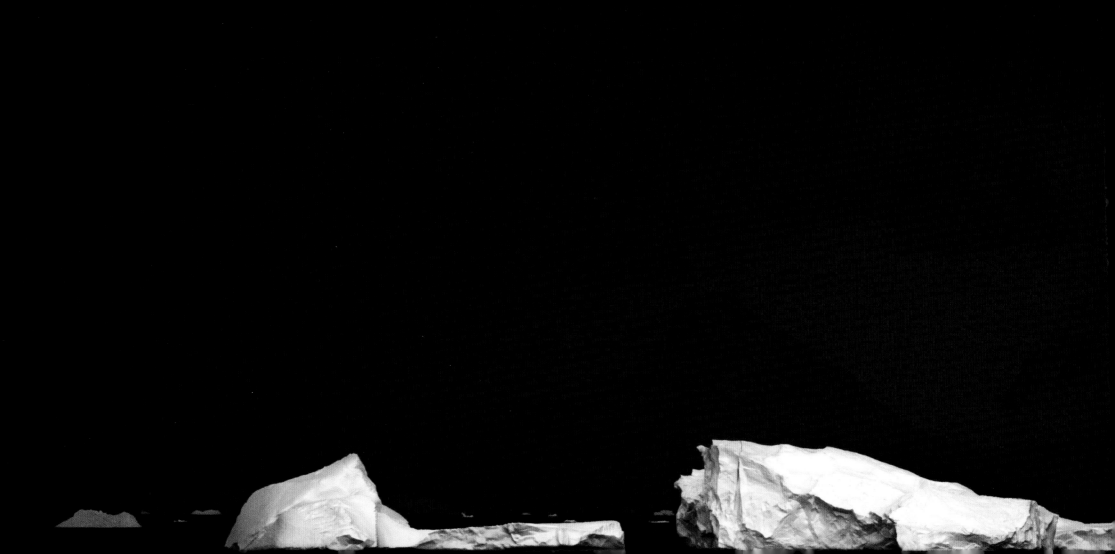

JUST TWO WHITE ICEBERGS

Out of nowhere, a beautiful sunny day turned grey and a storm arrived. No sooner had the sky darkened, though, than a gate seemed to open in the clouds. A beam of light poured down to illuminate a pair of icebergs in the distance, making them even more brilliant white than before and contrasting wonderfully with the gloom of the storm.

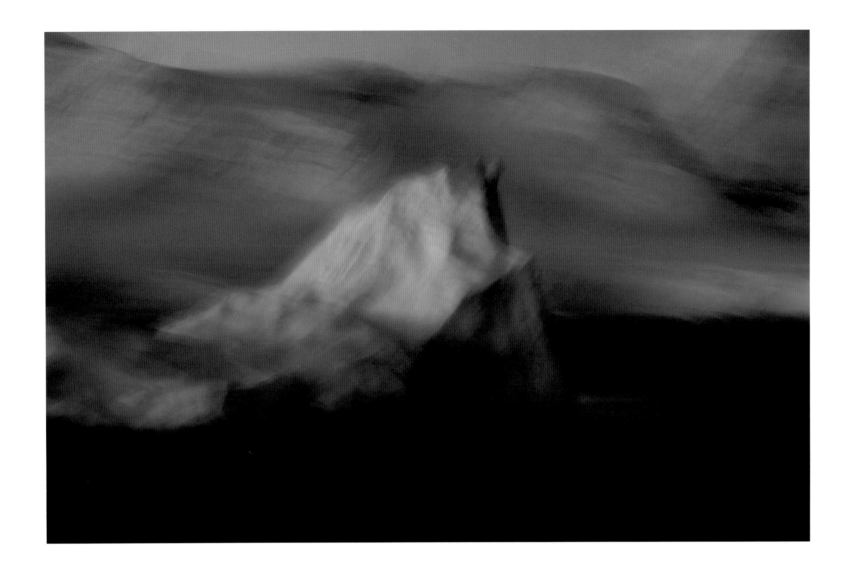

NIGHT

Night-time was a particularly big challenge. Antarctica never sleeps, and in the deep of the night you feel as though some strange and fascinating presence is looking at you through the darkness. As we journeyed south, we began to see more and more icebergs. All were beautiful to look at, but some could be disastrous to come in contact with.

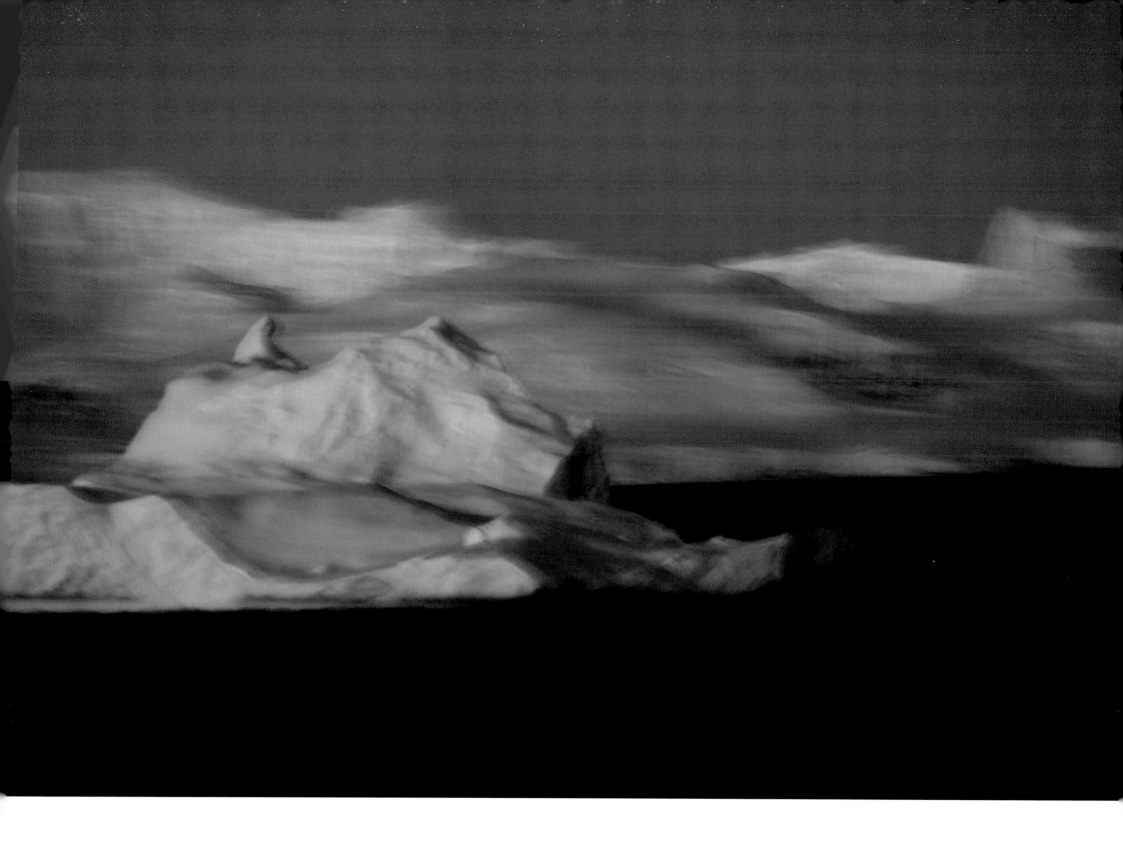

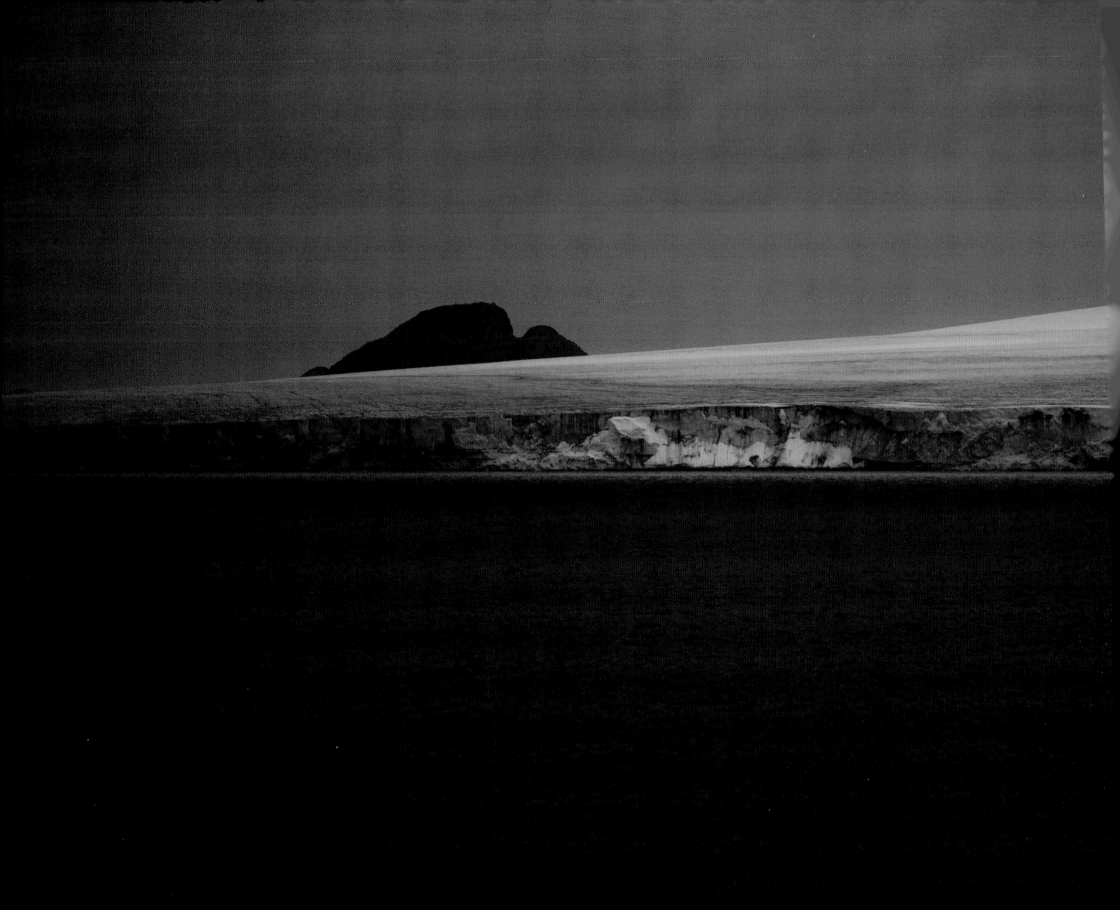

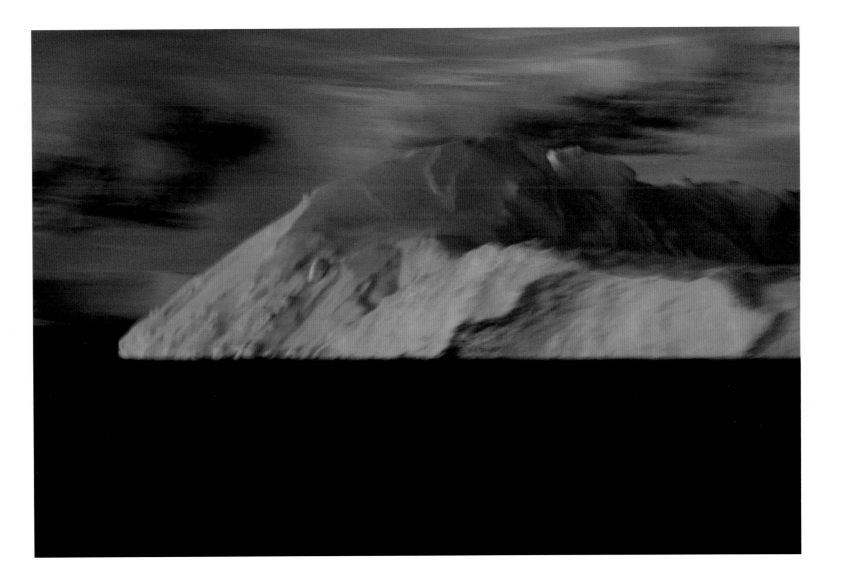

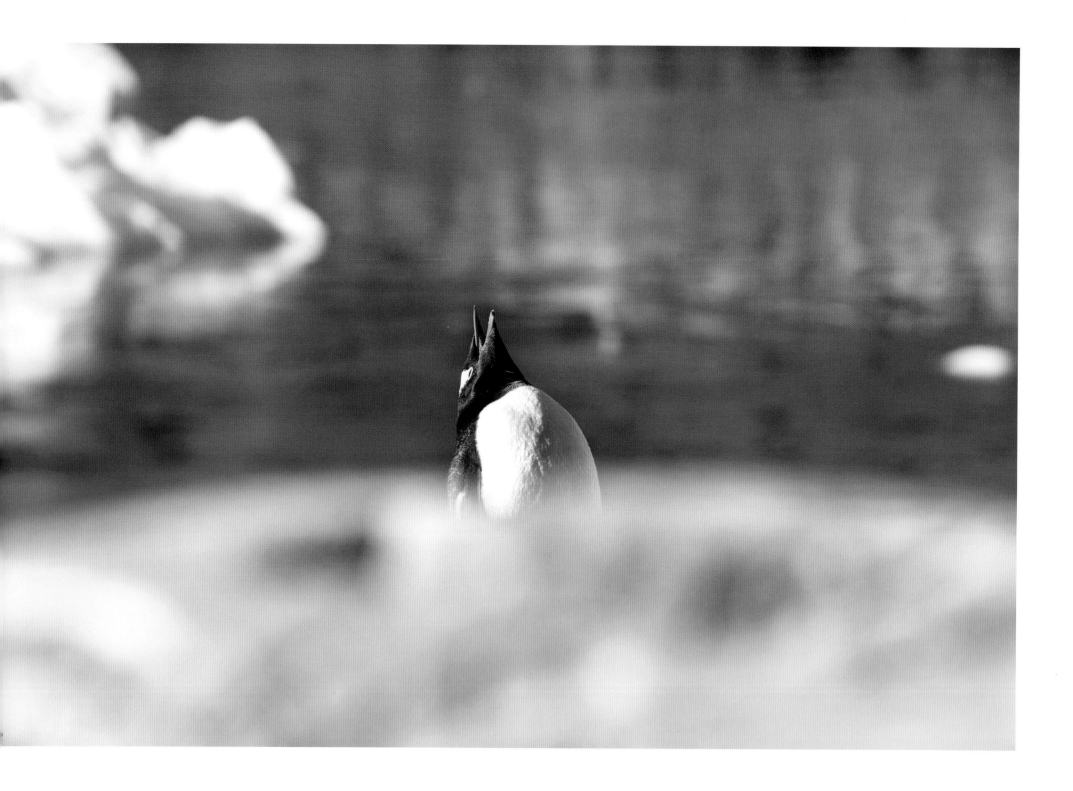

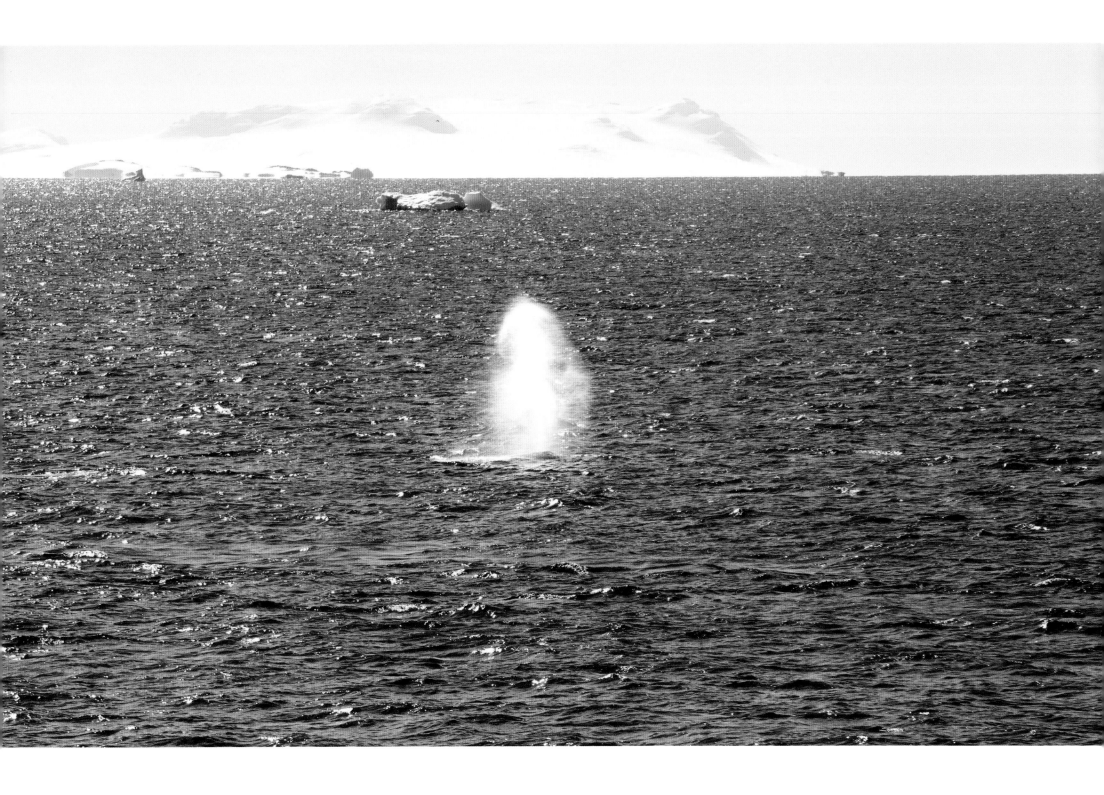

VOICES FOR ANTARCTICA

It was quite a departure when, in 2013 as an Italian fashion photographer, Enzo Barracco approached the Royal Geographical Society with a proposal to exhibit his photographs of Antarctica in our Exhibition Pavilion. Enzo's exhibition *The Noise of Ice: Antarctica* – the result of a month spent in the Antarctic taking an intimate, contemporary look at what he calls 'a world within another world' – provided a striking contemporary response to the historic images from our own Collections that had inspired his journey. Enzo's images of this 'mysterious place of real beauty' provide a new chapter in the visual recording of this extraordinary continent for a modern audience, one that we can all enjoy on the page in his striking book, inspired by our own holdings.

Dr Rita Gardner, CBE
Director, Royal Geographical Society (with IBG), London

The Scott Polar Research Institute, part of Cambridge University, is a centre for the study of the Arctic and Antarctic, covering the physical and social sciences. We undertake fieldwork in both polar regions and work from icebreaking research vessels, using the marine-geological record to reconstruct the past growth and decay of ice sheets. Our Polar Museum projects both the contemporary importance of the Arctic and Antarctic in the context of climate change, and the history of polar exploration, especially that concerning British explorers such as Captain R.F. Scott and Sir Ernest Shackleton. Among our holdings are Shackleton's four original diaries from his Antarctic expeditions and a number of Scott's last letters, including that to his wife, Kathleen.

The Institute was founded in 1920 as a memorial to Captain Scott and his four companions, Wilson, Bowers, Oates and Evans, who died on their return from the South Pole in 1912. The research, teaching, information and outreach activities of the Institute today provide a continuing legacy relating to these early explorers of the Antarctic. Enzo Barracco's book and splendid photographs will continue to inspire those interested in the polar regions in general and ice in particular. It is fitting that Enzo's research about the Antarctic began with a visit to the Institute's Polar Museum.

Professor Julian Dowdeswell
Director, The Scott Polar Research Institute, University of Cambridge

A picture is worth a thousand words. Enzo Barracco's feature of Antarctica is a timely reflection on the wider impact of the built environment on climate change. With the concept of global warming intangible to many, Enzo's work helps to remind us that human activity has far-reaching consequences for the rest of the planet.

We still have a narrow window of opportunity to design ourselves out of the problem and limit global temperature rises to under 1.5°C. The Paris Agreement drafted at COP21 in 2015 presented a heartening step in the right direction, with 198 parties from across the world agreeing to the text of a global agreement on climate change action. However, it is now crucial that the document becomes legally binding by at least fifty-five countries, which together represent 55 per cent or more of global greenhouse emissions, signing it by April 2017.

The Royal Institute of British Architects (RIBA) and other key built-environment organizations have joined a Global Alliance on Buildings and Construction to spread the message about the importance of governments signing up to the document. We need as many organizations and individuals to lead on similar initiatives and to put pressure on their governments to take stock. RIBA believes Enzo's work will help to spread this message widely.

Emilia Plotka
Royal Institute of British Architects, London

Photographs are not just images of a scene or a person; they go beyond that and are interpretations – the photographer's and, dare I say, the viewer's. Thus when I saw Enzo Barracco's exhibition at the Royal Geographical Society and was lucky enough to come across Enzo for the first time, we were able to walk round and discuss my interpretation of his work. It was the start of a friendship with someone who is able to look at the world around us with a fresh perspective and give others, through his photography, valuable insight into a precious and worryingly threatened natural world.

I laud Enzo's enthusiasm to explore beyond his horizons and to use his talent to help the rest of us understand the value of our world.

Edward Watson
Chairman, British Exploring Society, London

A portent of the future …

In light, white is the presence of all colours, and nowhere is this more evident than on the White Continent – its stark beauty a visual feast for the eyes, spanning the entire visible spectrum. Antarctica also harbours all manner of flora and fauna, both on its ice-cloaked landmass and in the chilled waters that lie offshore.

Since Antarctica was first spied in 1820, its forbidding climate has served as a great gatekeeper, ensuring that the wonders of the continent are shared only with those souls hearty enough to venture there – among them Ernest Shackleton, the first to traverse the Ross Ice Shelf and Transantarctic Mountains, in 1908–9; Roald Amundsen, the first to set foot on the South Pole, in 1911; and Richard E. Byrd, the first to conduct geological surveys, in the 1930s and 1940s. Today, scientists from more than thirty nations endure the seasons in the research stations and field camps set up across the continent on a quest to understand its critical role in the global environment.

To the list of intrepid voyagers one must add Enzo Barracco, who has turned a curatorial eye nurtured in the world of art and fashion to Antarctica's vast landscapes. His arresting imagery captures the play of sunlight in the transparency and opacity of the ice and the subtlety of the deep blues, greens and reds of age-old lichen, algae and geological formations, and in its totality reveals what is surely Earth's greatest catwalk show.

Angela M.H. Schuster
Editor-in-chief, *The Explorers Journal*, New York

I remember the moment clearly. Hidden by guests – and then, like a break in the clouds, an image of Antarctica that made me stop. And stare. I saw a glacier dripping with meltwater and a distinct 'sea-line' across the image.

The photographer was passionate about Antarctica. Naturally this drew me to the exhibition *The Noise of Ice: Antarctica* at the Royal Geographical Society (RGS) one special day in January 2013. And it was there that I had the privilege to meet Enzo Barracco and his work, as he spoke alongside Alexandra Shackleton. What a journey we weave.

Back in 1939, my late father met the explorer Edward Shackleton at the King's Camp for schoolchildren at Abergeldie Castle in Aberdeenshire. 'Keep the back of the neck warm – so always have a good thick scarf when exploring frozen lands.' This advice has remained in the family to this day. Some thirty years later, Edward, by now Lord Shackleton, visited the RGS's survey of the Gunung Mulu National Park in Sarawak, Borneo. The central mountain – Mulu – had first been climbed by the local Berawan community with the Oxford student Shackleton in 1931, hence his interest in the team of international scientists who were studying this pristine tropical forest.

It was there, as field director of that survey, living in a longhouse in the heart of this protected area, that I heard the 'song of the forest' by the huge and talented orchestra of mammals, birds, frogs and insects. And it was there that I began to understand how fast the world's habitats and musicians are disappearing, and how the planet's landscapes are changing even faster. Among the cicadas, Shackleton spoke of his love of the polar regions.

Enzo has an equal passion, and his images remain indelible as they capture a region that is undergoing rapid change. They make your heart beat faster. The sounds of his glaciers can be heard, reaching you as a song for the continent and its future. This is the role of the environmental photographer in recognizing the enormity of the task ahead in caring for and maintaining our planet as home.

Shackletons, all three, would be, and indeed are, proud. Enzo now shares his work to a wider audience in *The Noise of Ice*, knowing the challenges ahead for those accountable for the future sustainability of the continent, as well as the general public, who are familiar with melting glaciers and understand the personal connections.

Imagery of such passion contributes to our understanding of geographical regions. I wish to thank Enzo for bringing the great south into our homes. May his noise and song be heard loudly as the 'hymn of the universe'. Our weaving journey continues: for what we do today influences the look and sound of glaciers and forests tomorrow.

Nigel Winser, FRGS

Rather than superheroes, we have need of the daily heroic gestures that each one of us can perform, to reduce the impact of the human race on the planet. This is shown unmistakably by Enzo Barracco with his stunning photographs, which capture the fragile equilibrium of Antarctica.

Not only the heavy industries pollute, although they are major culprits; the 'greenhouse effect' is the main cause of global warming, and it is affected by what we eat, where we live, how we move and even what we wear. Yes, that is correct: by our clothes.

Each piece of clothing has an impact on the environment and 'weighs' differently in terms of greenhouse gases. Some materials pollute by way of their manufacture, production and transport; others stem from crops that compromise biodiversity. The fast-fashion chains, always expanding, multiply the use of resources and at the same time the emissions of the production cycle. There are still very few fashion brands with a real ecological sense.

Actions that could improve the fashion industry's effect on the environment are known, but the fear of lower revenue and higher costs makes these changes difficult, if not impossible. For the time being, it falls to us to consume less but better, to recycle as much as possible and to compensate for our carbon footprint, perhaps by using more virtuous companies.

It is our wish that the beautiful and the good of Platonic philosophy become one again.

Federico Chiara
Vogue Italia

Ice: in Antarctica it is everything. It is both the backdrop and the subject, the canvas on which the clear polar light washes the landscape with a myriad of colours. Enzo Barracco's images of Antarctica perfectly capture the beauty and simplicity of this ice-dominated continent. They highlight the fact that although vast, remote and otherworldly, the Antarctic continent is often subtle, delicate and fragile. The clarity and quality of Enzo's work leave a lasting impression on the viewer.

This remote world is connected subtly with our own; changes both present and predicted in the Antarctic's ice will raise global sea levels and affect global weather patterns. Highlighting this environment, its beauty but also its fragile nature to a wider audience is of crucial importance. The scientific and conservation messages from the frozen continent often get lost in translation or blurred through the lens of the media, so the ability of Enzo's emotive and evocative photography to capture and portray these important messages cannot be overstated.

Peter Fretwell
British Antarctic Survey, Cambridge

When I met Enzo Barracco, we had a moving discussion, which I later entitled 'The Inner Exploration'. The inner journey is a very hard, dangerous task. You find within yourself mountains, oceans, deserts, forests, precipices and abysses to overcome, wild beasts, horrible monsters and impossible battles to win, just like the most arduous, adventurous expeditions on Earth that very few have been able to face. Self-discovery is the very reason to begin such a journey, and self-mastery is the incredible, wonderful achievement to which every person on Earth should aspire.

Taken by a man who has braved the elements, and inspired by his journey to Antarctica, the images on these pages allow the viewer to experience at first hand the feeling of being an intrepid pioneer in that dangerous but magnificent territory.

Elio D'Anna
Founder and President, European School of Economics

First published 2016 by Merrell Publishers Limited, London and New York
Merrell Publishers Limited
70 Cowcross Street
London EC1M 6EJ

merrellpublishers.com

Main text and photographs copyright © 2016 Enzo Barracco
Foreword copyright © 2016 Ranulph Fiennes
Text on pp. 140–43 copyright © 2016 the contributors
Design and layout copyright © 2016 Merrell Publishers Limited

British Library Cataloguing in Publication data:
A catalogue record for this book is available from the British Library.

ISBN: 978-1-8589-4656-6

Produced by Merrell Publishers Limited
Designed by Claire Clewley
Edited by Rosanna Lewis
Proofread by Marion Moisy

Printed and bound in China

ACKNOWLEDGEMENTS

It was an amazing privilege when Sir Ranulph Fiennes, one of the world's greatest explorers and another of my heroes, agreed to lend his support to the project. I remember the day he agreed to write the foreword for this book. It was like seeing the landscape in Antarctica – difficult to believe.

I should like to thank some very special friends, who supported me on this project and for this book: Dr Rita Gardner, Kate Mosse, Darcy Conor, Prince Albert II of Monaco Foundation (Italian Branch), Edward Watson, Susan Lissack, Denise Prior, Alasdair MacLeod, Luciano Figueira, Alexandra Shackleton, Laura Savoldi, Nicole Hambro, Lynn Baker, Daniel Gava, Isabel Sozzi, John Rafter, Joseph D'Anna, Elio D'Anna, Elia D'Anna, Will Roberts, Richard Cook, Marcia Jennings, Federico Bianconi, David Wardrop, Richard L. Sadler, Alessandra Baldeschi, Jonny Sams, Rachel Collins, Pete McGlynn, Nigel Winser, Prof. Julian Dowdeswell, Andrea Sisti, Edo Pinotti, Stefania Morello, Mario Tozzi, George Alderwick, Suzanne Todd, Angela Schuster, Adeola Adeyemi, Ottavia Alieri, Rachel Andrews, Alessandro Antonioli, Melvin Benn, Deborah Martinelli Bonavia, Jane Bowers, Rodrigo Braun, Jason Carey, Enrico Castelli, Pamela Chan, Federico Chiara, Antonella Chiesa, Children's Hospital Trust Fund, Ludmilla Cocci, Maurizio Codurri, Ben Devere and Keeley Webb of Wilderness Festival, Karin Fouque, Peter Fretwell, Paolo Giusti, Stephan Glaettli, Tom Gorrard-Smith, Tatiana Hambro, Jeremy Hopkins, Amanda Hosie, Alex Keys Jackson, Georgina Jackson, Corina Lee, Tim Lindberg, Dave Lucken, Nina Mahlab, Richard Menzies, David Moy, Iolanda Naguel, Andrea Nigi, Lisa Page, Laurence Parry, Debbie Philippides, Frances Prenn, Ugo Privitera, Pushaun, Giuseppe Racanelli, Tony Randall, Tamiz Reynolds, Jane Richards, Francesca Riello, Jolene Rodrigues, Daniela Roncari, Sidney Ross; Elisa Rusconi, Alan Shand, Jeff Shear, Joanna Smith, Francesco Trenti, Victoria Tryon, Serena Vaturi, Christopher Williamson, Fabian Wood and family, Michael Zur-Szpiro; and my family, Carlo, Rosa and Antonio.

I must also say a huge thank-you to all who sponsored and supported me in my adventure with enthusiasm: Nikon; Royal Geographical Society; Royal Opera House, London; Royal Academy of Dramatic Art, London; Palazzo Seneca, Norcia, Italy; Royal Institute of British Architects; Scott Polar Research Institute, University of Cambridge; Studio Sisti e Associati; Tozzi Sud; The Dorchester, London; Hotel Principe di Savoia, Milan; The Explorers Club, New York; Bulgari Hotel, London; Action Cameras; Alma Energia; Arper UK; British Antarctic Survey, Cambridge; Cad & The Dandy; Carey; Los Cauquenes, Argentina; Christie's; *City Magazine*, Runwild Media; Columbia Sportswear; *Creative Review*; Eolo Argentina; European School of Economics; Fcf, Milan; *Financial Times*; Lloyd's Register; Nokian Footwear; Park Hyatt Group; The Print Space, London; Radley College, Abingdon, Oxfordshire; Rai – Radiotelevisione Italiana; Scott Prenn; Solution Group; *Sunday Times Travel Magazine*; United Nations; Venturethree; Villa D'Este, Como, Italy; *Vogue Italia*; The Welding Institute, Cambridge; Withers Worldwide.

Being involved in a project of this size and scope has brought me in contact with many people and organizations, and I am sure to have forgotten someone in preparing these lists. My apologies to anyone I have missed: I couldn't have done it without any of you.

Making this book involved another difficult journey. There were many things to organize, many stories to tell. I must say a special thank-you to one person in particular. He was very close to me from the very beginning of the project, when it was just an idea. I asked him: 'Do you know about Shackleton? I'd like to make a project in Antarctica.'

He laughed and said: 'Enzo, everyone in the UK knows him!'

I replied: 'Sorry, I'm Italian.' I told him my idea and from that point he supported me until this moment, as I am writing these words. Thank you, Richard Lissack.